Painting in Eighteenth-Century Venice

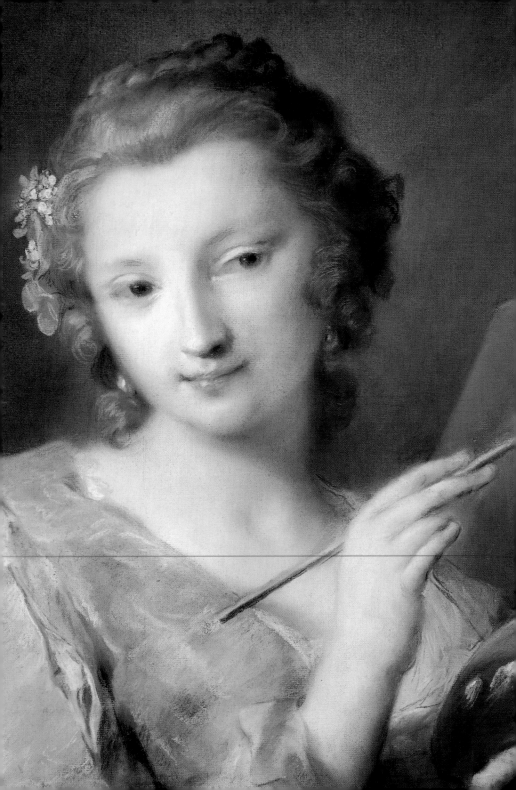

Painting in Eighteenth-Century Venice

Third Edition

MICHAEL LEVEY

YALE UNIVERSITY PRESS
New Haven and London

FOR BRIGID
con amore

First published 1959
Third edition published by Yale University Press 1994
This edition copyright © 1994 by Michael Levey
10 9 8 7 6 5 4 3 2 1

Library of Congress Cataloging-in-Publication Data
Levey, Michael.
Painting in eighteenth-century Venice /
by Michael Levey. – Rev. ed.
Includes bibliographical references and index.
ISBN 0-300-06057-2 (pbk.)
1. Painting. Italian – Italy – Venice. 2. Painting,
Modern – 17th–18th centuries – Italy – Venice. I. Title.
ND621.V5L4 1994
759.5'31'09033 – dc20 94-17558
CIP

A catalogue record for this book is available from
The British Library

Designed by Gillian Malpass
Set in Linotron Sabon by Best-set Typesetter Ltd, Hong Kong
Printed in Hong Kong through World Print Ltd

Frontispiece: Rosalba Carriera, detail from *Allegory of Painting* (Fig. 115)

Contents

Dust and ashes, dead and done with, Venice spent what Venice earned!
The soul, doubtless, is immortal – where a soul can be discerned.

<div align="right">BROWNING: A Toccata of Galuppi's</div>

Foreword to the Third Edition

How this book came to be written, and the way I approached my subject, were matters touched on in the Foreword, reprinted here, to the second, revised edition of 1980.

Nevertheless, it may be worth repeating that the book originated in an enthusiasm, though one not uncritical, for a period of painting in Venice which had never been written about extensively in English and which was not very widely or warmly esteemed in Britain, despite the notorious, long-standing British affection for the work of Canaletto. The book was, however, not intended to be a history of eighteenth-century Venetian painting. It was meant to serve as an introduction, an appetizer, suggesting something of the city and the circumstances within which the painters worked, and something also of the qualities of the chief exponents in the various categories of painting practised there.

For this edition I have made a number of significant changes to the text, without trying to alter the character of the book. To me at least, it would be alarming if my ideas had remained unchanged over the years. That they have changed is due to my looking longer and thinking more, and that is partly the result, I gratefully own, of increased scholarly attention to the period and its painters. Even a bibliography as 'select' as the one printed at the back of this edition offers substantial fare for any student or general reader, and when those catalogues and books have been digested, along with the often important books and articles referred to in the Notes, such a person will know much more about painting in eighteenth-century Venice than did – or could – the author in setting out to write this book in 1959.

While some youthfully naïve and excessively sweeping statements have now been suppressed, the text retains most of its original emphases. I am not afraid to declare that an urge to appreciate great painting – regardless

of period – still colours my approach. If that has become art-historically unfashionable, judged insufficiently professional, I am unstirred, unrepentant and ultimately defiant.

Were I writing an entirely new book on the subject today, I should of course wish to take advantage of the mass of admirable research thrown up by recent scholarship, some of it so recent that it has yet to be absorbed. But we do not, incidentally, possess all the information desirable about even the leading painters of the century in Venice. And anyway no sensible scholar, however knowledgeable about history, will ever want to claim to have all the answers to art.

What I hope this book does convey, as it appears in what must presumably be its final form, is my profound and time-tested belief in the true greatness of some eighteenth-century Venetian painters, Canaletto and Tiepolo above all. During the 1980s three exhibitions, in London, Venice and New York, demonstrated the uncontrovertible stature of Canaletto. There have been good and striking exhibitions of Tiepolo too, but for obvious reasons much of his finest work cannot be assembled in an exhibition, and besides he is a far more complex artist to examine and enjoy. My suspicion is that full justice will never to be done to his genius in Britain at least, though I would gladly live to be proved wrong. Trusting that my own estimate of him emerges from this book, I say no more here, except that I ought properly to have expunged every reference that links Tiepolo and the rococo style, since I have concluded that his art has little or nothing to do with it.

It remains only to acknowledge some substantial debts of gratitude I have incurred, beginning with that to my agent, Giles Gordon, for his kind and active interest in the re-publication of this book. To John Nicoll at the Yale University Press I am, once again, warmly grateful, and I feel proud to be appearing for the third time under his aegis. I am no less grateful for the collaboration again of Gillian Malpass, whose flair for design and care for the text have done so much for this edition. It is as much a pleasure as a duty to attempt to record my great indebtedness to Alyson Wilson. She has in effect been my co-reviser, not only researching for the Bibliography and the Notes, to the marked benefit of both, but putting forward several invaluable suggestions, as well as kindly reading a proof. For any errors I alone am responsible. However, without her sympathetic, near-telepathic assistance, I doubt if I could have faced up to the task of revision.

Turning over the pages for that purpose, after a number of years, I found my thoughts reverting to certain friends and scholarly colleagues to whom I am more generally indebted. Before it is too late, I should like to

single out gratefully Alessandro Bettagno, Francis Haskell, J.G. Links, Oliver Millar and, especially, Terisio Pignatti, who was my first guide to the Venetian eighteenth century on the spot and who has been unfailingly generous ever since, in scholarship and friendship. To those names I want to add that of Jim Byam Shaw, sadly now beyond my gratitude though not my respect.

Time has increased my awareness of the good fortune I had in studying a subject which brought me the privilege and pleasure of knowing them all.

M.L.
Louth, Lincolnshire, January 1994

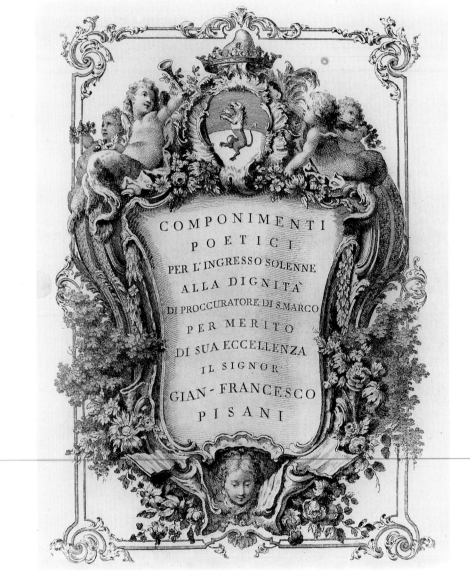

COMPONIMENTI
POETICI
PER L'INGRESSO SOLENNE
ALLA DIGNITÀ
DI PROCCURATORE DI S. MARCO
PER MERITO
DI SUA ECCELLENZA
IL SIGNOR
GIAN - FRANCESCO
PISANI

1. Title-page of the Congratulatory Anthology for the Procurator Gian Francesco Pisani. 1763. Venice, Museo Correr.

Foreword

Twenty-one years ago, when this book was first published, its subject – like its author – might reasonably be called young. At that date there were no *catalogues raisonnés* of such painters as Canaletto, Longhi and Sebastiano Ricci – still less of Domenico Tiepolo or Diziani. The name 'Guardi' normally still meant Francesco, and Simonson's monograph of 1904 was the standard work. Several important collections of eighteenth-century Venetian paintings and drawings had not yet been properly catalogued. There had been few major exhibitions of major artists and aspects of the period.

Apart from purely scholarly work by a few notable pioneers, little had been published in English on the subject. It is a fact that until 1955 there was, for example, no book on Giambattista Tiepolo in English. His reputation as a great artist was by no means settled. And the idea of the Venetian eighteenth century as a period of artistic decadence and triviality was probably fairly widespread, among art historians as much as among the general public.

Those who had grown up imbued with this view included, I may confess, myself. A Foreword should not degenerate into autobiography, yet it is perhaps permissible to say something briefly about how this book came to be written. I date my conversion to Giambattista Tiepolo (and through him to Venetian painting in his lifetime) from a first visit not to Venice but to Würzburg. Return visits have simply confirmed for me that Tiepolo's frescoes in the Residenz there are among the finest achievements of European painting.

Yet perhaps I should never have seen them if I had not, on joining the National Gallery, been assigned a modest section of the Collection to catalogue: the eighteenth-century Italian schools. Nobody else wished to do it; I wished to do it only because it was a catalogue in a great scholarly

series. When in Venice as a vaguely artistic undergraduate I had never glanced beyond Bellini and Titian. I dreamt of the Ruskinian Renaissance there ('Deep-breasted, majestic, terrible as the sea...') and awoke confronted by what seemed the prosaicism of Canaletto, the superficiality of Tiepolo, not to speak of the real pettiness of Pietro Longhi.

By the time the catalogue was finished, I hope I knew better about the first two artists. That is only a small part of my vast debt to the National Gallery for educating me. I wanted to write a book on the subject that should not be a mere assemblage of biographies nor just an inventory of works. I was, as my title meant to convey, concerned with a city and the painting produced there in one, then somewhat despised, and even now misunderstood, century. Although I could not praise every painter – and was to be much criticized, at least abroad, for expressing reservations over Sebastiano Ricci and unenthusiasm for Pietro Longhi – I felt I had something to say in appreciation of talents not so often discussed or very well known: about the great, idiosyncratic art of Piazzetta, the atmospherically sensitive landscapes of Marco Ricci, the portraits of Rosalba and also Alessandro Longhi, and the witty accomplishment of Domenico Tiepolo in every medium.

Reading and revising the book after so long a period, during which scholarly knowledge has significantly advanced, I found in it naïvetés as well as mistakes. The latter I have attempted to correct, while only occasionally modifying the former. I have not tried to alter the character of the book. It was conceived and written, just as it is dedicated, *con amore*. I never intended it to be either exhaustive or exhausting. After all, its subject is art, and time has only strengthened my belief that writers on the subject should display – along with knowledge – some pleasure in what they are dealing with. Few of my opinions on the subject here have changed, I find, except that my delight in certain painters (Canaletto, for example) has increased through prolonged looking and hence deeper understanding; I have added, accordingly, a passage or two.

I am grateful to the Phaidon Press for choosing to reissue the book, and in a more fully illustrated format. A particular debt of gratitude is owed to Keith Roberts, whose shrewd advice and numerous stimulating suggestions for improving the text and expanding the range of illustrations I have gladly adopted. If the result is a better book – as I venture to think – his is very much the credit. And though we may never agree on the respective merits of Rembrandt and Tiepolo, I hope he will accept this acknowledgement of my gratitude for his keenly intelligent, friendly interest.

* * *

A few days after the paragraph above was written, and the text handed over to him, Keith Roberts was unexpectedly taken gravely ill. Shortly afterwards, at the age of forty-one, he was dead. Profound regret must now mingle with my gratitude, and I leave to stand what I had previously written as some sort of testimony, in its way, to feelings which time has only deepened. I should like to add a word of warm thanks to Penelope Marcus at Phaidon who took over the task of this book and has shown a sympathetic interest in it.

M. L.
London, January 1980

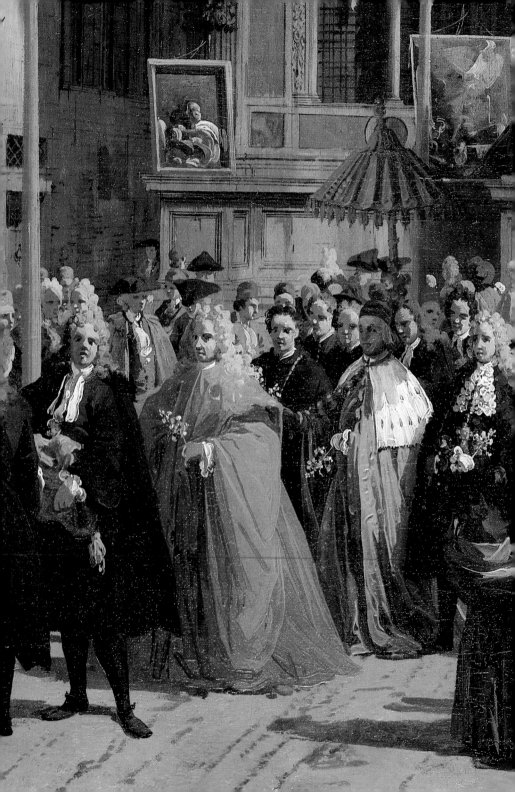

Introduction

A feeling existed throughout Italy during the eighteenth century that all was not well, a hint of thunder in the air, which did not break into a satisfactory storm until the Risorgimento. The cosmopolitan Venetian Francesco Algarotti, a friend of Tiepolo, Lady Mary Wortley Montagu, and Frederick the Great, puzzled it out. The Italians, he wrote and believed, had conquered the world, illuminated it with science and the arts – yet they were not cutting much of a figure in the present. As explanation the metaphor of sleep came to his aid: Italy was dormant only to wake up soon.

Algarotti died in 1764, and Italy was still sleeping when a very different person, Leopardi, born only just within the eighteenth century, looked round his native land. Leopardi saw the statues and towers of his ancestors, 'Ma la gloria non vedo.' And indeed the Italy of Leopardi might seem in worse case than Algarotti's. Despite stirrings of national consciousness, the reality of a unified country seemed far away, while the old organization of powerful independent city states had been smashed by Austria and by Napoleon. Besides, something else had happened in Europe between Algarotti's death and Leopardi's birth: the French Revolution.

Of all the Italian city states Venice could claim to have remained the greatest. None except the Papacy had played such a part in world affairs; in Italy none had challenged the Papacy more strongly; nor did the election of a Venetian Pope in 1758 much soften the Republic's proud defiance. Until the last Venice went through the motions of ruling, even while its domain dwindled and its political power declined: an anachronism in eighteenth-century Europe, either splendid and touching or intolerant and ridiculous, depending on whether a poet or a philosopher looked at it. As for the travellers who visited eighteenth-century Venice in such numbers, they mostly gave as much thought to the constitution of Venice as

2. Canaletto, detail from Fig. 4.

Blackpool's visitors nowadays give to the local council. They merely noticed and exaggerated the insignificant, repeated the comments of the guidebooks (themselves usually some years out of date, when not positively inaccurate) and came home to write yet another book of travels.

It was not quite their fault that this so often happened. There was little of beauty in eighteenth-century Venice except outward beauty; prying further only produced unpleasant sights and inconvenient facts. The State had every reason to discourage visitors from arriving at the conclusions of Montesquieu: 'my eyes are very pleased by Venice; my heart and mind are not.' Nor was it likely that the author of the *Esprit des Lois* would find much to approve of there, any more than could Rousseau. But most visitors to Venice in the eighteenth century were no more intelligent than the majority today; and this was fortunate for the Republic.

It had become a tourist centre. Its processions and ceremonies served for visitors to gaze at in the intervals of boating and gambling. Its ambassadors were accredited to the courts of Europe, but were ignored. The Republic as an entity lost ground – literally – as the century advanced; it lost contact with its possessions on the mainland. Gradually the State became the city itself, and gradually the actual conditions of life worsened while the carnival still gave an air of spurious gaiety to the moribund organism.

That process of decay was, however, to be comparatively protracted, and in contrast to political inertia there continued to be a considerable amount of activity in other spheres, not least that of building. We tend to think of building activity primarily in aesthetic terms, but often enough it had a practical or semi-practical basis. A family decided they would enjoy more space and were wealthy enough to build a new palace; a religious order wished to foster a cult and its own prestige, and raised sufficient funds to have a new church constructed. And in much the same way, for the greater glory of God or a patron saint, a confraternity might have decorated, or re-decorated, its main hall.

Only a few major palaces were added to those lining the Grand Canal. None was more imposing than the Palazzo Grassi, designed by the most talented of mid-century architects, Giorgio Massari, a slightly older contemporary of Tiepolo. But a number of outstanding churches was built, ranging from Massari's large and prominently-sited Dominican church of the Gesuati (S. Maria del Rosario), a handsome, confident essay in Palladianism, to the small, tucked-away church of the Maddalena by the scholarly architect, Tommaso Temanza (himself portrayed by Alessandro Longhi). Temanza's church is an austerely classical, circular 'temple', mingling Palladianism with echoes of the Pantheon in Rome.

2

The eighteenth century was in fact the last great age of church building in Venice. That serves as a reminder that the Church was still a force in daily life as well as retaining its role as patron of the arts – arts that comprehended not only architecture, sculpture and painting but the humbler yet necessary ones of masonry and carpentry. The building and decoration of a new church were an elaborate operation, giving employment to teams of different craftsmen.

Foreign visitors to Venice, especially those whose faith was not Roman Catholic, may have paid little attention to overtly religious 'modern' art there. After all, the majority of them had come not for edification but entertainment. And anyway Northern European attitudes to manifestations of Southern piety have usually been condescending, when not disapproving. Yet the matter is by no means straightforward in the eighteenth century, for Venetian taste in church architecture and church decoration did not – perhaps surprisingly – foster anything as exuberant, as wildly rococo, as the idiom of Bavarian and Franconian churches of the same period.

Of all the visual arts practised in a Venice declining but not yet fallen, painting was perhaps the most flourishing and certainly the most widely-known. It was also novel as well as vital and varied in the forms it took – as for instance in developing the view picture. 'Renaissance' is a word hard to avoid when contemplating the brilliant concatenation of talent and genius that characterized the eighteenth-century school of painting there. Although the Venetian *seicento* was far less dim and dark than used to be presumed, it lacked the lustre that came with the new century. Three native geniuses were working concurrently, in their very different styles, from the 1720s onwards: Canaletto, Piazzetta and Tiepolo. All three are of European stature. Piazzetta is the most 'difficult' figure of the three, partly because, unlike the other two, he could not meet the demand for a ceaseless flow of finished paintings. Yet at his finest he is an artist of the greatest power, profound and proudly idiosyncratic. As for Canaletto and Tiepolo, no history of Western painting, however concise, can fail to mention them.

Aside from the visual arts, other indications of cultural vitality existed in the politically stagnant climate of Venice. Firmly based on the tradition and reputation established in the previous century, music flourished – and, like the visual arts, in forms both secular and sacred. It was in Venice that the very first public opera house, the Teatro S. Cassiano, had opened in 1637. There were over half a dozen by the eighteenth century. In addition there were concerts, the famous female conservatories and notable choirs, like that of S. Marco. Music was the one art that united natives and

foreigners. 'The Venetians', wrote the Irish singer, Michael Kelly, in his *Reminiscences*, drawing on first-hand experience, 'are in general adorers of music, and Venice, one of the first cities in Europe for the cultivation of that art.' So far was adoration carried that in 1789 – the ominous, opening year of the French Revolution – an association of Venetian nobles and citizens set in hand a new and large-scale opera house. The theatre of the Fenice (the Phoenix), designed by Temanza's pupil Giannantonio Selva, was inaugurated in May 1792 and emerged virtually out of the ashes of the Republic, then within five years of its end. It was one last, splendid, almost reckless gesture, approved by the Senate, in the centuries' old programme of giving 'beauty and dignity' to the Venetian state.

A tremendous sense of tradition lay behind the state which had risen proudly from a few huts on scattered mudbanks in the Lagoon to become the Most Serene Republic. Tradition set its foundation as being on the Feast of the Annunciation in AD 421, and tradition fostered the belief that its reign would last for ever. Metaphorically, that has proved remarkably true, for Venice is still a capital city of the imagination, uniquely moving in its setting, its character, its corporateness, with its own myth of being at heart immutable, despite all that time and the elements can do.

The government, less attractively, was immutable while the Republic lasted. Its structure was oligarchic and aristocratic, in a way unique to Venice. A ruling caste of nobles made up and elected each other to the complicated series of councils and committees that were the government. The rest of the population was totally excluded, although below the patrician class there existed a no less proud class of original Venetian citizens (Canaletto was one). They could not vote or take any part in public affairs, but they were recognized as an élite above the ordinary inhabitants.

The Venetian government was not idle during the eighteenth century. Indeed, as it neared the end of its existence the Republic proliferated with regulations and requirements. An almost insane attention was paid to petty laws for establishing the nobles' dress, details of protocol, the position of benches outside cafés, conditions of work for artisans, import of, and printing of, books. After years of discussion, a Venetian academy was founded for painters, complete with regulations that kept it firmly ruled by the Senate. The State had turned in upon itself. It was everywhere. 'Never utter one word against the laws or customs of Venice', the manager of the S. Benedetto opera-house warned Kelly. Spies watched on the Piazza; clerics examined the imported books to see that nothing entered Venice by, among others, Helvétius, Berkeley, Rousseau and Voltaire. The Senate

even reduced, without permission from Rome, the number of religious feasts. The Inquisition of Three was a reality; accusations it received were acted upon promptly, and when the painter Northcote arrived in Venice (as late as 1779) it was with a shock that he saw displayed in the Piazza one morning a dead body bearing the legend, 'For treason against the State.' The tragedy of secret anonymous accusations became comedy in the last days of the Republic when finally it was the Inquisitors who were accused – and condemned, no doubt.

Against this sinister and hopeless background, hopeless because it revealed the State's inability to govern by open law, the Republic conducted grand ceremonies and proclaimed feasts: the vulgar and stupid formula of bread and circuses that had already proved its inefficacy with the Roman emperors. But ceremony and display needed their pageant masters, and the painters whom the Senate did not patronize for pictures might at least make themselves useful by designing carnival pavilions, decorative barges (Fig. 3), painting or engraving portraits of aristocratic persons appointed to official positions, or simply might reproduce the more splendid feasts in souvenir pictures (Fig. 4). These were really the only ways in which painters could serve the Republic officially; and even portraiture, so popular with governments in other countries, received little state patronage at Venice. The titular ruler of the Republic, the Doge, was usually painted once on election, though seldom again.

3. Francesco Guardi, *A Decorated Barge*. Drawing. Venice, Museo Correr.

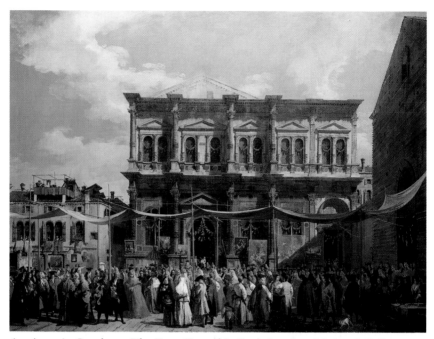

4. Antonio Canaletto, *The Feast Day of St Roch*. London, National Gallery.

But the Venetian ceremonies, with their studious parade of appearances, are perhaps one key to the artistic activity of the city. Venice itself, with its marble-faced palaces that are brick behind, is all appearances and illusions, and the life of the city in the eighteenth century was full of appearances. The Doge, who seemed to rule, was really the Republic's slave – his personal likeness did not even appear on Venetian coins. The nobles who seemed so haughty and grand were often desperately poor; there was a good subject for painting, the Abbé Richard thought, in seeing the subservience of a rich but mere citizen when speaking to a ragged nobleman. And sometimes when the Senate seemed about to strike, it thundered but no bolt fell: 'a parade of appearances', said the lucky Lorenzo da Ponte, who escaped with a reprimand for one of his poems when he had feared imprisonment. He had made a reference to not fearing the 'golden horns' of nobles – and this was taken seriously as a reference to the Doge, who wore a gold, horn-shaped cap.

Such topical aspects of life could find little direct expression in painting. It is significant that the ragged noble and the prosperous citizen – who

might have seemed to Hogarth good material for a conversation piece – were never painted by any of the Venetian genre painters. Satire and keen observation were not in demand. Nor did the State encourage freedom of thought. When Casanova tried to sustain the paradox with Voltaire that nowhere was one more free than at Venice, Voltaire replied accurately enough: 'Oui . . . pourvu qu'on se résigne au rôle de muet.'

The view pictures of Canaletto and many others, which are so often thought typical, were chiefly produced for tourists not natives. What continued to be a fundamental need within the city was for pictures consciously removed, in subject as in style, from mundane reality: scenes of mythology, whether pagan or Christian, and (to a lesser extent) of history. Not necessarily light-hearted, still less flippant, they were to be at once decorative and dignified in the Venetian manner exemplified supremely by Veronese, colourful, lively in handling and making a strong appeal to the senses.

Decorative pictures, charming rather than serious, were to the taste of the whole age, at least in the first half of the century, but nowhere more than at Venice was there such steady demand and supply. The Republic was retreating before reality, playing Canute to the remorseless tide of facts that lapped against it. Self-examination only proved what could not be said publicly: the commerce of the city was irreparably damaged by the great number of Mediterranean ports; the State archives, especially those of the Inquisitors, were in confusion; even the book trade was collapsing, not so surprisingly in a city where books were burnt publicly in the Piazza. Nor did the Republic really want to be remedied, fearing that the cure would prove unpleasant. Scipione Maffei drew up a very conservative plan of reform in about 1736; it never reached the Government proper (a government Kafka would have enjoyed depicting) and remained almost unknown until 1797. From these unpleasant facts there were distractions just as useless as, but considerably more beautiful than the promulgation of petty laws.

Painting offered one convenient and secure retreat, not so much from the present but from the future. In the secret instructions drawn up in 1786 for the French ambassador to the Republic there occurred the significant remark that for some years past there had reigned at Venice 'une sorte de terreur de l'avenir'. Venice herself perhaps seemed no longer under divine protection; worse, there were rumours that even divine protection was no longer an unassailable concept. It does not seem an illogical step thence to the hasty production of splendid altarpieces and frescoes to decorate new and rebuilt churches, nor to the grand ceremonial portraits

7

which enshrine so floridly those Venetian civil servants whose efforts held together the crumbling fabric for a few more years. And other pictures delighted the eyes with their playful homage to another religion, neither state nor ecclesiastical but classical. Poetry, history and mythology were all blended to produce a style of picture frankly imaginative; and in that pageant world people were dressed in the costumes of the great days of the Republic, the sixteenth century, which Veronese had once incarnated in his work.

All these different types of picture went on being produced at Venice long after they had fallen into disfavour elsewhere. Various reasons, not relevant immediately, had caused them to fall into disfavour; but reasons, like reality, could for long gain no admittance at Venice. When reality came, it destroyed the Republic. And when the reasons finally penetrated they sapped the impetus of painting. Venetian painting expires with the abdication of the last Doge, Ludovico Manin, and the fall of the Republic. A few artists, even one or two good ones, lived long enough to see the day when the Tree of Liberty was set up, in 1797, on that Piazza where the Republic had exposed its dead criminals, burnt modern books and served coffee. But the painters are inactive shadows like Alessandro Longhi or, like the old, impoverished Guarana, they are sadly active and begging for a pension. The artistic scene at Venice at that period is lightened only by the arrival of the youthfully talented and self-confident Canova, giving the city the benefit of being the site of his early triumphs.

Connoisseurs and Patrons

Venice had never had the reputation of being an intellectual city. A book published there in 1744, *L'idea generale delle scienze*, sounds a solemn and solid tome but actually was sixty-eight pages long; and it may stand as symbol of the learned 'appearance' rather than learned actuality which the city professed. During the eighteenth century when so many books were published to explain painting and painters, Venice produce few apologists for the type of painting most typical of it and few biographers of its artists. Thus Canaletto, Guardi, Pietro Longhi, Tiepolo, among those now famous, were none of them thought worthy of individual biography, for one cause or another. As for the style of unlearned painting practised at Venice – a style which may conveniently if not very satisfactorily be termed 'rococo' – this was left unsupported by any doctrine of aesthetics, was usually left undefended and, indeed, seems almost to have been left unobserved by Venetian critics of the period. To speak of 'Venetian critics' is to suggest a

8

body of informed opinion. However, no such body existed or, if existing, it has left no records of itself. On numerous aspects of painting in eighteenth-century Venice on which it would be desirable to have information Venetian records are at best patchy or silent; at worst there are no records.

Only one eighteenth-century person in Europe showed real inclination to compile factual information about all the living painters at Venice – not only inclination but determination: Pierre-Jean Mariette. Mariette's efforts were praiseworthy and persistent; but he was growing old and sickly in Paris, still trying to compile his dictionary of artists, and he was easily misled by the inaccuracies, the distortions and the well-meant vagueness of his Italian correspondents.

To the general neglect of modern Venetian painters by Venetians – neglect, that is, to record anything except occasionally that their pictures were beautiful – must be added the neglect by Europe in general. An extraordinary bifocalism may be observed, for the very foreigners who appreciated Canaletto, and were aware of Francesco Guardi, failed to notice Tiepolo; while the Venetians who praised Tiepolo virtually never mention either of the Guardi brothers and cared little for Canaletto. And neither party had anything much to say of Pietro Longhi (Fig. 5). This is so generally true that any exceptions that may emerge in the following chapters here have little significance.

It is the comparative silence of the Venetians that drives us to the visitors who at least put down something, however trivial, on paper. What they say about eighteenth-century Venetian painting is usually vivid, even if deficient. It would be alarming if the artistic life of eighteenth-century London or Paris had been recorded chiefly in the comments of foreigners, but of course in those places that is not so. The artistic life of Venice, itself so popular with visitors and so dependent on its visitors, is perhaps better reflected in travellers' accounts that in native comment. The travellers brought a sharp sense of perspective to what they said; they knew painting other than Italian, which is more than most Venetians did.

Yet they could not help being deplorably ignorant. Modern pictures were only occasionally mentioned in their guide-books; they had no other means of knowing whose pictures they were looking at, and in many cases must have liked a picture but could make no mention of its creator. Extraordinary gaps appear in their knowledge. The Président de Brosses thus lists a great many modern paintings and painters in Venice, specially for the benefit of a friend; the most striking omission in that list, as in all his letters, is Tiepolo – a painter to whom the French, unlike the English, were by no means indifferent. A painter like Pietro Longhi, most of whose

9

work remained in the private rooms of private palaces, could hardly be known to the ordinary visitor. A portraitist like Rosalba – ready to serve foreign collectors and tourists – was bound to become famous with her patrons; Alessandro Longhi, a portraitist never working for foreigners, remained totally unknown.

Even the public pictures at Venice were not so easily seen, physically. Bergeret and Fragonard complain how difficult it was to see pictures in Venetian churches: a complaint that Ruskin was to echo more eloquently, and which is far from irrelevant today. And the French engraver-cum-*littérateur* Cochin found himself cautiously peering up at a ceiling and saying that it *appeared* to be by Tiepolo. While the bad condition of canvases, especially old ones, made them hard to see, the light in the churches was, and is, often poor. The virtues of eighteenth-century fresco-painters could hardly be appreciated in a gloomy church; and travellers in general paid little attention to frescoes as opposed to oil paintings. Venice was packed with pictures. The modern painters also had to compete for attention with the great names of Titian and Veronese and, to a lesser extent for the eighteenth-century, Tintoretto. It is not therefore surprising that the minor history painters in eighteenth-century Venice are seldom mentioned by visitors.

Yet, despite everything, there were a number of people living in Venice who were interested in modern painting and who could comment perceptively. Some of them were not connoisseurs or patrons, but merely had some interest in what was happening in the city. Thus a Venetian patrician, Vincenzo da Canal, wrote a life of the great painter of his day, Lazzarini, and also fragments of a treatise on the fine arts; somehow, it is part of the city's insouciance that neither was published until long after his death. The patrician diarist, Pietro Gradenigo, kept notes of many artistic events along with notes on other aspects of daily life; his comments run from 1748 to 1774, often disappointingly terse but occasionally interesting and always useful. Pictures unveiled, churches consecrated, artists exhibiting their work in the Piazza or at S. Rocco, these are the minor diurnal happenings that he noted, and which in many cases would have otherwise been lost to us.

Venice did not produce many diarists; few people wrote memoirs, and the city itself lacked a native contemporary chronicler. Gasparo Gozzi, poet and journalist, attempted to provide a newspaper that should mirror life as *The Spectator* had in England; but the truth is that Venice could only with difficulty support the institution of a newspaper, and Gozzi's experiment soon failed. While it lasted Gozzi had managed to 'cover' the

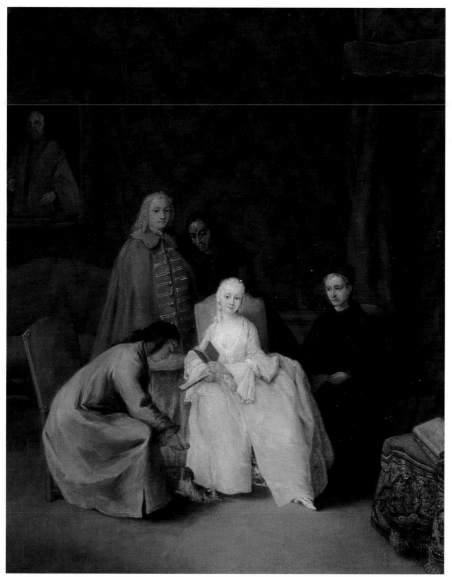

5. Pietro Longhi, *The Visit*. New York, The Metropolitan Museum of Art, Hewitt Fund, 1912.

same annual S. Rocco exhibitions of pictures, and had expressed his preference for the type of 'reality' in painting that he found in Pietro and Alessandro Longhi.

Gozzi was simply an *amateur*, and an isolated one. For *belles-lettres* neither flourished nor were encouraged in Venice, and there was no society where poets and painters and literary men could meet and talk. The greatest literary personality, Carlo Goldoni, left Venice finally in 1762. Indeed, when Baretti arrived in Venice from England in the same year he found that good conversation, civil manners, morality and literature were utterly unknown there: 'cose interamente sconosciute a Venezia', he wrote. Baretti had the standards of Dr Johnson and Mrs Thrale to apply, and he was a peculiarly critical person, yet the fact that he remained three years in Venice is not a reason for dismissing all he says as exaggeration. And Gozzi himself, reporting in 1765 on the crisis in the book trade, states quite openly that Venice lacked the esteemed writers (*scrittori di conto*) that England, France and Germany possessed.

In fact, it was in the earlier years of the century that there had been a group of internationally minded and receptive connoisseurs at Venice, closely connected with painters both Venetian and foreign. As these people grew old and died, their places were not taken. Contact with Venice as an artistic centre dwindled, as Venice grew politically more isolated and out of date. England had been the great market for things Venetian throughout the century, yet by 1789 John Strange writes to his agent Sasso in Venice complaining that there has been a change: old and foreign things are despised, 'modern rubbish' is the fashion. Well before that, however, from the other great market of Paris, Mariette reported the shift in taste that had substituted for Italian art that of the Low Countries. Writing in 1769, he recognizes that his own taste is out of date; people now spend vast sums on Netherlandish work, while an Italian painting or drawing is regarded only 'avec une sorte d'indifférence'.

It had been very different early in the century when Mariette was young. At Venice, Rosalba and Sebastiano Ricci were then drawing the attention of Europe to a Venetian renaissance; Venetian painters and decorators were travelling all over Europe and meeting their *confrères*. The links between London, Paris, and Venice were close. Rosalba was in touch with Crozat and Mariette at Paris; they brought her into contact with Watteau; Sebastiano Ricci paid Watteau the chief compliment Ricci could pay: he copied his drawings. In England Rosalba's brother-in-law Pellegrini was acting as her agent; Anton Maria Zanetti the elder, friend of Rosalba, stayed at Mr (later Consul) Smith's house in London, visited Hampton

Court and made English friends. Francesco Algarotti visited London and Paris. (Consul) Smith settled in Venice. Apart from Smith, all these people kept up correspondence with each other, swapped engravings and gems, drawings, bits of gossip, mutual praise and well-turned compliments. Between Mariette and the elder Zanetti, himself an engraver and a *marchand amateur*, a friendship subsisted for nearly fifty years, broken only by Zanetti's death.

Zanetti is indeed one of the chief uncreative personalities on the Venetian artistic scene. With his identically named young cousin, the librarian of the Marciana, he forms a phenomenon which touches most aspects of the period. The cousins collaborated on two volumes of classical antiquities at Venice, a project the elder had first conceived perhaps as early as 1722 but which finally appeared – *Delle Antiche Statue Greche e Romane* – in 1740 and 1743. Neo-classic before his time, the elder Zanetti was yet early writing in praise of Canaletto, acting as agent for Sebastiano Ricci at the court of Turin, and finding no division between his various interests. He was a good friend of Rosalba Carriera's, was in Paris with her and travelled on to London. He lived to the age of eighty-nine, dying in 1767, but years before that (in 1752) he had lamented the lack in Italy of amateurs and patrons interested in the fine arts. Later neo-classicists were to use the club of learning to batter the heads of people like Ricci and Tiepolo. Zanetti was learned but far from humourless, and his sharp observation of life is well shown by his amusing caricatures – often mildly ridiculing opera singers of the day (Fig. 6). He had a collection of pictures and drawings, chiefly by Venetian fifteenth- and sixteenth-century artists but with one or two 'modern' things such as two pictures by the German C. W. E. Dietrich and a group of Marco Ricci gouaches: some idea of what it contained is given in the letters of Sasso who acted as agent at Venice for a number of English collectors, as well as Strange, late in the eighteenth century.

More relevant for painting than the elder is the younger Anton Maria Zanetti, who lived long enough to see the rise of every Venetian painter of importance. His *Della Pittura Veneziana*, published in 1771, was an attempt at a history of Venetian painting from earliest times to the latest age. For him, quite rightly, it is Tiepolo who dominates the scene; the less public painters receive much less attention, Pietro Longhi being barely mentioned, Marco Ricci only very briefly, and the Guardi brothers not at all. In part Zanetti is on the defensive, aware that there is a case to be made against the whole Venetian School from Veronese onwards; in a learned age, as the eighteenth century had become, he had to admit, for

6. Anton Maria
Zanetti, *Caricature of
Antonio Gaspari*. The
Royal Collection ©
1994 Her Majesty
Queen Elizabeth II.

example, that Veronese had not painted for scholars and that his historical inaccuracies were compensated for by beauties in the actual painting.

Zanetti did not embark on a complete defence of 'rococo' painting; he himself reproved such excesses and frivolity, and in the Europe for which his book was written it would have been impossible to do otherwise. He had planned the book for a long time, and it is perhaps a pity he had not published it earlier. Early in life (in 1733) he had usefully amended and brought up to date Boschini's guide to Venetian art, the *Ricche Minere*. In 1760 he had published *Varie pitture a fresco*, which attempted to record frescoes in Venice and which has, among other things, given us some idea of what then remained of the work of Giorgione and Titian on the Fondaco dei Tedeschi. More than connoisseur, he was a historian; that, he says in his preface to the *Della Pittura*, he has tried to be. There is no evidence that he himself collected pictures. He read carefully what others had written about the Venetian School, especially among his foreign contemporaries, and in *Della Pittura Veneziana* he compiled a book that has retained all its original usefulness.

Among those who subscribed to the Zanetti cousins' *Statue* were (Consul) Smith and Francesco Algarotti. In their very different ways these two are the most vivid personalities among patrons at Venice. Joseph Smith had never sought wide European contacts; his sphere was Venice and his passion the most extensive collection formed privately in the city. Apart from his patronage of contemporaries, he had collected pictures by Rembrandt, Bellini, Mantegna and Vermeer – to name some of the most interesting; his library too had been carefully assembled and well stocked. It is not odd that he should have sought immortality for himself, his books and pictures, gems and drawings by offering them for sale in 1762 to George III, an offer accepted by the young King. Even after most of them were sold, his passion for collecting broke out again and he assembled more pictures and *objets*. Above all, his patronage of Canaletto has brought him posthumous fame as it brought him sour criticisms at the time. Horace Walpole, with his accustomed generosity, sneered at Smith as the 'Merchant of Venice', and somehow Smith was supposed to have exploited Canaletto. In fact, whatever their business arrangement, Smith must have encountered in Canaletto the same hard bargainer as other people did.

What he obtained from Canaletto over the years was a superb, unparalleled range of the artist's work, large-scale and small-scale, beginning with boldly handled view pictures of the 1720s and closing with a group of Palladian architectural caprices painted for him in the 1740s. When in 1751 Smith eventually had his palace on the Grand Canal altered by the architect and engraver Visentini, and given a new, vaguely neo-classic façade, he also had Canaletto record the alteration on a view picture of that area executed some twenty years earlier.

Despite much recent research on aspects of Smith's activities, especially his scholarly interest in Palladianism and his association with the scholar-cum-bookseller Pasquali, his role as a patron of painters is by no means clear. Even the facts about his own life are somewhat meagre. He settled in Venice, probably very early in the century, as a young, ambitious businessman and merchant. He married the famous, rich, though mentally unstable singer Katherine Tofts – a marriage sometimes regarded rather cynically. That he had at least one child seems evident from a tombstone in the church of SS. Apostoli (the parish he always lived in), which records the brief existence of John Smith, born 1721 and died 1727. Perhaps Smith's collecting began as something of a hobby, without strong predilections, and only gradually outgrew all other interests. He looks likely to remain for posterity a shadowy figure, having somehow been a shady one for many of his contemporaries.

Whatever shady things there were in Smith's life, they are irrelevant to him as a collector. Friendly and of an age with the elder Zanetti, he patronized chiefly the painters of their own generation, collecting many paintings and drawings by Marco and Sebastiano Ricci, and pastels by Rosalba. He was perhaps too old to appreciate Guardi's view pictures, and seems never to have had much interest in Tiepolo, while clearly attracted by Piazzetta. As well as a choice array of Zuccarelli's work, he had, unusually for an Englishman, pictures by Pietro Longhi; one of these seems to have been a special commission to Longhi and was a group portrait of John Murray and his family, Smith's brother-in-law and the English Resident at Venice.

Smith, finally appointed British Consul (in 1744), remained throughout his life a collector. And he remained a Venetian by adoption, never apparently returning to England. He is not typical either of Venetian patronage at the time or of English patronage. He was eccentric and is still something of a mystery; nothing survives of his attitude to the individual painters he patronized, nor of his attitude to those he did not. It seems apt, where so little definite is known, that no portrait of him should exist.

Altogether more loquacious, ambitious, vain and pretentious, Count Francesco Algarotti (Fig. 7) made one or two stays in his native city and affected in some instances the art of the day. He yearned, however, for higher things than Venice could offer; like many other snobs, he had a mild obsession with royalty, and the courts of London, Dresden, and – most successfully – Berlin underwent his siege. Algarotti's acquaintance was as wide as he could make it; even in death he sought new and important connections, bequeathing a group of drawings and a cameo to the elder Pitt, whom he had never met. At Venice his reputation was quickly established. When he returned there in 1743, charged with the task of acquiring pictures for Dresden, a contemporary sardonically recorded the fact and recalled that some years before the comedians of the San Luca Theatre at Venice had intended to put on a comedy ridiculing him.

Algarotti was the chameleon of the age, changeable, charming, intelligent, eager to please but anxious not to be deeply committed: either in literature or in love. Though he died prematurely at Pisa in 1764, aged fifty-two, he had not had too prosaic a life. He had written on opera, and Russia, and the Incas and architecture, and the art of painting; and most of the European celebrities of the day had had a visit from him. He was in touch with Mariette, who remembered him with affection. Lady Mary Wortley Montagu had been in love with him. Frederick the Great paid for his tomb

7. Jean-Etienne
Liotard, *Francesco
Algarotti*. Dresden,
Gemäldegalerie.

(Fig. 8). And busy as Algarotti always was, he had found time, too, to
form a collection.

When Newton was the fashion Algarotti had written on Newton. It is
part of his admirable ability to keep up to date that in his advice to young
painters he should already have expressed neo-classic doctrines. They
should, for example, study ancient coins and medals; not only for cor-
rectness in drawing *but*, and the 'but' is the serious neo-classic sequel,
so as to be familiar with the appearance of those personages whom they
will later paint. At the same time, Algarotti did not fail to appreciate the
chief offender against this canon at Venice: Tiepolo. It must be allowed
that he was sincere in his friendship for Tiepolo, proud of it and adept at
utilizing it.

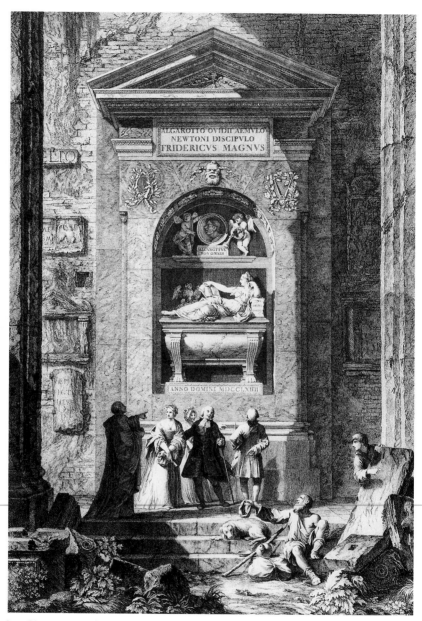

8. Giovanni Volpato, *The Tomb of Algarotti*. Engraving. London, British Museum.

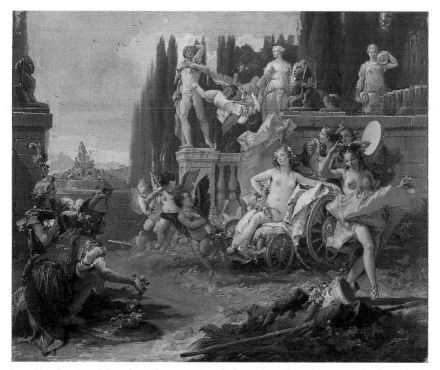

9. Giambattista Tiepolo, *The Empire of Flora.* San Francisco, M. H. de Young
Memorial Museum, Gift of Samuel H. Kress Foundation.

Back at Venice in 1743, he quickly extended the original schedule of
Old Masters required by Dresden to include also the modern Venetian
masters. Perhaps this helped to check criticism at the time that he was
despoiling Venice of its treasures. He commissioned work from all the
leading Venetian history painters. He offered to the powerful Minister at
Dresden, Count Brühl, painted flattery planned by himself and executed in
a pair of pictures by Tiepolo: the Fine Arts kneeling in a noble building
with Brühl's palace in the background; the goddess Flora bowling along in
her chariot in a landscape with the Neptune fountain from Brühl's garden
(Fig. 9). And no doubt Algarotti thought Tiepolo's pictures greatly im-
proved by the dash of learned sycophancy which he had contributed. For
he must have been well aware that the greatest Italian painter of the day,
one moreover whom Algarotti was to praise for his immense imagination,
was not learned by nature.

19

Beneath his parade of learning, Algarotti was probably Venetian enough to appreciate and understand Tiepolo. He certainly wrote about the harmony of the collaboration between Tiepolo and the architectural painter Mengozzi-Colonna in the Pisani Villa at Mira (see p. 219). He himself eventually visited the Villa Barbaro at Maser and appreciated there the brilliantly decorative and quite unlearned frescoes by Veronese, while in his writings he deplored Titian's anachronisms when dealing with Roman soldiers and found faults in the classical learning of Rubens (who in fact was probably a better classical scholar than Algarotti). He recommended cameos and medals as subjects for the young student artist, but he himself enjoyed sketching fantasy oriental heads and helmeted warriors, copied in some instances out of Tiepolo's *Banquet of Cleopatra*, a picture that remained obstinately a fantasy even after Algarotti had done his best to make it scholarly and Egyptian.

As for his collection of pictures, this was partly formed not on principle but by bad luck. Occasionally in his dealings with foreign and royal patrons Algarotti found he could not sell them some picture that he had already purchased; like many dealers he thereupon put the picture into his own 'collection', whence it could always become available later. But from the contemporary painters in Venice he bought, or acquired, pictures that do represent his own taste; he had a good Piazzetta, a Pittoni, an Amigoni, a self-portrait by Ricci, and the largest group of all was made up of paintings and drawings by Tiepolo. In his collection or in his writings, both quite extensive, he names most of the leading painters of the day, in the rest of Italy as well as Venice; but like the great majority of his contemporaries he says nothing of the Guardi brothers, and – perhaps more significantly – never mentions Pietro Longhi.

Algarotti would not have cared to be thought a purely Venetian pheno-menon. In his fashion, he was a European; there were other cosmopolitan Italians of his type, though very few Venetians, and none so showy. Despite his title of Count, actually bestowed by his friend Frederick the Great, Algarotti was of the middle classes, a stratum of society not active as patrons in eighteenth-century Venice. The Church and the aristocracy remained the two great forces behind patronage; they were even to some extent *one* force since the great churchmen were nobles, and a well-bred air of fashionable similarity exists between Venetian religious pictures and secular ones. Both types of picture deal with an elevated world of noble, handsome beings, whether historical or divine: a fairytale world (and perhaps also an operatic world), enchanted, inbred, courtly, where reality was kept at bay. According to one historian, satires were in fact directed at

Venice against religious pictures painted with this profane air in which the Virgin often looked as if she was the goddess Flora; these satires (if they exist) only confirm the extraordinary similarity between the two types of picture.

The Painters

The majority of painters worked to commission. There was not much corporate sense among them, and when, finally, an Academy was founded at Venice it was in no sense a parallel body to the Académie in France or the Royal Academy in London. Nothing illustrates better the easy carelessness of its affairs than the fact that a year or two after Zuccarelli was elected president the Academy had to admit it had no idea where he was.

After years of discussion the Venetian Academy was formed in 1750. From the first it was hardly more than a teaching college. The government showed little interest in it, and the Academicians showed even less. Not only did it plan no exhibitions, but it strongly objected to being required by the government to exhibit pictures in the Piazza at the Ascension Day carnival; the painters presumably thought this would be of little benefit to themselves, and year after year they complained of the difficulties and expense. The chief long-term benefit of the Venetian Academy has been that each member was required on election to present a reception piece and these form a nucleus of eighteenth-century works in the present-day Accademia gallery at Venice.

Painters wishing to exhibit their work publicly in the city could either show in the Piazza S. Marco, on their own initiative, or on the feast day of St Roch (16 August) at the Scuola di S. Rocco. On that day, when the Doge went in solemn procession to mass at S. Rocco (Fig. 2), the painters hung up their work partly perhaps as decoration and partly as self-advertisement. These San Rocco exhibitions are really the nearest form to an organized exhibition that took place in the city, except that there was no organization, there were no catalogues, and hardly any foreign visitors to the city knew of the annual event. And, finally, the references by natives were disappointingly terse. In all these ways the event was typically Venetian; it had the same haphazard air as the Academy's proceedings, but seems to have been quite free from government interference (if indeed the government ever noticed its existence).

Other Italian cities had for long possessed academies and had arranged exhibitions of one sort or another. Outside Italy, Reynolds and Diderot

excelled any critic or connoisseur whom Venice could produce. The attraction and importance of Venice, artistically speaking, lay in something much more vital than any of those things: its painters. It was a foreign visitor to the city, Cochin, who summed up the situation as it seemed to him at the mid-century: 'Venice can still boast of possessing the most skilful painters in all Italy, and such as can rank with the best to be named throughout all Europe.'

Such a statement might seem chauvinism on the lips of a Venetian, or sentimentalism on those of any foreigner except a Frenchman. From its source alone the statement compels our belief, tinged with amazement. But Cochin was honest and correct; and what he said cannot be put better.

1

The History Painters

One innovation in eighteenth-century Venice (one of the few in that conservative city) was the specialization of certain painters in branches of painting: branches which form the subject of subsequent chapters.

When the century opened, no group of painters occupied a more important position there than the history painters. Indeed, the great majority of painters were history painters, by which term was meant painters of figure subjects derived indifferently from religious or historical or classical-mythological sources. The prestige of such art was very real, since it represented exercise of the imagination at its most obvious; academically, it was the least mechanical – and so a highly respectable – aspect of painting. The position of the history painter throughout Europe was really being challenged by other categories; and hardly a great history painter but found it convenient to cultivate also the portrait. In England in the early years of the nineteenth century Haydon was going to waste his energies in trying to make history painting a reality. Elsewhere, history painting grew more serious by suppressing decorative elements and by aiming at being true or 'natural', though elevated. Poetry and mythology were less to be illustrated than history itself. Academies stressed the need to be accurate – something Tiepolo, for one, flagrantly failed to be. Yet even at Venice the Academy observed the conventional hierarchy, and placed history painters above those of genre and views.

Well before the end of the eighteenth century Lessing in his *Laokoon* had rebutted the idea that the painter must take his subjects from poetry; indeed, he specifically named, among poems unsuitable for illustration, Dryden's *Ode on Saint Cecilia's Day*. That poem was one equally specifically chosen years before by Algarotti for illustration by Tiepolo. As for the treatment of historical and literary themes in what might be called decorative terms, it has been left largely unattempted by anyone of genius or talent since Delacroix's death in 1863.

23

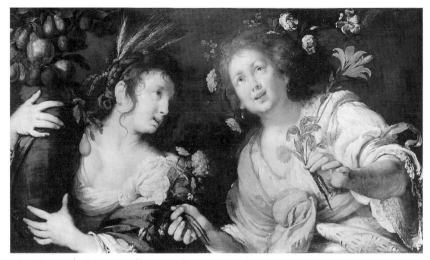

10. Bernardo Strozzi, *Allegory of Summer and Autumn*. Dublin, National Gallery of Ireland.

But in the Venice of the early eighteenth century history painters still possessed prestige and patronage. The demand at Venice itself for their work was so constant, and the occupation so dignified, that hardly any painter – whatever his speciality – but could produce a history picture when called upon. Francesco Guardi spent the earlier portion of his life exclusively as history painter and was still painting a few altarpieces long after he had begun to specialize as a view painter; Pietro Longhi painted some later feeble frescoes; and even Canaletto is recorded, rightly or wrongly, as having painted a *Holy Family* for a church at Mestre. In addition, there are pathetic shadowy people caught up by the general demand and barely capable of satisfying even a rural parish priest in frescoing his village church: cousins and brothers and sons of better painters, or simply misguided persons with no talent at all. Such painters form the murky, mercifully anonymous background against which the brilliant history painters of the age must be seen.

Not only is there a murky background to set off the scintillations of the best history painters but they emerge from a somewhat sombre, if not entirely murky, past: the shadows of seventeenth-century Venice when native art was at its least inspiring, and the most talented painters there were either non-Venetian or non-Italian altogether. Venice had then attracted artists less by what it was producing than by what it had already

produced and still possessed. Nearly every great European painter of the seventeenth century had visited Venice and had felt the influence of Titian or Tintoretto or Veronese. Some major as well as minor foreigners came to Venice and stayed on: to become the best artists in a rather dreary milieu.

Brilliant colour and virtuoso handling of oil paint were two of the characteristics already associated with the Venetian school and which were to culminate with Tiepolo. Something of these qualities was kept alive in a vigorous way during the seventeenth century in the work of Bernardo Strozzi (1581–1644), a Genoese who settled in Venice in his later years. A talented portraitist and the creator of sturdily individual altarpieces, Strozzi had a vein of half-earthy poetry, which partly anticipates Piazzetta. The people of his allegories and personifications (Fig. 10) may have the look of dressed-up peasants, but they are touched with fantasy and painted in subtle, delicate tones of unusual colour. More forceful, even uncouth, is the character of typical pictures (Fig. 11) by Carl Loth (1632–98), with thundery chiaroscuro and what seems like a deliberate prosaicness, a stress on 'realism', in dealing with mythological and historical subjects. He too may have had some influence on Piazzetta; and the early work of Tiepolo is oddly closer to this tradition than to Veronese.

11. Johann Carl Loth, *Mercury and Argus*. London, National Gallery.

12. Johann Liss, *Inspiration of St Jerome*. Venice, S. Niccolò da Tolentino.

25

Loth was a German, and German too was arguably the greatest, and certainly the shortest-lived, of non-Venetian painters active there in the seventeenth century: Johann Liss (c. 1597–1629/30). His originality has increasingly been recognized in recent years, and no single stylistic adjective will sum him up. He is an artist in his own right and of interest not merely as an influence – though he must have been one – on much later decorative painting in Venice. His warmly glowing *Inspiration of St Jerome* (Fig. 12), painted in 1629, remains a memorable experience in the under-visited church of S. Niccolò da Tolentino. The strongly modelled saint seems understandably rapt and almost engulfed by the vaporous vision floating and curving excitingly around him and out of which a scarcely less strongly modelled angel firmly clasps his arm, to arrest him writing. This composition is often claimed as having its effect on Piazzetta, to which may be added the name Pittoni when one looks at his *Sts Jerome, Francis and Peter of Alcantara* (Fig. 34).

Nevertheless, despite the achievements of individual painters, there is something fitful about painting in seventeenth-century Venice. And, despite the intimations of influence here and there on subsequent developments, it represented an ideal against which the eighteenth century turned – not only in Venice but all over Europe. Styles more graceful, playful and lighter (in every sense) were preferred.

During the early part of the eighteenth century, it was not only in and around Venice that Venetian history painters in particular found employment. Foreign courts and foreign rulers, often with much more money and much grander projects in mind, turned to Venice to find artists trained in decoration; and the artists themselves turned to *nouveau riche* countries like Russia where demand always exceeded supply. Northern Europe, especially, suffered already from *fatigue du Nord* and nostalgia for the South with its long tradition of graceful luxury. The cold, petty courts of electors and prince-bishops needed an infusion of that warmth and a delusion of grandeur. Versailles still stood as the epitome of grandeur, and for those who could not build so big in reality it was something to have vast palaces built among the clouds painted on the ceiling of a drawing-room. It is in art, as Freud has pointed out, that there is omnipotence of thought. Man, consumed by his wishes, produces something similar to the gratification of these wishes and by means of artistic illusion this playing calls forth effects 'as if it were something real'.

So the history painters became in their way theatre painters, turning every room they decorated into a stage, and life was lived amid a series of enchanted illusions. Just as the suites of rooms opened out one from

another, so the walls of a room opened out in painted vistas, while beyond the windows stretched the artful perspective of terraced gardens which in the compass of a few acres would suggest infinity. The furniture too of such rooms was often full of ingenuities of concealed space, *meubles à transformations* where spring-catches released panels and drawers, and those *tables volants* which could rise or sink through the floor, effectively seeming to defy by magic the natural laws. Everywhere space was supposed, even where it plentifully existed. But space is more exhilarating when something moves within it and reveals its area: like an aeroplane in the sky or even a single camel in the desert. In the space created by the history painters man moved, or rather, beings moved who resembled man but who, unlike him, triumphed in this element. Gods and goddesses are the natural inhabitants of such a sphere, and so is God himself. The religious decorations have no difficulty in repeating the effects of profane decorations, and subjects like the Ascension and the Assumption can be painted in a spirit almost of envy at those miraculous feats of divine levitation.

Towards such effects the Venetians of the century aspired, and all their pictures, whether painted on canvas or on a wall, are to some extent conceived within these decorative conventions. The style itself offered every possible danger, now empty and rhetorical, now overblown and heavy, at one time too flagrantly insincere, and too melodramatically intense at another. Conjurers with varying degrees of skill, they played throughout the century to increasingly empty houses; only one genius rose and out-soared them all, Giambattista Tiepolo, and even he began to face hostile criticism some years before his death. Not every palace was decorated by Tiepolo, but even without him Venetian interiors could be no less richly decorated in playfully illusionistic style (Fig. 13).

Outside Venice the problems raised by decorative painting had already been solved during the seventeenth century. The Baroque style had already envisaged tremendous and stupefying effects which surpass nature and leave her gazing. Venice, itself lacking adequate space and anyway unfitted for the solemnities of the Baroque manner (however it is defined), had had no Baroque painters nor truly Baroque architects. The great building of seventeenth-century Venice – the greatest artistic feat of the city in that century – was Longhena's S. Maria della Salute; and it is hardly an exaggeration to say that this church with its air-borne domes and sea-washed steps needed merely to be brushed on to the canvases of Canaletto and Guardi to become rococo.

Rococo before its time, it was suitably decorated by a non-Venetian painter, rococo also before the time, Luca Giordano (1632–1705). He

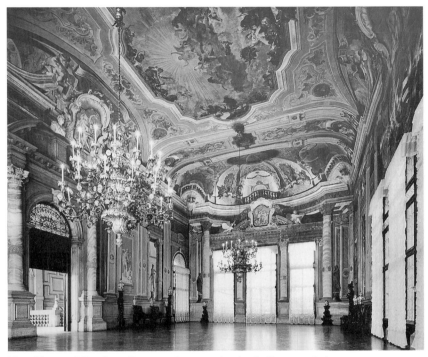

13. Giovanni Battista Crosato, frescoes in the ballroom of the Ca' Rezzonico, Venice.

left three altarpieces in the church, of which the *Presentation of the Virgin* (Fig. 14) with its elaborate architectural setting and its radiant shafts of light preludes the new style and also provides a welcome piece of grand decoration amid the gloomy darkness of much seventeenth-century Venetian art. The picture is painted with startlingly bright colours: there is generous use of white and a strong blue juxtaposed to it – very much as Tiepolo was to juxtapose them more than half a century later in the Palazzo Labia frescoes. There is no fixed date for two of these altarpieces except that all were done by 1674. An 'outside' artist was preferred for this important work to any native talent available at the time. Giordano's legacy to Venice did not go unperceived, and a few years later the style of his altarpieces was no longer an isolated phenomenon but, made more graceful and less vigorous, had become part of a Venetian style.

Giordano, Neapolitan by birth but peripatetic by inclination, anticipated the personality of Tiepolo: brilliantly rapid worker, in demand at European

28

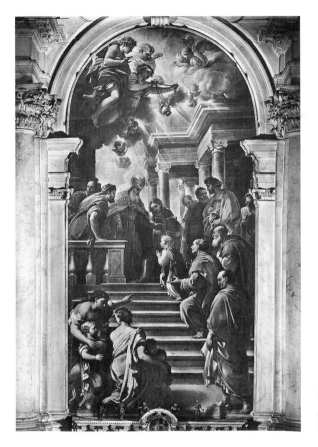

14. Luca Giordano, *The Presentation of the Virgin*. Venice, S. Maria della Salute.

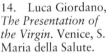

courts, improviser of extensive fresco schemes, and finally leaving the impress of his style on a whole group of other men. The tradition of Giordano himself was to be closely followed at Naples, and throughout the eighteenth century there was a specifically Neapolitan school of decorative painting, which counterpointed the Venetian.

At Venice, there had once been much greater prototypes than Giordano in decorative painting. There had been, above all, Veronese. His decorative ideals had been partly obscured in the seventeenth century in Venice while something more sombre was in fashion. With the coming of fresh attitudes, he was to be rediscovered or at least more deeply appreciated. Eighteenth-century visitors to Venice paid an obligatory visit (of the kind later visitors would pay to the Scuola di S. Rocco) to the Palazzo Pisani, where then

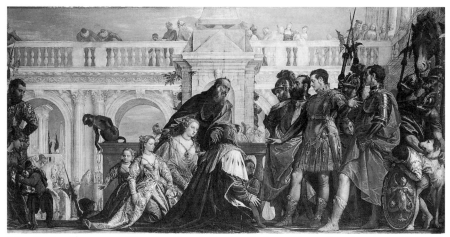

15. Paolo Veronese, *The Family of Darius before Alexander*. London, National Gallery.

hung Veronese's *Family of Darius before Alexander* (Fig. 15), a glamorous epitome of the greatness, artistic and otherwise, of Renaissance Venice. It was copied and discussed. It influenced Tiepolo directly. Several collectors believed they owned the preliminary sketch for it. In an age demanding frescoes, Veronese as a uniquely great fresco painter was bound to become the master of those practising the technique. Titian had painted only one fresco scheme (and that at Padua); Tintoretto had painted none; but Veronese had left at least a single masterpiece, the frescoes in Villa Barbaro at Maser, and his followers had frescoed other country villas of the Veneto. In an essay on such frescoes Valéry summed up their decorative, half-mythological, half-country world as 'a blend of poetry and trickery'; and just this blending was to be the intention behind so much of eighteenth-century Venetian decorative work, both frescoes and oil paintings.

Not only in Italy were there stirrings towards those ideals. All over Europe there were signs that grace and charm and a poetic playfulness were to be sought in art, partly in relief from the learned, academic aspect of art in the late seventeenth century. Painters had been becoming increasingly 'learned', without always improving their pictures; in reaction painters were to become, with much less difficulty, unlearned again. A new age, priding itself on being civilized, was to make civilized use of art: synthesizing architecture, furniture, painting, to create a setting graceful and inhabitable. At the very end of the seventeeth century, in the autumn of 1699, Louis XIV seems to celebrate and initiate the change. In a note on

30

the redecorating of a château for his favourite grand-daughter-in-law, the Duchesse de Bourgogne, he stigmatized the subject chosen as 'too serious'; and he concluded his criticisms with a command that seems to have found an echo throughout Europe: 'Il faut de l'enfance répandue partout.'

In Venice particular conditions caused particular results. One of the most striking was the fact that Venice had behind it such a magnificent tradition, in art as in government; perhaps the tradition was rather an albatross hung about the eighteenth century's neck, and it certainly led to a neglect of contemporary painters by many visitors. The English, for example, did not object to the religious pictures of Titian, though they ignored those of Tiepolo. Admittedly this must have been partly the sectarian prejudice from which post-Reformation England has usually suffered, for French critics like Cochin were of course far from neglecting contemporary Venetian history painters. To most mid-eighteenth-century connoisseurs in Europe 'painting' meant history painting, unless otherwise indicated. At Venice when the Academy was founded, the majority of foundation members were naturally history painters.

The tradition of Venetian art and life met most opulently and obviously in Veronese's work. Venice herself had been present there more clearly than in the pictures of either Titian or Tintoretto. And there the Republic had seemed at the height of success and pleasure and health: its men magnificent, its women blonde and alluring, and itself Queen of the Sea. Since so much of Venetian eighteenth-century painting was concerned with fantasy as opposed to fact, it is not surprising that Veronese offered the safest fantasy-refuge of all in an age when the Republic was yearly shrinking. Backward glances to the past were more than the habit of painters; but the eighteenth-century painters felt a natural kinship with the High Renaissance rather than with the immediately preceding century. And kinship showed itself in the flattery of imitation. Veronese's influence was everywhere, and it extended beyond painting even to Venetian porcelain of the period on which his compositions were occasionally reproduced (Fig. 16).

The flattery of imitation showed itself most patently and importantly in Sebastiano Ricci (1659–1734). Almost everything that happened in Venetian history painting of the century goes back to Ricci. He is a disconcerting phenomenon since he began so much, while yet as an artist is very variable, only fitfully inspired and often merely competent. His very attachment to Veronese leads to comparisons in which he emerges eternally the loser. And the existence of Tiepolo, who learnt so much from him, leads to another comparison in which Ricci is defeated again.

16. F. Cozzi, ceramic plate with a scene of *The Rape of Europa*, after Veronese. London, Victoria and Albert Museum.

But as early probably as the 1690s Ricci was capable of creating the luminous decorative effect of his ceiling in S. Marziale at Venice: an effect considerably enhanced by cleaning. To come on this ceiling unexpectedly is to experience something of the excitement it must have generated when it was first shown. It is full of gaily coloured airborne figures, as in the roundel of the *Miraculous Arrival of the Virgin's Statue* (Fig. 17), and has something of the pastel effect of fresco, although all the decoration is actually on canvas. Ricci at this time had not settled in Venice, but was still wandering about Italy and the rest of Europe. He had not become quite so obsessed with Veronese as he was to be later, and the S. Marziale ceiling is an unusual example of him creating something for himself, though not without hints from Correggio and Giordano.

In the early years of the century the best opportunities at Venice for decorative schemes were offered by the Church. No century has left less artistic legacy in the Doges' Palace than the eighteenth; during that period the government commissioned virtually nothing. Few nobles in the opening decades were commissioning decorations for their palaces, and in fact most of the leading history painters quitted Venice at one time or another,

17. Sebastiano Ricci, *The Miraculous Arrival of the Virgin's Statue*. Venice, S. Marziale.

lured by better foreign projects. Quite early on, England became the goal of many, chiefly in the hope of getting the commission to paint the interior of St Paul's. That was not, finally, given to a foreigner, nor to a Roman Catholic, but to Sir James Thornhill, whose monochrome decorations represent the finest tradition of English artistic compromise. But the Venetian decorators were employed by intelligent private patrons, as they were also employed privately and publicly in France and Germany and Spain. Without too much paradox, it can be claimed that the very greatest decorative schemes of Venetian painters of the period are (or were) any-

where but at Venice. Ricci himself produced two delightful secular fresco schemes – for the Palazzo Pitti and the Palazzo Marucelli at Florence.

Outside Venice the painters were often called on to exalt absolute monarchies, dignify petty princes and create a mythology to surround quite ordinary events. Their function was to bolster up, with clouds and *putti* and allegorical personages, institutions just on the point of decay and collapse. But their work for the one mythology that still had true believers, religion, was less exhausting; the very people they painted might be supposed to exist, and the people for whom the pictures were painted might be supposed to be already convinced. Nevertheless, there was little alteration in the history painter's style for religious as opposed to secular work.

Ricci, having discovered Veronese, set about utilizing him on every occasion. His sumptuously-coloured, graceful, 'grand manner' altarpiece of the *Madonna and Child with Saints* (Fig. 18), painted in 1708 for S. Giorgio Maggiore, is consciously derived from Veronese, and announces the use to be made in the eighteenth century of the casual *sacra conversazione*, where a group of saints are assembled alone or with a presiding figure, usually of the Madonna. Such a picture as this was soon famous in guidebooks of the period. Vincenzo da Canal was living through the change of taste that Ricci had initiated, a change which, in his own words, was substituting grace for force in painting. Partly he lamented this, although he admitted that the new style had a compensating prettiness and charm. Ricci's altarpiece he had no difficulty in admiring; it was a most attractive picture, a *vaghissima tavola*. And Cochin, sharp enough in some of his criticism of the modern Venetians, found it *très beau* some forty years after it had been painted.

To Venetian painters, Ricci's convenient discovery of a style so literally borrowed from Veronese was to prove sufficient for nearly seventy years. Ricci's pupils went on quite happily with the method, toning down the plagiarism and livening up the actual brushwork. Ricci himself is not at all free from the suspicion of having occasionally tried to pass his own work off as by Veronese. From the French artist Charles de la Fosse (himself a devotee of Veronese), whom he had deceived with such a pastiche, he apparently received the snub 'Paint nothing but Paul Veronese's and no more Ricci's'. And there can be little doubt that Ricci felt a compulsive need to imitate the greater man because he possessed no truly independent style of his own. His gifts were for colour and for varied and agreeable if rather slack compositions. He never failed to produce an adequate piece of decoration; what too often eluded him was the essential energy that lifts a painting into being a work of art.

34

18. Sebastiano Ricci, *Madonna and Child with Saints.*
Venice, S. Giorgio Maggiore.

Nevertheless, Ricci's importance as a forerunner was colossal. He was particularly welcome at Venice in the early years of the century, when he finally settled there, and he was much patronized. He was assisted in the landscapes of his pictures by his nephew Marco (discussed here in chapter 2), and Marco was in the studio watching out and promising to send to at least one patron anything Ricci executed in 'his best style'. Ricci, member of foreign academies and doyen of painters at Venice, led a very grand life in the city; in private he appears to have passed a good deal of time consuming cheese, for which he was – as he confessed – a glutton. Born at Belluno, he had trained in Bologna and Rome as well as Venice, and his style was full of judicious borrowings from other men's work before he attached himself to that of Veronese. Already before the end of the seventeenth century he is found treating certain themes that occur again and again through the following century, often with treatment very similar to his own.

This constant repetition is yet one more remarkable thing about the Venetian history painters: themes like the 'Continence of Scipio', or 'Apelles painting Campaspe' appealed to a mingled sense of the historical and emotional, as did also especially dramatic and poignant subjects like the arrested sacrifice of a virgin (whether derived from the Bible or from classical literature), plagues averted and miraculous appearances of gods. Ricci responded to such a subject as *St Helena Finding the True Cross* (Fig. 19) with a vivacity communicating itself to the paint, especially in the small scale of this sketch. This is very late work, fluent, sparkling and streaming with light. A miracle has taken place, while visually the most miraculous thing is the way the tall cross stands supported only by a touch of St Helena's hand.

Already Ricci's *Continence of Scipio* (Fig. 20) contains many of the chief elements of eighteenth-century Venetian history painting, though the picture itself probably dates from the very beginning of the century – when Tiepolo, for example, was still a child. A black and white photograph hardly hints at the chromatic brilliance of the tonality (unusually brilliant, in fact, for Ricci), with a rich olive-green for Scipio's drapery and a harmony of blue, gold and white for the clothes of the blonde, kneeling girl. The subject is treated like a piece of theatre, even to its Palladian-classical architectural setting. Types rather than individuals, more elegant than earnest in their poses, the characters act out a pleasing charade of love and war, of passion and duty. The effect is less of French tragedy than of Italian opera, and operatic heroes of the period included Scipio.

Even the theme of St Helena and the Cross had been the subject of a

19. Sebastiano Ricci, *St Helena Finding the True Cross*. Washington, D.C., National Gallery of Art, Samuel H. Kress Collection.

20. Sebastiano Ricci, *The Continence of Scipio*. The Royal Collection © 1994
Her Majesty Queen Elizabeth II.

libretto by Metastasio, set to music by the Venetian-born composer
Caldara. Painters like Ricci often worked for the theatre, and when he was
coming to London, horror was expressed by an Englishman living at Rome
that 'Rizzi of Venice [whom] everyone knows to be no more yn a scene
painter . . .' was hoping to be commissioned to paint the dome of St Paul's.
The inherent theatricality of religious paintings by Ricci was confused with
insincerity, then as quite often now; the style that might be permitted
when decorating a villa was not going to prove acceptable in an English
cathedral.

In fact the same feelings were at work creating, and being satisfied by,
the dramatic *Continence of Scipio* and by the religious drama of some
alluring female saint. Amid the panoply of war Ricci's heroine occupies a
prominent central position as she meekly awaits her fate, while the

38

handsome and magnanimous hero is about to return her inviolate to her fiancé. This incident, supposed to have taken place after Scipio's victory over New Carthage, had for long been a famous event in his biography. Scipio ranked with Alexander as an example of the merciful conqueror; and perhaps there is even a hint, in the many eighteenth-century treatments of such generosity, of Venice herself hoping to be mercifully treated in her impending defeat by the rest of Europe. Leaving that aside, the theme is still one to arouse a sort of delicious pathos and there is an element also of suspense – for Scipio has not yet exercised his mercy. The heroine here, and the heroine more obviously in other similar subjects, is intended to be in that state of uncertainty which, caused by sex, adds to her sexual charm. She is a virgin (according to the best authorities), and the century of Richardson, Choderlos de Laclos and Goethe, derived peculiar pleasure from such an idea, as its literature reveals.

To some extent, the reaction in the later eighteenth century against such pictures as this is no doubt a sense that they are ambiguous. Connoisseurs and scholars found them lacking in 'seriousness', and this criticism probably includes the persons of the painting as well as the way it is done. Art should improve and instruct, neo-classic aestheticians believed; the painter should follow 'Nature', not his own imagination. There is no attempt by Ricci to convey the aftermath of a real battle, no proper attempt to dress his characters accurately (the heroine is not only derived from Veronese but dressed à la Veronese), and instead of a dignified classical scene we are given at best a decorative anachronistic pageant with a dubious sentimental basis. Later connoisseurs (and earlier ones) would have felt a lack of sternness, a certain melting, charming quality which was not suited to a high Roman subject. When Poussin, for instance, had treated the subject, the central figure of his composition was the fiancé not the heroine; she was relegated to the background while the meeting of the grateful Carthaginian and the generous Roman occupied the foreground. Just as the opera of the eighteenth century used such affecting situations but always tacked on a happy ending, so similarly Ricci only plays with our emotions and with the ideas of 'love' and 'duty'.

This, for us, does not affect the picture as a piece of good decorative painting. Looked at, however, as an inculcation of morality the picture is a failure; it is a failure as a document telling us about ancient Rome; and finally it is not true to life, for the colour is prettier than nature and the drawing is not flawless. The colouring of pictures like Ricci's was especially felt to remove their last chance of passing as serious or sublime; 'in historical painting a gay or gaudy drapery can never have a happy effect',

Burke remarks severely in his *Philosophical Enquiry* on the Sublime and the Beautiful. The unfortunate Ricci was to be specifically accused at the end of the century of being the person who caused the downfall of the whole Venetian School. An honorary member of the Venetian Academy, Niccolò Passeri, wrote a two-volume set of dialogues imagined between the great aesthetician Winckelmann and the neo-classic painter Mengs; in one of their dialogues they decide exactly what is the danger of painters like Ricci: such men, bad enough in themselves, are positive menaces because they have pupils whose taste is thus early corrupted.

This much-deplored fact is really one of the best things about Ricci. Among his many pupils, Giovanni Antonio Pellegrini (1675–1741), who has been rather neglected by art historians, was not only a better painter but a more graceful and lyrical one. Pellegrini indeed is probably the first of the Venetian history painters to paint decorative scenes as such – pure fantasies without any definite story or subject; and these he painted in England. He was, in fact, the first of the Venetians to make the journey. With him the influence of the theatre was equally strong and much more successfully utilized. The Earl of Manchester, returning from his second embassy at Venice, brought back Pellegrini and Sebastiano Ricci's nephew Marco in 1708. Recent scholars have drawn attention to the production of Alessandro Scarlatti's opera *Pyrrhus and Demetrius* at the Haymarket the following year, when the scenery was said to be by 'two Italian painters lately arriv'd from Venice'; these must certainly have been Pellegrini and Marco Ricci.

Vanbrugh was already at work at Lord Manchester's seat, Kimbolton Castle, and his grandiose Italianate conceptions are suitably allied with the decorations Pellegrini painted there. Manchester had intended to find in Venice a suitable painter for such work; a few years before he had been ambassador in Paris but does not appear to have made any effort to find a painter there. And from Venice too must have come the magnificent set of florid gilt chairs once at Kimbolton, presumably acquired by him.

Among Pellegrini's various decorations at Kimbolton, some of those on the staircase (finished early in 1713) best display his gift for enchanting improvisation and his silvery, rainbow colour schemes. These decorations are painted in oil, with considerable impasto, directly onto the wall, yet they have all the spontaneity and lightness of fresco. The *trompe l'œil* effect of the *Musicians* (Fig. 21) is a piece of light-hearted theatre; Pellegrini half suggests a balcony and space behind, but more as jest than really to deceive. His figures are not stolen like Ricci's from Veronese, but are dressed up in mock-oriental-cum-sixteenth-century Venetian cos-

21. Giovanni Antonio Pellegrini, *Musicians*. Kimbolton Castle School.

tumes, themselves witty variations on the Moors and pages who decorate Veronese's pictures. They already announce the eighteenth century's love of the exotic: real Negro boys to serve chocolate or carry torches, and oriental clothes to lounge in and to wear at fancy dress routs. Pellegrini's turbaned player of the recorder is clad in a gamut of colours, his tunic silver-blue, his sleeves heliotrope with highlights of yellow, while his turban is yellowish-white, topped by a patch of red. Other decorations continue the new taste, with parrots and monkeys, and the scenes are framed by patterns of ribbons and flowers. The whole surface here is painted with a speedy, flickering touch that conveys light on a creased silk sleeve, a dog's soft fur, the fringe of a curtain: all with an enviable un-English virtuosity that would have appealed to Gainsborough.

Pellegrini repeated his success at other country houses, notably at Castle Howard (which Vanbrugh was then rebuilding for Lord Carlisle), and at

22. Giovanni Antonio
Pellegrini, *Narcissus*.
Norfolk, Narford Hall,
Collection of
Commander Andrew
Fountaine.

Sir Andrew Fountaine's Norfolk home, Narford Hall. And Wren is said to
have favoured him as the painter for St Paul's. At Narford his silvery
woodland scenes are once more a fresh approach to the problem of
decoration: with vaguely but far from exhaustingly classical figures (Fig.
22) and delicately-leaved trees, which crowd into an artistic shade. Tiepolo
could not have been more than fifteen when such work was painted and
his own early years were to be influenced by artists very different from
Pellegrini. Yet Tiepolo is the logical development of Pellegrini's style. Had
Pellegrini executed his decorations in the Veneto rather than in the
isolation of English private houses, he would have been a potent influence,
if not on his contemporaries at least on the rising generation.

23. Giovanni Antonio Pellegrini, *Allegorical Entry of the Elector Johann Wilhelm.*
Munich, Staatsgalerie Schloss Schleissheim.

After England Pellegrini went off to Düsseldorf where he was employed
by the Elector Johann Wilhelm during the years 1713/14. Among other
work he produced a series of allegorical canvases celebrating events in the
Elector's life, which are the most elaborate treatment of German iconogra-
phy by an Italian painter before Tiepolo's work at Würzburg. The lightness
and even gaiety of the large *Allegorical Entry of the Elector Johann
Wilhelm* (Fig. 23) show again Pellegrini's gift for transforming everything
into decorative terms; and here the bright pale draperies, the falling roses
and the silvery-white of the horses enchant the eye and persuade us briefly
to enjoy the arrival of the Elector. The picture's tone is almost that of
pastel, pale as a portrait by Pellegrini's sister-in-law, Rosalba. A few years
after his German stay, he was commissioned to paint a great allegorical
ceiling in the Banque de France in Paris (probably in 1720) and this
had considerable effect on the evolution of rococo decorative painting in
France; but once again it left Venetian art unaffected.

Just as Ricci was to face criticism after his death, so Pellegrini did not
escape the censure of, for example, Mariette, who lived long enough to see
the rococo drop out of fashion. Pellegrini's virtuoso speed in painting the
Banque de France ceiling did not appeal to him at all, and it is true that

43

24. Giovanni
Antonio Pellegrini,
Rebecca at the Well.
Destroyed, formerly
New York, Samuel H.
Kress Foundation.

time began to reveal on the ceiling traces of this haste. This, it seems, was made the excuse for its destruction, which Mariette – despite his lack of sympathy for it – deplored. Mariette had loved the soft and rather vague rococo of Rosalba's portraits, but Pellegrini's extended decorative display struck him as too hasty and confused.

Nor did Pellegrini approach religious subjects in a particulary elevated way, and it would have been easy to convict him of treating these with a total lack of high seriousness. The theme of 'Rebecca at the Well' was one more of those so often repeated by the eighteenth-century Venetians, and Pellegrini's version (Fig. 24) is at once partly idyllic and partly flippant. The subject itself, of Abraham's oldest servant producing jewels for the woman intended as a bride for Isaac, appealed as a romantic episode from the Bible – where it is actually dealt with in a strictly business-like way.

There is even, perhaps, a touch of the theme of the pandar in Pellegrini's conception, and his attractive blonde Rebecca certainly seems to be engaged in bartering herself for the old man's jewelry. The scene is not set in a specific time, or even a specific place; it is part of a new feeling that all

such details should be generalized as far as possible – a deliberate reaction against the prosaic and more careful attitude of the seventeenth century. Pellegrini thus provides no more than a pair of his silvery-foliaged trees, a fragment of Renaissance-style fountain, and one superior sheep. In this airy setting a snub-nosed Venetian blonde poses with a hand on a property watering-pot, and with an elegant finger retains a piece of rope that is quite unnecessary, granted the type of fountain shown in the picture. Pellegrini is not really *illustrating* the theme of 'Rebecca at the Well' but playing his own variation upon it while, at the same time, dignifying his concept of youth and amorous old age by giving it a biblical title. Eighteenth-century Venice did not feel strongly about titles for pictures, and when it was necessary to turn Tiepolo's *Banquet of Cleopatra* into a *Banquet of Nabal* for a book of engravings, it sufficed to suppress the pearl in Cleopatra's hand and place a verse from the Book of Kings under the composition.

One other considerable peripatetic decorative painter was active in the early part of the century, Jacopo Amigoni (1682–1752), who has been claimed as the true initiator of the Venetian rococo style. In point of time, Amigoni must yield his claim to Sebastiano Ricci and in grace of technique he must yield to Pellegrini; yet it remains true that his rather pedestrian manner contains the seeds of French rococo, especially Boucher, and it directly inspired Bavarian rococo painting. The hint of the operatic in his style is rather subdued, but he actually painted scenes from operas in which his friend the *castrato* singer Farinelli had appeared. He was not born at Venice but at Naples, and in some ways is the least Venetian – even by adoption – of those who worked at Venice. Like Pellegrini he was active in England (where his portraits pioneered a welcome rococo style which the native school largely ignored), but before that he had spent ten years in Germany, chiefly working for the Munich court of the Elector of Bavaria.

And so once again it is outside Venice and Italy that his great secular decorations are to be found: at Schleissheim above all, and at the Elector's summer residence of Nymphenburg, in some English country houses, and finally at Madrid, where he became court painter to Ferdinand VI and where he died. In England he received his most sustained patronage from Mr Styles, the owner of Moor Park, who happened to quarrel with Thornhill, whom he had begun by employing. There, Amigoni painted for him slightly stolid mythologies (Fig. 25), which have some cloudy, graceful touches, all on a fairly intimate scale. But in Spain and Germany Amigoni was caught up in the grand new expansionist building schemes of

sovereigns: at Madrid in the Royal Palace, where later Giaquinto, Tiepolo, and Mengs were to work, and at Nymphenburg, where the group of buildings and the gardens were constructed, decorated and laid out by a huge international team.

At Venice only the State could possibly have initiated schemes like these and the State already possessed sufficient buildings. Ricci had found patronage at the Piedmontese court of Turin, as well as outside Italy; Pellegrini had wandered from Germany to Flanders, back to England again and then to Paris. Amigoni remained abroad for much longer periods and had probably decided to quit Italy finally when he left for Madrid in in 1747. The pattern of these painters' wanderings was duplicated by many lesser figures, all of them to some extent prophets without honour in their own country and enjoying abroad rather greater prestige than they deserved. The supply of Venetian history painters far exceeded the demand. Although they were at times employed in other North Italian cities they remained very much more likely to be offered commissions out of Italy than elsewhere in Italy, beyond the Veneto. Florence, Rome, Turin, Bologna, Verona, and Naples especially, all had their own little or great local men, some of them working in provincial styles. A strong sense of rivalry existed, and the more obscure artists often found partial local biographers who made unwarranted claims for their provincial hero; thus a certain Veronese artist, Lorenzi, found a biographer who claimed that Tiepolo had been unable without his help to draw up the scheme of decoration for the Royal Palace at Madrid, Tiepolo being so illiterate and Lorenzi so learned.

In each city the Church became the steady patron of history painters, constant where secular patrons might be inconstant or non-existent. A painter like Amigoni is therefore represented at Venice by pictures *in situ* still in churches, but not by any secular decorative scheme *in situ*; they were never executed or have not survived. Yet we know that pictures of mythological scenes by Amigoni were certainly popular in eighteenth-century Venice and hung in private houses. These needed no particular architectural setting but simply served as ornament to relieve the damasked walls; a painting like the *Venus and Adonis* (Fig. 26), while not remarkably novel, is typical of such pictures intended for private owners. Pietro Longhi's genre scenes (discussed in chapter 4) are valuable for the documentation they provide on Venetian interiors of the period from about 1740 onwards, and in them again and again are shown pictures clearly intended to be by Amigoni. Some can probably be identified, either through Amigoni's existing work, or through engravings of it executed about the

25. Jacopo Amigoni, *Juno Receives the Head of Argus*. Hertfordshire, Moor Park.

same time: further sign of his popularity. The *Venus and Adonis* probably dates from his last stay in Venice, between 1740 and 1747, by which time he was no longer a pioneer of anything, and a fresh generation of younger

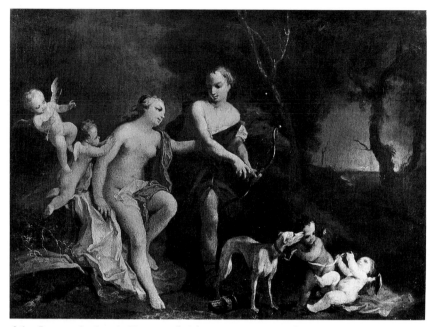

26. Jacopo Amigoni, *Venus and Adonis*. Venice, Accademia.

men had formulated a more truly vital style. Against the new manner,
almost exaggerated in its airy elegancies and light-filled compositions,
Amigoni's canvases seem naïve, rather slack and sadly unpoetical. And
though Walpole is often unfair and obtuse in his comments on foreign
painters, when he speaks of Amigoni's manner as 'a still fainter imitation
of that nerveless master Sebastian Ricci' and complains that his figures are
'entirely without expression', it is impossible not to feel that he has put
one's objections very well.

At Venice rococo style manifested itself only sporadically – rarely in
architecture, arguably little in painting and chiefly in the decorative arts: in
stucco work, or garden statues, or in some elaborate chandelier of glass
flowers; and the picture frames of the period are often more rococo than
the canvases they surround. While in painting there is no easily apparent
and consistent evolution towards a rococo idiom, this can be neatly traced
in the evolution of, for example, chairs: from the exuberant yet grand style
of the late seventeenth century to the curving, animated and highly coloured
variety of styles which represents the peak of rococo. Decoration of the
furniture was often entrusted to painters of the period who supplied

designs even if they did not ever actually execute such work themselves. Amigoni, among others, is said to have supplied furniture designs. Even the cradles of the mid-century at Venice expressed the longing to be airborne and to conquer space; from one that has survived there rises a long wire with a *putto* suspended at the top holding a coat-of-arms; and others are equally fashionable, and exotic, with branches and birds suspended in the Chinese style. Where the rococo penetrated deepest in Venetian art was in the production of illustrated books, the plates of which are often more fantastic and bizarre than any picture dared be. And the mania for illustrated books resulted in anthologies for every occasion, private and public (Fig. 1), where the plates eventually swamped the exiguous text.

So widespread a taste for the rococo probably had an effect upon painters, rather than was in any way inspired by painting. One great painter in fact stood apart from the whole tendency: Giambattista Piazzetta (1683–1754). He is a very great artist indeed but until recently he remained comparatively little-known, perhaps through the rarity of his work and through some of his finest, large-scale religious pictures being still *in situ* in the churches for which they were painted. He is the grand exception to every generalization about eighteenth-century Venetian art, and his personal example was sufficient to create a school of imitative painters, non-conformist like him but largely lacking his genius. He was, among other things, a most sensitive and accomplished draughtsman, and has left the image of himself (Fig. 27) highly charged in character, proud, reserved-seeming and somewhat challenging. Unlike most of his contemporaries he did not pride himself upon his speed of execution; rather, he seems to have prided himself on his slowness, which became almost proverbial. 'He is a snail,' reported Count Tessin, arrived in Venice in 1736 from Sweden, going on to praise in contrast Tiepolo, who 'executes a picture while another person has hardly mixed the colours'. The decorative painter learnt speed from fresco work – since the paint must be applied while the plaster is still wet – and carried the same principles of haste into canvases. Piazzetta was in no sense that type of decorative painter. He painted only one fresco-style picture in Venice, the ceiling of the *Glory of St Dominic* in SS. Giovanni e Paolo, and though since cleaning this is seen as idiosyncratically effective, that type of commission was probably not congenial to Piazzetta. His thundery chiaroscuro effects and his feeling for heavy, rather static, drama are much better conveyed in subjects composed as pictures. His training under a dull naturalist painter, Antonio Molinari, and at Bologna under Giuseppe Maria Crespi, must have confirmed these tendencies and encouraged his abstention from any rococo movement.

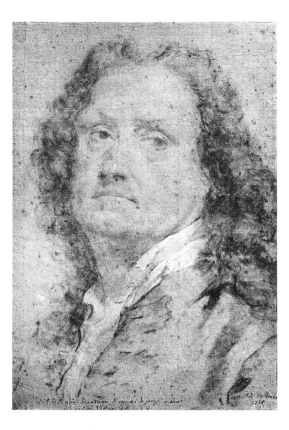

27. Giambattista
Piazzetta, *Self-portrait*.
Drawing. Vienna,
Graphische Sammlung
Albertina.

His *St James Led to Martyrdom* (Fig. 28), painted for S. Stae at Venice
c. 1722, makes the work there of the rest of his contemporaries look very
slight and artificial – except for that of the young Tiepolo, who was then
briskly and misguidedly aping Piazzetta's style. It is true that Piazzetta's
drama tends here to melodrama; but it is significant that he has taken
a scene lacking in all supernatural incident, and what he shows in fact is
a vigorous old man dragged along in a contorted and confused way by a
brawny, tawny, younger man. In character there seems nothing to choose
between saint and executioner. Whereas the rococo, however defined, is
always aiming to elevate the subject to an exciting operatic movement of
grand gestures and radiant personalities, Piazzetta recalls the uncouth
literalness of Loth, for example, and seems almost to 'debunk' his subject
with, however, powerful, haunting effect. Sebastiano Ricci's airy *St Peter
Released* (Fig. 29), from the same S. Stae series, was probably painted

only shortly after Piazzetta's picture there, but has obviously nothing in common with it; real analogy exists, however, between Piazzetta's picture and Loth's *Mercury and Argus* (Fig. 8), which was painted at least a good fifty years before.

While everybody else in Venice was, under cover of a debt to Veronese, going forward, Piazzetta was going back. While colour was brightening even garishly the rococo painters' canvases, Piazzetta was largely restricting his palette to chestnut-red, black, white, and grey. Working within that deliberately narrow range, his genius achieved at least one great tonal *coup* in the *Sts Vincent Ferrer, Hyacinth and Luis Beltràn* (Fig. 30) for the new Dominican church, the Gesuati: an altarpiece that is probably the greatest picture of its kind set up in Venice in the eighteenth century. Piazzetta has emerged from the grotesquerie of the *St James* and is also untroubled by subject-matter; he simply disposes his three saints in a cloudy nondescript atmosphere and from their juxtaposed habits of black, white, and grey, he makes more effective contrast than would another painter with a whole rainbow of colours. Unlike the majority of his contemporaries, he aims at tonal effects, gradations and harmonies of monochrome, and he cuts down the amount of light in the picture in a manner almost rebuking the superb chromatic brilliance of Tiepolo's ceiling in the same church, also painted in 1739.

The taste for reproducing the trivia of life which runs in Venice from the history painters to the view painters, via genre, is absent from Piazzetta. The clothes of his people have a simplicity that is sculptural; and his concentration on the figure, like his subdued, unified tonality, is sculptural too. He positively models in paint, giving his figures and the heavy folds of their draperies a kind of gravity and weight recalling the technique of Zurbarán. From pungently expressive head to bony articulated foot, a saint by Piazzetta is a concentrated, powerful presence, expressive, eloquent yet invested with intense dignity. His trio of Dominican saints are truly saintly figures, fiery and ecstatic, vessels of piety who are also thoroughly human and solid. Not until late in life, when painting altarpieces in Spain, (see pp. 238–9) would Tiepolo catch and match the mood of that achievement. Even when dealing with a full-scale vision, as in another great work, the large altarpiece of *The Vision of the Virgin to St Philip Neri* (Fig. 31), Piazzetta creates a static drama, magnificently bold but somehow still, fixed and immutable. There is none of that sweeping sense of an abrupt, almost annihilating miraculous appearance which makes so thrilling Tiepolo's *Madonna of Mount Carmel* (Fig. 140). Piazzetta's Virgin and saint are moulded from the same clay – and clay, with its associations of

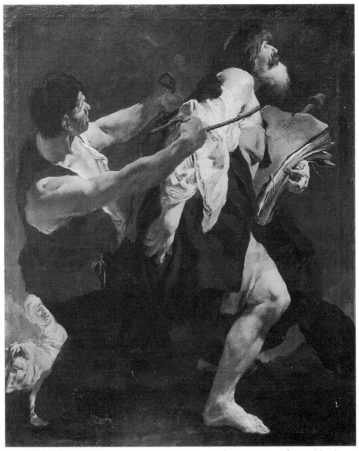

28. Giambattista Piazzetta, *St James Led to Martyrdom*. Venice, S. Stae.

the plain and the durable, seems a suitable material for Piazzetta. Perhaps there really is some genuine relevance in the fact that his father had been a sculptor or a wood-carver; perhaps it was from him Piazzetta inherited that feeling for the monumental that makes him stand out so boldly and forcefully amid the soft, coloured mists of much eighteenth-century Venetian art.

Difference was perhaps one of his claims to the interest of his contemporaries. For while he remained in Venice, his pictures (when he could get them finished) were in demand beyond Venice, especially in Germany. In

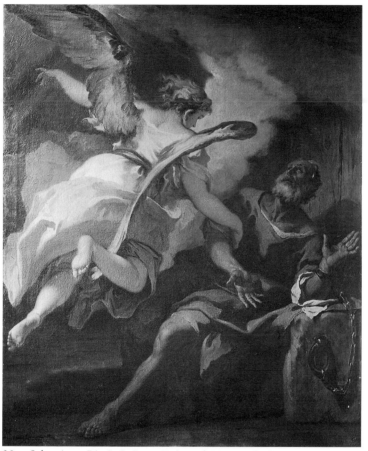

29. Sebastiano Ricci, *St Peter Released*. Venice, S. Stae.

the city his prestige was such that on the creation of the Academy he was appointed first Director. On his death he, almost alone among Venetian painters of the period, became the subject of a biography, by his devoted friend the printer Albrizzi. Most other painters travelled outside Venice, if not outside Italy; Piazzetta seems to have taken no journeys beyond the city and certainly none to foreign countries. And of all the famous painters of the time at Venice, he died the poorest. His last years were spent in teaching rather than working, and on his death his widow had to appeal to the State for help as he left her and their children in desperate indigence.

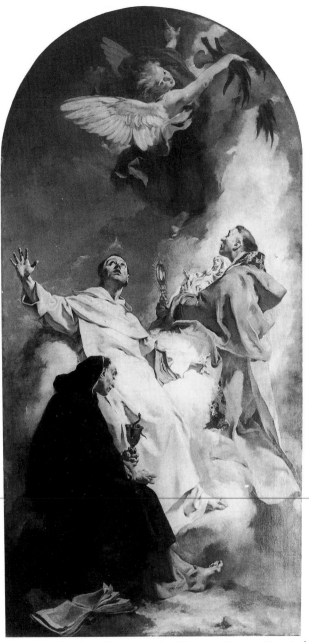

30. Giambattista Piazzetta, *Sts Vincent Ferrer, Hyacinth
and Luis Beltràn*. Venice, Gesuati.

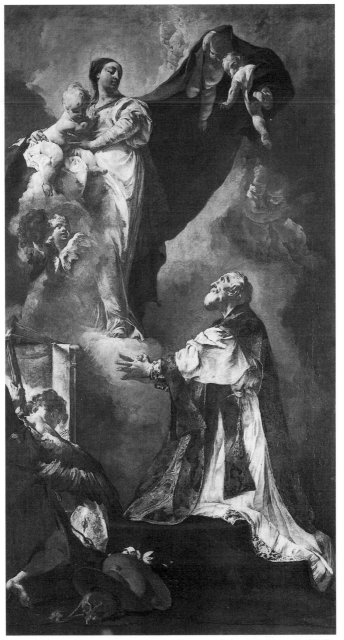

31. Giambattista Piazzetta, *The Vision of the Virgin to St Philip Neri*. Venice, S. Maria della Fava.

Something of what he aimed at in painting may be summed up by his version of *Rebecca at the Well* (Fig. 32), forceful enough a contrast with Pellegrini's earlier treatment of the subject. Here there is no attempt at the graces of style, and the scene is treated in what may be described as a bourgeois manner: Rebecca and her companions become peasant girls while Abraham's old servant is a rather dashing cavalier in Caravaggesque costume – and we might seem to be witnessing a rustic seduction. This 'genre' treatment is, in one way, more 'real' than Pellegrini's treatment, and it leads into the essays in pure genre subjects, which Piazzetta also practised (and which are discussed in chapter 4). The painter has once again by-passed the actual biblical subject and ignored whatever religious overtones are to be supposed to be present in it. Not only grace and lightness are absent here, but also decorum. In the hands of a painter like Poussin the subject had been grave and even touching; Rebecca had heard the commission with the attention and pose of the Virgin Annunciate. French eighteenth-century critics coming to Venice found Piazzetta's lack of dignity extraordinary, even while they quite liked his work. Although he

32. Giambattista Piazzetta, *Rebecca at the Well*. Milan, Brera.

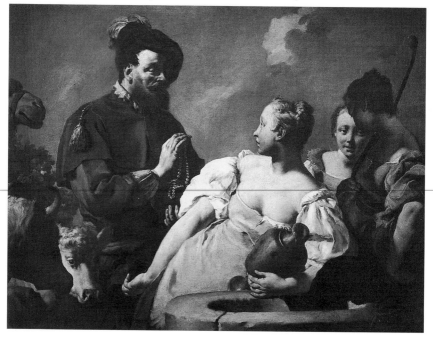

returned in some sense to the seventeenth century, it was not to those academic standards in which, for example, a king was kingly and a hero heroic. Of Piazzetta's King Darius Cochin remarked with dismay that he had 'the air of a sailor'. Nor would he have been less dismayed had he seen the lowering of social and religious tone shown in the *Rebecca.*

Thus, while one aspect of religious painting in Venice at the time exalts the theme into the superhuman sphere (apotheoses and glories and visions), another aspect is represented by the isolated art of Piazzetta, which depresses or, rather, fuses piety into common humanity.

The year 1754, the date of his death, may conveniently mark the apogee of the rococo at Venice. The early generation of pioneers was dead: both the Ricci, Amigoni, Pellegrini, as well as the few interesting strays like Antonio Balestra (1666–1740), who has been crowded out here but whose work tentatively preluded the eighteenth century well into the actual century. Balestra himself is interesting because his was one of the few voices raised at the time against the rococo: the bright colours used by 'modern' painters and their airy compositions roused him to quite open attack. He would have been horrified at being hailed as a pioneer of that style which was triumphing everywhere as he grew old. But with Piazzetta dead, all the great history painters who remained at Venice felt one dominant, ever-present influence: that of the new head of the Venetian Academy, Giambattista Tiepolo (1697–1770). Wherever they had first trained, with whom, by whom influenced otherwise, they could not fail to be aware of the sole genius among them. Tiepolo's own career deserves a whole chapter and is given it (chapter 6), but he is the behind-scenes master for other men's careers. The Tiepolesque idiom can be tedious when practised by anyone other than the master, but then so can the idioms of Michelangelo or Picasso.

The existence of Tiepolo was perhaps most unfortunate for the reputation – in posterity's eyes – of Giambattista Pittoni (1687–1767). Nature may have intended him as the great rococo painter of the day, and certainly he was famous enough and in demand. Possibly he never recovered from the effects of being taught the rudiments of painting by his mediocre uncle, Francesco; possibly he lacked from the first any real vigour or originality, while possessing enough competence to avoid being interestingly bad. And one of Pittoni's chief faults was an eclecticism remarkable even in an age of borrowing. He equipped himself with the means of saying something and then found he had little to say.

Nevertheless, that is partly a judgement after the event. Venetian contemporaries did not see the clear-cut division between Tiepolo and the rest of

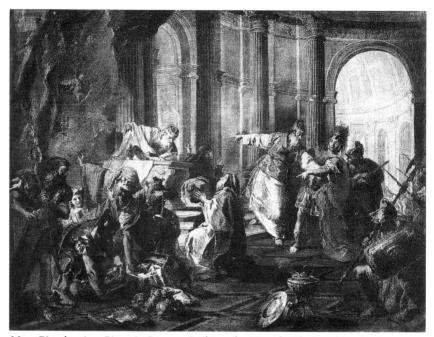

33. Giambattista Pittoni, *Crassus Sacking the Temple*. Venice, Accademia.

the history painters, and Pittoni formed part of a grand trinity with
Tiepolo and Piazzetta. As Tiepolo had succeeded Piazzetta as head of the
Venetian Academy so Pittoni succeeded Tiepolo. Like them he received
commissions from Germany for altarpieces, being much more patronized
by the Elector of Cologne, for instance, than was Tiepolo. Count Tessin,
however, did not care for his work or think him suitable for the Royal
Palace commission at Stockholm. And Cochin had reservations about him
and about his 'too beautiful colour' combined with empty compositions:
another case of Cochin's sharply accurate judgement.

Francesco Algarotti, back in Venice in 1743 from Dresden, also commis-
sioned work from him for the Court there; he himself had in his collection
a *bozzetto* by Pittoni for one of these pictures, *Crassus Sacking the Temple*
(Fig. 33), which was a subject Algarotti had chosen. And Algarotti care-
fully remarks in a letter that when choosing subjects for painters he had
tried to find those most appropriate to the painter in question. Pittoni was
probably considered rather 'learned' and he presents an architectural setting
more elaborate than most contemporary painters would have been capable

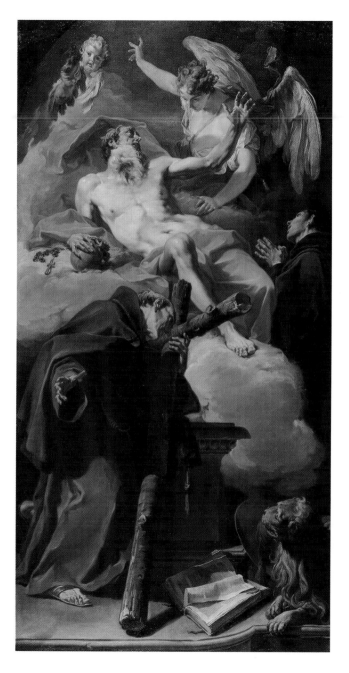

34. Giambattista
Pittoni, *Sts Jerome,
Francis and Peter
of Alcàntara*.
Edinburgh, National
Gallery of Scotland.

of thinking up. Certainly in eighteenth-century France elaborate classical subjects often had to be planned between the painter and the Académie des Belles-Lettres. Architectural settings, especially classical ones, were well worth the trouble of delineating, and Madame Geoffrin speaks for her age when she says of a picture Vien had been commissioned to paint, 'Temples always make a fine effect by enriching pictures'. The architecture in Pittoni's painting lends it additional value, and Algarotti had noted Pittoni's response to painting architecture. The subject also is very noticeably drawn from history rather than mythology; it is a good deal more serious and elevated than the love-and-duty themes which were no doubt more popular with Venetian taste. But it remains a moment of high drama, and offers contrast between the looting Roman soldiery and the distraught aged priests: it is still an emotional depiction, a clash of wills and the despoiling of an ancient civilization by a more modern one.

The picture, even if not particularly successful as a work of art, has at least a more 'engaged' air than most of Pittoni's painting, and also a rather more vigorous warm tonality. Unguided by Algarotti, Pittoni inclined to a dreamy, languid rococo style, sugary colouring and commonplace sentiment: too sweetly pious Madonnas kneeling by cribs, and equally sweet classical goddesses. Pittoni is basically sentimental in his art, the only Venetian of the period who is; perhaps part of the vogue in Germany for him at the time is to be explained by his *kitsch* vein, his combination of the homely and the pretty. He can be deplorably languid as a painter of altarpieces, whereas his sketches for them, and also his sketches in their own right, show that he had some basic qualities of 'attack'. He carried them successfully into one of his finest pictures on a large scale, the altarpiece of *Sts Jerome, Francis and Peter of Alcantara* (Fig. 34). Here, it seems, a strong injection of Piazzetta's vigour has set Pittoni's art on not an original but an exciting course, not to be sustained. The effective zigzag composition, the concentrated forms and the juicy succulent paint combine to create a masterpiece of Venetian religious art of the period.

Considerably humbler than Pittoni in reputation were the Guardi brothers, whose activity as figure painters has excited far more attention from twentieth-century art historians than it did from anyone at the period. And, ironically, some of this attention arises from Francesco Guardi's activity as a view painter. To some extent they do present a problem, though they presented few problems to their contemporaries in Venice who hardly heeded their existence. Painters' lives at Venice were not princely, and no eighteenth-century artist there (not even Ricci) enjoyed any of the colossal flattering reputation enjoyed almost contemporaneously

by artists like Mengs and Batoni at Rome. And at Rome Piranesi, as well as enjoying fame, enjoyed privileges also: such as that of being exempted from paying the tax due on the paper he used for printing.

Painters like the Guardi took what work they could get, and no doubt were grateful. They were very rarely asked to paint a picture for any building in Venice itself. Almost the only religious work acceptably by them (or by one of them), and *in situ*, is that of the organ case in the small church of Angelo Raffaele; and the documents that have survived about this do not even bother to name the painter. The Guardi family, though settled in Venice from early in the eighteenth century, came from further north, from Val di Sole near Trento, and had for a period been in Vienna. Domenico Guardi (1678–1716) moved to Venice and had a studio among a small colony of other Trento families, some of whom were related to the Guardi. And it was for this area above Venice that most of the altarpieces of his sons Gian Antonio (1699–1760) and Francesco (1712–93) were to be painted. Nothing of Domenico's work has survived. It is probable that Gian Antonio and Francesco became a firm, a studio from which work was issued as by 'Guardi' and in which the dominant painter was Gian Antonio, the elder brother. Certainly there is a reference in the will of a Count Giovanelli in 1731 to copies of pictures done by the 'Fratelli Guardi'. There was also a third brother, Nicolò (1715–86), who apparently practised also as a painter, but no authenticated work by him either has survived and he may safely be ignored.

Even between the two elder brothers it has often seemed hard to decide which painted which picture, a difficulty increased by the fact that most of the best Guardi work is unsigned and unmentioned by contemporaries. The pictures are very varied in subject and in quality; there are battle pieces and flower pieces, altarpieces, scenes of mythology, and some genre scenes derived from Pietro Longhi. Venice was full of painters copying compositions from each other, but the Guardi never bothered to invent when they could borrow. Gian Antonio copied, for instance, Pittoni's *Crassus Sacking the Temple*, copied a picture by Balestra of *Abraham Visited by Angels*, copied from his brother-in-law Tiepolo and copied from seventeenth-century painters such as Feti. More often than not he seems to have borrowed via an engraving (such as in the case of the Balestra, engraved by Rotari). In the hands of the Guardi such compositions underwent a change, becoming fluid, wavering and capricious in design and in actual handling of the paint; the line flickers and the tonality grows silvery and misty. Sometimes one can see that the composition has been borrowed, but the Guardi touch conceals its source.

Whatever the degree of collaboration between the two brothers, it is clear that Gian Antonio, the elder, was the dominant partner. Francesco only gradually begins to emerge as an artistic personality from the frothy, feathery shadow of his elder brother. Only in 1761, it seems, was he inscribed in the Fraglia of Venetian painters, a year after his brother's death. Only in 1757 did Francesco marry. Before 1760 documents do speak of Gian Antonio, but chiefly of him alone; after 1760 Francesco begins to be heard of, but mainly, of course, as a view painter. Gian Antonio must have been head of the studio, and whatever subtle distinctions are drawn between the two brothers' handling of paint, their style itself seems to be the invention of Gian Antonio. It seems not fully developed in the *Death of St Joseph* (Fig. 35), a picture of some importance since – unusually – it bears, with almost ludicrous prominence, Gian Antonio's signature. This altarpiece may date from about the mid-1730s, or rather later, and though an important document cannot be accounted a very thrilling work of art. It helps to explain contemporary lack of concern with the Guardi brothers' activities.

Something much more attractive, livelier in handling and more iridescent in colour is found in *Erminia among the Shepherds* (Fig. 36), which can reasonably be assigned to Gian Antonio, and which is part of a series of pictures illustrating incidents from Tasso's *Gerusalemme Liberata*. The compositions are all based on Piazzetta's designs for an edition of the poem published at Venice in 1745 by his friend Albrizzi, but the paintings appear stylistically to date from about a decade later. Having borrowed the composition, Gian Antonio proceeds to blow it up – and apart – in more senses than one. Everything seems bubbling, shimmering and on the point of dissolving. People, objects, landscape all share the same foam-like texture which has its own enchantment but also robs the scene of any dramatic impact. And in other pictures in the series even armed combat between Christian and pagan dwindles to the playfulness of a pillow-fight – one in which rainbow-hued feathers have filled the air, fluttering around and forming what composition there is.

This style is perhaps at its most effective on a small scale; and in the Tobias series (Fig. 37), decorating the organ parapet in the church of Angelo Raffaele at Venice, it has produced a miniature masterpiece. That Gian Antonio was the creator of these magical pictures seems now generally accepted. Less clear, it must be admitted, is the documentation surrounding them, but some decorative work was carried out on the organ by 1750, when the 'laterali' at least were finished, though no painter is named. Possibly by that date the seven parapet pictures had been finished.

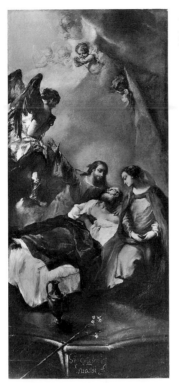

35. Gian Antonio Guardi, *The Death of St Joseph*. Berlin, Staatliche Museen.

36 (below). Gian Antonio Guardi, *Erminia among the Shepherds*. Washington, D.C., National Gallery of Art, Ailsa Mellon Bruce Fund 1964.

37. Gian Antonio Guardi, *The Departure of Tobias*. Venice, Angelo Raffaele.

The commission was anyway a modest one, in a modest, rather tucked-away church. Decoration was required, and in sparkling, spun-glass manner Gian Antonio has provided it. The tonality of the pictures, almost swimming in a bluish-green atmosphere, with brilliant highlights often of coral pink, has a watery, lagoon air. Each object and figure seems vibrating as if glimpsed through a heat-haze or tinted sea-mist. Nothing is quite solid. Surfaces are splintered and refracted under the constant play of light, set dancing in a truly rococo vision which seems shared only by Fragonard. In the sober Venice of Piazzetta and of Canaletto, Gian Antonio takes on a butterfly-like incongruity.

Whatever the exact date of the Tobias series, Francesco Guardi certainly did not cease painting figure subjects when he pursued view painting after

38. Francesco Guardi, *Sts Peter and Paul Adoring the Trinity*.
Roncegno, Parish Church.

his brother's death in 1760. The fairly recent discovery of an altarpiece of nearly twenty years later was a cheerful event since it revealed as by him a large-scale figure work from which Gian Antonio's hand is utterly excluded. This altarpiece, SS. *Peter and Paul Adoring the Trinity* (Fig. 38), was painted about 1777, once again for a Trento church, this time at Roncegno. It must be admitted that the picture is not quite as good as one would like, or expect; while it is full of rococo *sfumato* and broken touches of light which seem to derive from Tintoretto, it is obviously tame in composition even clumsy.

But the picture is in the same vein of soft (almost scented) rococo that was the contribution of the Guardi to eighteenth-century Venetian art. It is unfortunate that we have nothing to suggest that this contribution was either welcomed or enjoyed in the city: only a curious silence on the subject of the Guardi and their work. And in some ways their style was not very much bound up with conceptions of illusionism and space, or with the imaginative heroes and heroines of Ricci and Tiepolo who peopled such space. They did not manage or organize their work into perspective schemes, being little concerned with depth. Their settings are therefore usually nothing but tinted vapour amid which an occasional frond of foliage or a few spikes of grass stand out in almost Chinese manner. And the people inhabiting this world are equally a blend of the vaporous and the calligraphic. In fact, theirs is a style that is almost aggressively linear, and it is significant that the most pleasing decorative work of theirs to survive – apart from the Tasso and Tobias series – are drawings. Even their paintings aspire to the condition of drawings; they are at once too improvised and too faint to ornament a ceiling or a wall, and expanded to the large scale of altarpieces they tend to look insubstantial. Part of the charm of the Tobias series is its smallness and intimacy, ornamenting not any architectural feature but in effect a piece of furniture.

Meanwhile, the tradition of Ricci continued more obviously in a whole group of painters who were public personalities, discussed at the time whereas the Guardi were not. Some of them were particularly gifted as fresco painters – such as Giambattista Crosato (1686–1758), a Venetian active a good deal for the court of Turin. He was a scene-designer as well as fresco painter, but the two merge in his highly illusionistic frescoes in the Ca' Rezzonico at Venice (Fig. 13), to turn the already large hall into a stage of almost bewildering complexity and limitless space. No less competent but less daring, and much less of a sheer decorator, was Gaspare Diziani (1689–1767). Born at Belluno, he went to Venice and worked under Sebastiano Ricci before finding employment in Germany and in

39. Gaspare Diziani, *The Flight into Egypt*. Venice, S. Stefano.

Rome (where a Venetian cardinal was his patron). Although one contemporary described his style as modelled on that of Tintoretto ('sul gusto del Tintoretto'), Diziani was marked most significantly by his association with Ricci. As with Ricci, his sketches and *modelli* – and especially his very lively, rapid drawings – represent the most immediately attractive aspects of his talent, but he was an accomplished painter on a large scale. His *Flight into Egypt* (Fig. 39) dates from 1733, almost the mid-point of his career, and shows him taking very much the way of Ricci, detached from the forceful monumentality of Piazzetta or the dazzling grace of Tiepolo. Among other painters of this kind Francesco Fontebasso (1709–69) was one of the most distinguished. Like other lesser men, he originated as a pupil of Ricci's but was touched by the influence of Tiepolo; and, like so many of the lesser men too, he established a recognizable style more firmly in drawings than in paintings. His art is slight and is perhaps never so successful as in book illustrations, but he worked as ceiling painter, was summoned to St Petersburg by Catherine the Great and in a two years' stay speedily executed considerable decorative work for her.

At Venice he clearly stood well in the academic milieu. He was appointed a teacher at the Academy, though he seems to have had trouble in getting himself respected by the students, and finally in 1768 was elected President. A small picture like *The Adoration of the Magi* (Fig. 40) shows his usual

40. Francesco Fontebasso, *The Adoration of the Magi*. Private collection.

charming feathery touch, which helps to lighten the Ricciesque compo-
sition, and shows also the small refinements of manner which are really his
sole pretence at style: his round-eyed *putti* and saints so consciously
attractive, while the colour is richly pleasing. Fontebasso had no fresh
comment to make on his subject, not surprisingly, and he therefore
concentrated on being agreeable. His pictures provide yet a further illus-
tration of the fact that what is revolutionary in one generation becomes
conservative in another. Ricci had actually been dead thirty-four years
when Fontebasso was elected head of the Venetian Academy; Pittoni also
was dead; Tiepolo was in Spain. Of the history painters in the city
Fontebasso must have seemed a very obvious choice for President. In so far
as his work shows any evolution, the late pictures show him returning
to Ricci's influence; there is no sign of advance, simply a clinging to that

style of his youth, which had already reached its climax and was in fact in decline.

On Fontebasso's death there remained in Venice one talented decorative painter in the pure Tiepolesque tradition: Jacopo Guarana (1720–1808), whose activity as well as life continued into the nineteenth century. Guarana, foundation member of the Venetian Academy, is said to have studied first under Ricci and then to have studied with Tiepolo. Of all Tiepolo's pupils, Guarana was the one who succeeded best in carrying on the decorative tradition. Unlike the majority of contemporary artists, he was employed in the Doges' Palace (where some of his work survives), as well as in other palaces and in churches.

But his ability is shown in Venice itself most happily perhaps in the simple decoration of the music room at the Ospedaletto, painted about six years after Tiepolo's death. This seldom-visited room is a complete piece of *settecento* decoration, in which every available wall space has been frescoed and ornamented light-heartedly and intimately; only the existence of radiators discreetly reveals that time has passed. The children of the Ospedaletto were famous for the concerts they gave, and Guarana has taken up the theme of music in a charmingly half-humorous, half-poetic Apollo with female musicians who play at one end of the oval room among painted marble columns (Fig. 41). The whole deceptive architectural setting is the work of Agostino Mengozzi-Colonna, son of the architectural painter who had been Tiepolo's constant collaborator in such schemes. Agostino's *trompe l'œil* is in the best tradition of his father, while Guarana has peopled it with vaguely classical figures, in vaguely period costume, who are not taking themselves too seriously.

Part of Guarana's charm is in this unpretentiousness, and even in irrelevance. The dog on the steps is sufficient to tell us that the fresco is Venetian: it has strayed out of ordinary life, to be teased by the woman at the right who extends a doughnut to it, and is a comic adjunct to Apollo earnestly conducting; and it also aids the illusionism of Mengozzi-Colonna's steps. Since Veronese, at least, there had been a cheerful Venetian tradition of irrelevance, if not irreverence, in depictions of solemn scenes. Like his master Tiepolo, Guarana is not concerned with a solemn classical world but with creating a piquant and impressive effect: which indeed he succeeds in doing. And Mengozzi-Colonna is concerned with creating an effect of space by a Palladian-style portico of double columns (almost like a miniature of Adam's portico for Osterley) and nothing but sky beyond. First the room is dignified by simulated architecture, its proportions enhanced by the figures, and then the wall is dissolved into the lilac space

41. Jacopo Guarana, *Apollo and Musicians*. Venice, Ospedaletto.

42. Jacopo Guarana,
*The Sacred Heart and a
Group of Saints*. Venice,
S. Polo.

of limitless sky. Guarana and Mengozzi-Colonna thus assert, for almost the last time, that preoccupation of their age with illusionism in decoration; and their frescoes in the Ospedaletto close the cycle initiated by Veronese at Maser two centuries before.

A new century is a mere calendar event in an artist's life, and the coming of the nineteenth century cannot have seemed particularly significant to the old but active Guarana. He had survived the fall of the Republic and lived on, probably without quite realizing it, into a new age. In 1802 nothing can have seemed more out-moded than the rococo style, but in that year Guarana signed and dated his altarpiece of *The Sacred Heart and a Group of Saints* (Fig. 42) for the church of S. Polo. There is something almost touching in this last expression of rococo ideals, even though as an artist Guarana had never been, nor was to be here, particularly competent or outstandingly talented. He had known Tiepolo when Tiepolo's name was celebrated in half Europe. And here he pays tribute to that pervasive influence upon him, in a picture that breathes the last sigh of the Venetian *settecento*.

71

43. Marco and Sebastiano Ricci, *Allegorical Tomb of the Duke of Devonshire*.
Birmingham, Barber Institute.

2

Landscape Painting

Altogether on a lower plane than history painters were the landscape painters. At Venice landscape painters as such were few; landscape could hardly be claimed as an individual category of painting there in the eighteenth century, were it not that one or two painters like Zuccarelli devoted most of their lives to it. Even Zuccarelli, however, painted some religious pictures and a few portraits.

Throughout eighteenth-century Europe the landscape occupied a rather equivocal position, as indeed Nature itself did. The landscape of one's own country so often lacked that romantic appeal which the century was always seeking in art. Addison speaks for his age when he says, 'in the wide fields of Nature, the Sight wanders up and down without Confinement, and is fed with an infinite variety of Images'. But a greater variety of images was to be found abroad: above all, in Italy. And in Italy the landscape had already been delineated by seventeenth-century artists whose very names went on evoking down the following century two very different types of landscape painting: the calm pastoral world of Claude and the stormy dynamic world of Salvator Rosa. These, with Gaspard's, were the names that every traveller muttered as the individual effects of Nature prompted him:

> Whate'er *Lorrain* light-touched with softening Hue,
> Or savage *Rosa* dash'd, or learned *Poussin* drew.

But the ecstasies of foreigners were not likely to be echoed by Italians themselves, least of all by the Venetians in their tree-less, water-bound city. Landscape had played its part in Venetian painting, superbly in the background of many of Bellini's and Titian's pictures and quite interestingly in the engravings of Campagnola. In the eighteenth century landscape still needed to be enlivened by people and objects, enhanced by ruins and

tombs and peasants; and at Venice it was best appreciated when it was not too literal. Landscape begins to shade off into the 'caprices' of the view painters: blends of two or three views with some prominent monument, a patch of Venetian lagoon, some people looking at a ruin or digging under the stones. Landscape in these pictures is not quite as it was in the pictures of Gainsborough or Constable. One of Constable's patrons asked for a landscape from which he could feel the wind blowing; that fresh, breezy atmosphere was not at all what the 'caprice' aimed at conveying.

Even at Venice there existed a style of landscape hardly related to the 'caprice' but it did not possess much in common either with Constable. The practitioners of it were not view painters, though like them they were often scene designers for the theatre.

The most versatile and important was conveniently the first, Marco Ricci (1676–1730), nephew of the too famous Sebastiano. Like his uncle, Marco Ricci initiated new tendencies at Venice; his ruin-pieces, his romantic scenes, even his sober seasonal landscapes, had each their influence. And Canaletto, Marieschi and Guardi, view painters all, are in different ways indebted to him. As a phenomenon Marco was later overshadowed by his uncle, with whom he had often collaborated, and there is little explicit reference to him by his contemporaries. As a person he seems to have been quarrelsome but convivial.

He was born at Belluno above Venice, and Zanetti in a brief reference reminds his readers of the picturesque countryside around there and speaks also of Titian's influence on him. Marco's admiration for Titian is in fact recorded in a letter. As for the actual countryside, Marco Ricci is untypical of the later Venetian landscapists in his feeling for the North Italian countryside of fact; he gives a sense of having felt and seen what he paints of it. Despite being a talented scene designer, he was quite capable of excluding anything overtly theatrical from his landscapes and presenting instead a vivid scene of the countryside under some special effect of weather or season. In such work he is at his finest and most personal.

A variety of influences jostles with Titian's to create one at least of his styles. He travelled a certain amount in Italy with Sebastiano Ricci, and is said to have spent a further enforced period outside Venice after having split open a gondolier's head. His travels brought him also to England in the company of Pellegrini, with whom he quarrelled before returning again with Sebastiano Ricci. Capable of producing dynamic landscapes of storm and rocks and torrents, he could not fail to be affected by Salvator Rosa's work in this genre. The romantically violent side of Rosa's talent probably was transmitted to him through the bizarre but repetitious Alessandro

Magnasco (1667–1735), a person whose work has sidled into exaggerated repute after a century or so of judicious neglect. Magnasco did not work at Venice, and there had been nothing of this kind at Venice, but the two painters may have met at Milan. Marco Ricci's essays in the manner, of which the *Storm at Sea* (Fig. 44) is typical, are therefore something quite new in the city, though not generally novel in Italy.

The picture is at once exciting and incredible. It communicates a sense of terror without danger, which is exactly what the century always sought in such scenes whether painted or actual. Even Dr Johnson had enough of the romantic beneath his commonsense exterior to grow fond of such effects when in Scotland and to think of viewing from a castle on a promontory – rather as in Ricci's picture – 'the terrifick grandeur of the tempestuous ocean'. Ricci's adds the yet further excitement of a noble ship being dashed to pieces; in this guise the human element remains, and we are not witnessing simply an act of Nature but a battle between natural forces and mankind.

The drama is hectic enough, but hardly convincing. The waves rise impossibly high, the promontory with its castle towers impossibly tall, and the whole picture has a typhoon in a teacup air which is like the opening shot of a rather amateurish film. It is not surprising that this type of

44. Marco Ricci, *Storm at Sea*. Bassano, Museo Civico.

marine picture found few successors at Venice. For most painters who came after, the sea had quietened into the millpond of the Lagoon under clear skies and washing softly against the islands with their remains of ruins. A different and less dynamic aspect of the picturesque was found, and one specifically Venetian.

Equally, the romantic extravagance of pictures like *The Cascade* (Fig. 45) was to be softened in the later Venetian landscapists. But the *Cascade* remains an anthology of all that the susceptible traveller hoped to see abroad: a wild landscape lit by a lurid sunset and torrents hurtling down amid jagged rocks. And here the mood of the picture is conveyed by the strangely glowing sky with its evening light and pale purplish cloud; unlike the *Storm*, it is something the painter has seen. Subtle effects of light and shade in evoking the mood of a picture were real contributions to landscape by Ricci which remained neglected except by Guardi. Canaletto lights nearly all his work with a cold, clear radiance, while Zuccarelli's gauzy but unwavering light is only one aspect of his monotony.

More closely linked to later work at Venice are Marco Ricci's ruin-pieces and architectural pieces. These are closely allied too to his work as scene-designer. In them he often collaborated with his uncle, and the collaboration is as typical as what was produced. Just as gardens needed to be enlivened by statues and grottoes, and indeed ruins, so the pure landscape picture needed a judicious assortment of interesting objects if anyone was to pay it attention. Gradually the landscape element was edged out more and more, and in the hands of someone like Panini at Rome these pictures are ruin-pieces with the minimum of landscape. Italy was the land of ruins. The prestige exerted by the monuments that remained of the Roman Empire had been something very real, especially at Rome, since the Renaissance. And at Rome ruin-pieces became quite serious and archaeological; even when capriciously distributed in a landscape, each monument was recognizable as itself.

In the North of Italy, the mixture of ruin-piece and landscape was more decoratively and carelessly assembled, and fancy replaced archaeology. Temples of the imagination were set amid feathery trees at the edge of romantic lakes from whose shores blue mountains rose steeply; even the landscape became only vaguely Italian. This type of work was extensively practised at Bologna, where whole rooms of palaces remain with frescoed decoration in the manner. And it was a type of architectural decoration that was popular throughout Europe for the stage. This did not necessarily recommend it to everyone, and Girolamo Zanetti (a relation of the two Anton Maria Zanetti), seeing the opera *Bajazet* at Venice in 1742,

45. Marco Ricci, *The Cascade*. Venice, Accademia.

found the scenery a 'strange agglomeration of Gothic, Greek and Roman architecture'. But in general such mixtures of period and style were enjoyed for their capriciousness and fancy.

The two Ricci's collaboration on the *Allegorical Tomb of the Duke of Devonshire* (Fig. 43) is an example unusually elaborate at Venice. These extraordinary 'Tombs' were a series of twenty-four pictures planned as a venture *c.* 1720 by the bankrupt impresario Owen McSwiny, who was

living in Italy to avoid his creditors. Artists from Bologna and Venice were employed in collaboration upon them, including as well as the Ricci, Canaletto, Pittoni and Piazzetta. The Ricci at least had practice in collaborating together; even if they could not understand the meaning of the various symbols to be placed on the 'Tombs', as other painters of the series certainly could not, they understood the convention. McSwiny managed to dispose of ten 'Tombs' to the Duke of Richmond for the dining room at Goodwood, and there they served as decoration, much as did the frescoes on the walls of Bolognese palaces.

At Venice elaborate examples, such as those McSwiny had planned in honour of English Whigs, were obviously not going to be in demand. But some tombs do appear in Canaletto's caprices, and a tomb itself, like a monument, had those associations of the past, melancholy yet pleasant, which are finally expressed for the whole century by Gray's 'Elegy'. In Italy too some churchyard poetry was produced, even a musing on *La Tomba di Shakespeare*. As for tombs in art, it must suffice to say that the Ricci themselves were honoured by having imaginary tombs drawn in their memory by their friend, the architect Juvarra.

The ruin-picture, whatever the actual ruins were, remained more popular than a landscape that was simply a view of ordinary countryside. Yet even insipidity could be a pleasure after too much hectic and 'savage' landscape, and as a change also from the ruins that crowded out trees, mountains and nearly the grass too.

Marco Ricci's own straightforward landscapes are far from the extremes of insipidity or excessive drama. Possibly it was towards the end of his life that he concentrated on a type of small work of art that he had previously painted occasionally – landscapes in gouache on kidskin, a material he seems to have been very fond of, and which became his speciality. They represent a more private and more profound aspect of him than his other work. A large group of such pictures, clearly executed over a considerable period of time, was owned by Joseph Smith, and another group was owned by the elder Zanetti. A selection from both collections was engraved after Ricci's death by Davide Fossati, but does not appear to have had much influence. Marco himself had produced a number of etchings of comparable subjects (also published posthumously), yet they lack the delicate touch and pervasive pastoral feeling of his best gouaches. Smith's was a fine collection of them, and fortunately it was included in the sale to George III and survives in the Royal Collection today.

Since everything must have some sort of prototype, Marco's gouache scenes may have theirs in seventeenth-century Dutch and Flemish landscape

paintings, some of which he may have seen when travelling with his uncle in Europe. Others he almost certainly noted in Smith's collection, but he easily transcends pastiche. Nothing inspired him more directly than the actual countryside of North Italy. He may be said to have discovered it, and most poetically did he interpret it.

His *Winter Landscape* (Fig. 46) is not a prettification of nature, nor a caprice; nothing suggests the scene designer. Instead, and perhaps for the first time in Italian landscape, winter reigns quite truthfully: from the bruised sky to the frozen water and the frost-rimed trees. The simple effectiveness of the scene, in which people are a few scattered, muffled puppets, riding hurriedly through the snow or gathering twigs, is repeated in other gouaches where autumnal and summer moods are captured. The simplicity is such that the pictures hardly seem novel after the vast parade of nineteenth-century landscape, yet their authenticity and uniqueness remain. The mood of the day, the season, the weather, is what Ricci has seen and felt; and he has set it too in the fertile, beautiful landscape round

46. Marco Ricci, *Winter Landscape*. The Royal Collection. © 1994 Her Majesty Queen Elizabeth II.

47. Marco Ricci, *An Opera Rehearsal*. Washington, D.C., private collection.

his native city. During his lifetime, in the severe winter of 1708, the
Venetian Lagoon froze; at least one naïve little picture records the scene on
the ice. It is interesting, and perhaps even significant, that Marco does not
depict that scene. The topical has no place in his landscape work – though
he was quite capable of topical witty comment as we know from his
caricatures of opera singers rehearsing (Fig. 47). His gouaches of deep
countryside, with winding paths where bullock-drawn carts pass under
summer trees or labour through the snow, have an almost Virgilian feeling
for the soil: serious, evocative and with some trace of sadness. The
unusual, skilfully composed *Courtyard of a Country House* (Fig. 48)
shows an almost tender response to simple things like sun-dappled foliage,
a flight of steps, a line of washing, a half-opened door; and this charming

80

yet ordinary rustic courtyard is the scene surely of morning activity, with servants going about their tasks in a timeless way, tending a plant or doing the laundry, as if part of a cycle of nature itself.

Zanetti was right to emphasize Marco Ricci as not Venetian. Venice remained urban, severed from the countryside except as that offered a retreat from the city in summer. The poet and journalist Gasparo Gozzi, in a lively letter to his mistress who had withdrawn to her villa, sighs for the song of birds in place of Venetian church bells ringing out eight days on end to celebrate an abbess' feast day. But Gozzi is suitably vague about what sort of birds one hears in the country, and at heart adored the bustle and noise of Venice. Birds were more likely in eighteenth-century ears to have the effect that Tickell's 'Woman of Fashion' complains of in Kensington Gardens:

> Whose ridiculous chirruping ruins the scene,
> Brings the country before me, and gives me the spleen.

A park is one thing, but unordered Nature is another. And in the work of Francesco Zuccarelli (1702–88) Nature is kept well in hand, softened

48. Marco Ricci, *The Courtyard of a Country House*. The Royal Collection © 1994 Her Majesty Queen Elizabeth II.

81

from the drama and asperities of Rosa and Magnasco, and kept safely away from the seasonal effects of Marco Ricci. No doubt Zuccarelli, born in Florence but active largely at Venice and in England, felt the influence of Ricci. When he had finished, however, not much trace of the influence remained; he had, in his fashion, created his own style of enchanted landscape, with skies forever blue, trees forever green and the whole scene appearing bathed in sweetened pinkish mist.

So considerable was Zuccarelli's reputation that it is almost impossible not to wish to redress the balance savagely before his pictures. The English particularly were great admirers, and they have since proved his harshest critics. At the time he was preferred to Richard Wilson, and as Wilson has risen to what is arguably over-esteem, the mechanism has operated in the reverse direction. Wilson was himself on familiar terms with Zuccarelli, whom he met in Venice in 1751, and is early recorded as receiving 'strong impressions of colour and effect' from Zuccarelli's landscapes. Probably it was really under Zuccarelli's influence that he took up landscape painting himself, and their friendly relationship is a fact.

In the days before Wilson was a great English genius – that is, when he was alive – he was by no means too grand to think highly of Zuccarelli and he probably also knew incidentally Marco Ricci's landscapes in Consul Smith's collection. Zuccarelli is, Wilson writes home from Venice in 1751, 'a famous painter of this place'. Perhaps Smith, who was kind to the obscure Wilson, introduced the two painters. Smith was to prove a major patron of Zuccarelli's, and by 1753 he was recorded (in Guarienti's edition of Orlandi's *Abecedario*) to own many paintings of his in his houses in Venice and on the mainland. Most if not all of those pictures were acquired by George III with Smith's collection, and the king was subsequently to commission work himself from Zuccarelli when the painter was in England. For Smith Zuccarelli painted landscapes lightly sprinkled with mythological figures, with a few biblical personages or just with some pretty and usually relaxing female peasants. In the mid-1740s Smith had him collaborate with Antonio Visentini (1688–1782), the architect and engraver, on a series of paintings of English Palladian buildings in fanciful, vaguely Italianate settings. Thus, Burlington House appears not too incongruously removed from its urban context to the tranquillity of a sweet, sunny Italy (Fig. 49). There is deliberate playfulness in the capricious effect, achieved at a time when caprice pictures were becoming a popular category in Venice. And it is notable that though Zuccarelli's is the inferior part in this and other paintings in the series, he has taken care in each case to provide airy and attractive landscapes, and also some lively figures.

49. Francesco Zuccarelli and Antonio Visentini, *Burlington House in an Imaginary Setting*. The Royal Collection © 1994 Her Majesty Queen Elizabeth II.

Within distinct limits he had or was required to display a certain amount of minor variation. His basic preference, however, was for painting a generalized and ever-pleasing concept of the Italian countryside, with happy peasants, serene skies and blue mountains. It is not entirely a travesty, and there is no reason for sounding-off sociologically about its inherent 'falseness'. Zuccarelli was creating pastoral pictures whose purpose was to please by suggestions of peace and calm, depicting the countryside as a delightful retreat from mundane existence. In some of his finest landscapes for Smith (Fig. 50) he admirably succeeded. His trouble was – though he may not have felt it as such – that he grew monotonous over the years of a long career. Having invented his formula, he stuck to it for the most part, and it becomes undeniably wearisome. He is a prime example of the painter who would rank higher had he painted less.

He toyed with religious and classical figures in the landscape and once with the witches' scene from *Macbeth*: they are none of them solemn nor playful; at best they are irrelevant, at worst just silly. His version of *Hercules Slaying Nessus* (Fig. 51), probably in Zuccarelli's own London sale of 1762, is a rather more overtly romantic landscape than usual and rather better organized. It is something of an essay in the vein of Claude, but the slightly absurd figure of the child Hercules, a cupid with bow and

50. Francesco Zuccarelli, *A Landscape with Peasant Women Resting by a Pond.*
The Royal Collection © 1994 Her Majesty Queen Elizabeth II.

arrow, is presumably a prettification of the classical story by Zuccarelli,
who has got himself into difficulties with an adult Deianira. Instead of
Hercules' bride, she appears to be his mother. In this instance the figures
may be ridiculous to the point of irritation, but the landscape, with its
vista of water and its castle bosomed among trees, has an air of verse if not
poetry; it hovers on the borders of enchantment, like the work of some
minor eighteenth-century poet, and shows that Zuccarelli does not deserve
his general modern neglect.

He had Italian patrons, among them Algarotti who sent off his work to
Dresden. And he was praised by Italians: Baretti, indeed, calling him
'mio Zuccarelli', associates him with Ariosto (with whom Diderot was to
compare Boucher). Yet, like so many Venetians, he felt the need to travel
and again, like them, he chose England. No other Italian painter had such
a success in eighteenth-century London as Zuccarelli. He spent on and off
some fifteen or so years in England, exhibited at the Free Society, the
Society of Artists, and at the Royal Academy of which he was a founder-

member. When, after Algarotti's death, the heirs wanted his bequest to Chatham to be taken to England Zuccarelli was chosen to execute the commission, and perhaps was ultimately received by Chatham, who entrusted him with a letter of thanks for Algarotti's brother. In England, Zuccarelli's pictures had considerable success; they remain in plenty of country houses, those 'beautiful landscapes', which 'must ever please', as Henry Angelo wrote of them.

Certainly Zuccarelli provided a charming enough impression of a country many of his patrons did not know. And a landscape by him was intended merely as decoration, set into a wall or above a fireplace, not as depiction of an actual view at a particular season. Just like 'wings' of scenery, trees flank the composition and a river or a road gently leads the eye towards the pale hills of the distance, past picturesque pines and peasants, into a soft blue infinity. No clouds darken the view; no rain or snow falls; the trees are never bare. Such reality would break the spell he is attempting to weave. Arcady had gone through many literary and artistic metamorphoses from its original bleak reality as a district of Greece; and Zuccarelli's

51. Francesco Zuccarelli, *Hercules Slaying Nessus*. Glasgow University, Hunterian Collection.

85

depictions of gentle countryside are perhaps the last evocation of it as a deliberately golden-age place. 'A kind of fairy land' Steele says that pastoral poetry should present; it is to the same realm that Zuccarelli attempts to transport us. On the walls of a modern gallery his spell can look very fabricated and flimsy – like Victorian pantomime scenery exposed to daylight; but in a room of the period even the sugary tonality of his pictures plays its decorative part.

Henry Angelo had known Zuccarelli in London and copied his work as a boy. He vividly if inaccurately evokes an incurably penniless painter who was always needing a loan, and loyally speaks up for those pictures which were already passing out of fashion. Carey in his *Thoughts* of 1808 had said 'No artist gave so many charms to the lovely serenity of a rural scene as Zuccarelli'. That was said to a world where Constable had already exhibited at the Royal Academy and where *Lyrical Ballads* had been published, and re-published. By the time the Redgraves were writing on British art and artists (in 1866) the tone of denigration was established: 'his rurality rather that of the stage or novel...mawkish and pretty insipidity', and then we read of Wilson's striking merits. It was not because Zuccarelli was feeble that he was condemned, but because he was artificial, and the sturdy morality of the Redgraves, which stresses the 'stage or novel' in puritan tones, would have condemned Tiepolo too if given a chance. Victorian distrust of the Continent had begun.

While Zuccarelli received praise and has gone on receiving attention, even if abusive attention, a much more lonely figure practised land-scape painting contemporaneously at Venice: the shadowy Giuseppe Zais (1709–84). Little is known of him and he has remained unknown, largely because his work continues to pass through the sale rooms as by Zuccarelli. Zais's handling is much more vigorous than that of the more famous man who no doubt influenced him; it has something of the 'dash' of Marco Ricci, itself inherited from Rosa via Magnasco. While not afraid of being pretty, Zais's pictures are much more firmly constructed and painted than Zuccarelli's. In some way or other, probably via engravings, he must have seen French *fêtes champêtres* compositions, and a picture like the *Country Scene* (Fig. 52) is partly a homage to Watteau (indeed, partly a copy).

Whereas Zuccarelli's people are usually intended to be indigenous to the scene, watering their cattle or posing archly with their flocks, Zais often shows people out for the day enjoying the country. The landscape is evoked solidly and with much less trickery than Zuccarelli used; it is more 'real', though that word is otiose. There is, combined with feeling for the landscape, a French elegance, for instance, in the figures fishing in the

52. Giuseppe Zais, *A Country Scene*. Venice, Accademia.

River Scene (Fig. 53): smartly dressed aristocrats having some fun, who are more tolerable than the rouged peasants with whom Zuccarelli would have sweetened the scene.

Zais remained totally unknown to the English apparently, and his name never appears in eighteenth- or nineteenth-century sale catalogues. Yet some of his pictures entered the country perhaps as by Zuccarelli (remaining so attributed), for they are not uncommon. But Zais is a mere postscript to a theme that was never fully worked out at Venice. One or two other landscapists existed, among whom Antonio Diziani (1737–97) may be mentioned for completeness' sake. The son of the history painter

Gaspare, he had some feeling for the countryside, seeing it far more soberly than Zuccarelli, and his seasonal landscapes (Fig. 54) possess their own quiet truth of observation. The echoes of Marco Ricci in such pictures are obvious; and like him Antonio Diziani seems at his most successful when he keeps the figures in his landscapes small, allowing natural scenery to dwarf humanity. Yet it is notable that his peasants – unlike those of Zuccarelli – often do more than merely recline. They are acquainted with work and may well be shown working. Whatever their tasks, they are seldom static, and their lively, if faintly caricatured, gesticulations add piquancy to the rustic scene. Diziani's bucolic pictures probably never attracted much attention, and it is interesting to find that the Adam brothers owned two of them in 1773, said to have been acquired 'during their long residence abroad'. But it was not in Venice that the landscape of the eighteenth century was created. An unsubstantiated anecdote records Rosalba, for instance, being highly scornful of Zuccarelli for practising as

53. Giuseppe Zais, *A River Scene*. London, National Gallery.

88

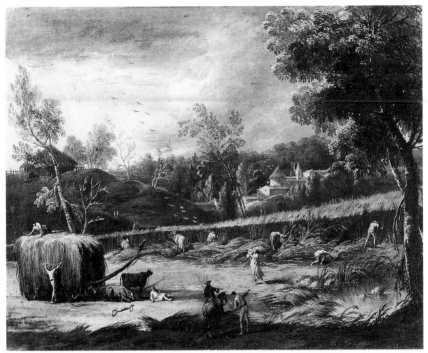

54. Antonio Diziani, *Summer*. Padua, Museo Bottacin e Museo Civico.

a landscape painter. The whole category of landscape was not really popular in Italy. Goethe, arriving in Rome late in the century, was amazed at the low estimate of it there. At Rome landscape had merged into the ruin-piece. At Venice landscape was merged with a much more prolific and lively category of painting: the view picture.

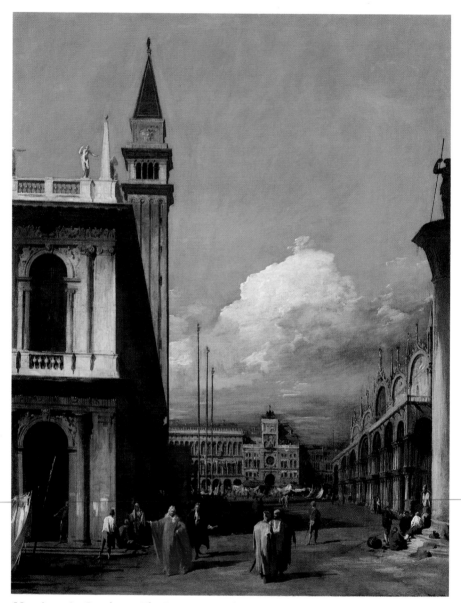

55. Antonio Canaletto, *The Piazzetta Looking North*. The Royal Collection © 1994 Her Majesty Queen Elizabeth II.

3

The View Painters

In Alessandro Longhi's *Compendio* of the lives of important contemporary Venetian painters, a book of portraits with brief eulogistic biographies, no view painters or landscape painters are mentioned. Both categories are pointedly excluded by the title adjective of 'historical' painters. The *Compendio* was published in 1762, when Canaletto was a famous figure not only in Venice but throughout most of Northern Europe. Alessandro Longhi must have been perfectly aware of Canaletto's existence but like many other academically minded people in Venice he chose to ignore it, as he chose to ignore the existence of Zuccarelli. And it was only in the following year, when Canaletto was aged sixty-six, that the Venetian Academy admitted him.

The view painters were in some ways yet more humble than the landscapists. Where Venetian interiors of the period may well show a Zuccarelli on the wall, they never show a view of the city itself. And the view painters had every cause to be grateful to the tourists, especially the British tourists, who filled Venice. It was tourist demand that called into existence the supply of picture-souvenirs that could be carried back to the North, shown to admiring untravelled friends, and which brought Southern light and warmth into that cold world. There might even exist a sort of therapeutic value in delineations of Venice, and when the valetudinarian Mr Woodhouse in *Emma* needs to be entertained, Jane Austen has Mr Knightley produce engravings of 'some views of St Mark's place, Venice', which help to while away the morning.

The eighteenth century had perfected the idea of the 'Grand Tour'. It was particularly a British idea, and equally specific was its devotion to Italy. 'A man who has not been in Italy', said Johnson (who had not), 'is always conscious of an inferiority.' And the visitors in Venice, eager to be portrayed by Rosalba, were probably eager to bring back further proof of their superiority with a painted view of Venice. Venetians did not want, or

need, view pictures. And so the view painters received few commissions from their fellow-citizens; their fellow-painters despised them, and most of them even now remain in oblivion – only the famous names of Canaletto and Guardi being generally known. They had little place in the discussion of art in their own period and none in the period that followed. Canaletto was lucky to get a mention at all in the mid-nineteenth century – even an unfavourable one by Ruskin. Guardi was barely known and seldom mentioned.

But they are among the most important, as they are among the most typical aspects of art in eighteenth-century Venice. Canaletto and Guardi between them have created a concept of Venice which influences those who have not seen it – and those who have. There has never been a city so extensively the subject of such sustained representation; but perhaps that can quickly be explained by adding that no other city has deserved to be. The view painters, besides, are a marvellous tribute to the eighteenth century's rational *use* of art; their pictures have a definite purpose, a purpose the British did not find in the contemporary history painters whom they therefore ignored. Nothing had yet been said about 'tame delineation of a given spot', and the record of 'a given spot' had all the impartial value of an eye-witness record. Enthusiasm was required less than accuracy.

Nor did Venice need any enhancing of the picturesque. It presented, as it still presents, the traveller with an eternal surprise. This was the lure of Italy, in general, and though the sober qualities of the eighteenth-century mind are so often emphasized the age actually loved a good surprise, appreciated fantasy and enjoyed incongruity; it was civilized enough to be the first century that could truly savour and indulge these emotions. 'One finds something more particular in the face of the country [Italy], and more astonishing in the works of nature', Addison remarked, 'than can be met with in any other part of Europe.'

That ability to astonish was crystallized by Venice, beginning with the enchanting infraction of nature's law whereby it rises from the water; it was a city of the imagination to console those who without it would have had no illusions; it was a *pays lointain*, which fortunately turned out not to be too far away. Not only tourists felt its permanent attraction. A native like Goldoni, by no means uncritical of his city and its citizens, looked back to it, the city he would never see again, as an old man in Paris: 'Venise est une ville si extraordinaire qu'il n'est pas possible de s'en former une juste idée sans l'avoir vue. ... Chaque fois que je l'ai revue, après de longues absences c'étoit une nouvelle surprise pour moi.'

92

As well as a surprise, Venice offered entertainment with its theatres, cafés, gambling houses, brothels. Its prostitutes were famous, and the general air of licence and amorality excited even the sluggish hearts of the English. It was the civilized world's concept of a city, although it had not the glamour of antiquity that took travellers on to Rome. What it lacked in classical ruins it made up in carnival, the delightful air of being forever *en fête* deceiving many visitors into thinking it an ideal city.

The view painters catered for the eyes alone; they represented, and they did not need to comment. What Goya, for example, would have made of the corrupt but fascinating spectacle is an intriguing question; but the Venetian Republic would have dealt with Goya long before his satire grew savage. From the fact of the city's declining power the view painters turned tactfully away; more, they concealed that decline under the splendour their pictures derived from the great pageants so often represented. The pictures became then both views and pageant scenes recalling those of Carpaccio. The annual feasts which the Doge attended at various churches became popular subjects, and each of these was part of Venetian history, a traditional spectacle which age had consecrated and time had made meaningless. Like a simulacrum, the Doge revolved through the preordained circle of pompous, empty activity. Painted by Canaletto, such moments as the *Wedding of the Sea*, most splendid of all Venetian festivals, must have made his countrymen proud again. The crowd agog on the Piazzetta that he shows us, a seething mass through which the ducal procession had to push its way to reach the golden, many-oared barge of the *bucintoro*, forgot politics and poverty in the excitement of the day. And in the *bucintoro* the Doge was enshrined as the gilded symbol of the Most Serene Republic – like the Host in a monstrance was Goethe's apt comparison.

With Canaletto people retain their individuality almost to the last, though in his late style they tend often to be just dashes and dots. With Guardi the ordinary man sinks his significance until he becomes a mere blob on the horizon, an articulated puppet to enliven the scene:

> His knowledge measured to his state and place;
> His time a moment, and a point his space.
> (Pope: *Essay on Man*)

Certainly figures seem part of the gaiety and conviction of view pictures; and part of the attraction for the English was to gaze at these variegated Venetian throngs. Dr Moore, one of the more sober travellers, cannot help evoking the crowd '. . . in St Mark's Place, such a mixed multitude of Jews, Turks, and Christians; lawyers, knaves, and pickpockets; mountebanks,

56. Antonio Canaletto, detail from *Piazza S. Marco with the Basilica*. The Royal Collection © 1994 Her Majesty Queen Elizabeth II.

old women, and physicians...'. However arbitrarily Canaletto grew to treat this assortment, he did not ever omit them, and in his early paintings he hit off, with extraordinary sensitivity, life in the Piazza (Fig. 56), the Jews and the Turks, the raffishness of the loungers and beggars, the pride of a passing senator (Fig. 57); and, as the eighteenth century enjoyed its life as mirrored on the stage in topical comedy, it enjoyed these reminders of man amid the topography of Venice.

The view picture was a microcosm. It was basically a product of observation, almost a scientific one since it was often observed through the *camera ottica*, a sort of camera obscura in which mirrors reflected the scene outside. In his dark box, as he peered towards it, the view painter saw his scene compose – rather too steeply in perspective, admittedly, but that could be corrected. Canaletto occasionally, and Guardi more often, did not bother to correct the distortion and it can be seen in some

57. Canaletto, detail from Fig. 55.

telescoped line of buildings, or in a sprawling distant feature which was beyond the *camera ottica's* range of true focus. But in the *camera ottica* the world was mirrored while the viewer watched, himself withdrawn. Life became a peep-show, and the painter himself was no more part of what he saw than somebody looking through a keyhole is part of what he sees.

The Venetians themselves had not failed earlier to peep at their city once or twice. Early depictions, however, had been mere background in a few rare pictures, apart from the series of religious festivals painted by Gentile Bellini and Carpaccio; and even in that unique example the city itself is subordinated to the religious-civic scene. In fact, Venice was still the active centre of an empire, too absorbed to consider its appearance a subject for painting and not yet a show-place for the tourist. Early in the sixteenth century a few painters do occasionally brush a vague, summary sketch of the Campanile and the Piazzetta, seen from the lagoon, into the far background of a picture: mere reference points to Venice, and by no means views, as in Giorgione's *Madonna* (at Oxford) or Sebastiano del Piombo's *Death of Adonis* (at Florence).

These isolated examples – symbols of Venice as they are – are very different from the careful townscapes of Northern painters. Early Netherlandish pictures are often as topical and as urban as Villon's poems. While Italian art again and again lifts its subjects outside time, Northern artists more usually emphasize the moment of actuality, a room cluttered with everyday objects, a window beyond giving upon an almost unnaturally clear landscape or townscape – as if embalmed in a glass paperweight. This interest in immediacy was to be the impetus behind Venetian view painting. The first painters of the city for its own sake were in fact Northern artists, with their uncomplicated ability for painting what their eye fell upon.

The activity begins in the seventeenth century, at a time when native Venetian painting falters and almost peters out. Just as native talent was replaced among figure painters by foreigners like Liss and Loth, so it was foreigners with equally barbarous names who painted the first tame views. We hear of Corrado Filgher, of Monsù Cussion, Monsù Giron, and so on. Among the less obscure are Joseph Heintz, from Germany, and Richter, from Sweden. Heintz seems to have reached Venice by 1625; a contemporary described him in 1660 as '*l più capricioso*, and the adjective will serve for the lively, doll-like figures who cram his pictures. Already it was Venetian festivals which fascinated such painters, and a scene like that of the Patriarch's procession to S. Pietro di Castello (then the Cathedral of Venice) gives a good idea of Heintz's talent (Fig. 58). Richter, who did not

die until 1745 and is then recorded as eighty years old, is altogether duller; his entry in the register of deaths does not even mention him as a painter, and perhaps he had ceased well before then to struggle on in his unsuitable career. But at the time some people – even painters – could refer to Richter's *genio* for view pictures; Antonio Balestra went so far in 1717 when obtaining small pictures from him.

The first spurts of view-painting activity were probably inspired by some sort of demand, Heintz's perhaps by the demand of those involved in the ceremonies he painted. Such patronage was later to utilize both Carlevaris and Canaletto. A superior foreign painter who visited Venice, probably from Rome where he was already settled, was Gaspar van Wittel (1653– 1736), whose name was euphonized italianately into Vanvitelli. We know that he was in Venice certainly by 1697, for a view of the city (now in the Prado at Madrid) is dated that year. His pictures of Venice are a wonderful tribute to Northern sobriety and commonsense; they make nothing of the glamour of the city in their cool competence, but they seem to have left some mark upon the first native painter of views, Luca Carlevaris, a Venetian by adoption. Carlevaris (1663–1730) was born at Udine, the son of an architect of sorts, and he seems to have inherited a talent for mathematics. When late in life he came to have his portrait painted (by the well-known portraitist Bartolomeo Nazari) it was with the

58. Joseph Heintz, *The Procession of the Patriarch*. Venice, Museo Correr.

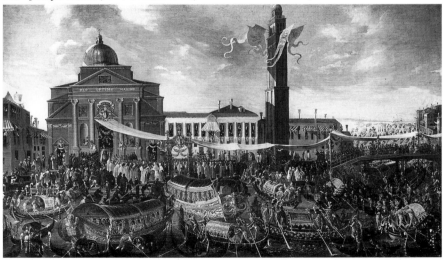

dignified item of dividers – not paintbrush – in his hand. Nevertheless, it was probably as painter that he was most widely known, a gentleman painter: *Pictor Venetus et Mathematicae cultor egregius*, was inscribed under the engraving executed after his portrait.

In England Carlevaris was probably hardly known during his lifetime. A good deal later in the century his name begins to appear in London sale catalogues. One of the earliest mentions is at the sale of part of a famous Venetian collection of the time, that of Marshal Schulenburg, sold in London in 1775. Schulenburg, last of the condottieri, defender of the Venetian territory of Corfù against the Turks in 1716, settled in Venice and commissioned many pictures from contemporary painters, including Gian Antonio Guardi; no doubt his four pictures by Carlevaris were obtained directly from the painter. An earlier reference occurs in a description published in 1761 of Foot's Cray Place, home of the collector Bouchier Cleeve; there are mentioned views by 'Carlevarin' (sic). We know that the English Resident at Venice, John Strange, also sent home pictures by Carlevaris. In Strange's own sale of 1789 there was an essay by him on Italian art, and notes to the pictures. His reference to Carlevaris is probably the first explanatory one in English and it explains also the infrequency of Carlevaris' name in the sale catalogues of the period. 'The first of any note', Strange says, 'who painted views of Venice; though his pictures are scarce.'

Carlevaris' view pictures, undramatic as they are, are certainly the first we have about which we can make any definite statements; that alone would endear them to art historians. He was not exclusively a view painter, and his career probably opened with caprice scenes of harbours, ruin-pieces and so on – that type of work that goes back to Salvator Rosa and which has its roots in seventeenth-century Rome. His view paintings are something more original, for while he may have been influenced in a general way by Vanvitelli the results are much more interesting than anything Vanvitelli produced. Carlevaris gives us the first really conscious expression of painting Venice to emphasize the importance and the grandeur of Venice. Not the first to take Venetian festivals as his subject, he created scenes that are often of Venice internationally engaged: the reception of a foreign ambassador or a regatta in honour of a foreign king. Such grand occasions were recorded in a picture, itself then engraved and so disseminated through and beyond Venice. When Carlevaris produced a book of etched views of the city (*Le Fabriche...*, issued in 1703), he expressly announced on the title-page that the etchings were to make known abroad the splendours of the Venetian republic. Visiting grandees

often carried home the picture Carlevaris had painted of the scene in which they took part; while it served them as memento, it served also as advertisement for Venice.

With the turn of the century, at the very time Carlevaris published his *Fabriche*, Venice needed advertisement of her splendours. The past was needed to bolster up the present. The war of the Spanish succession which broke out in 1700 threatened the neutrality of Venice; she was wooed by both France and Spain, until both countries tired of her evasions and ignored her neutrality. That act, by which the Republic suffered French capture of Desenzano and Austrian occupation of the Veneto, was perhaps the first public declaration that Venice had ceased to be a European power. It had once been called the new Noah's ark where liberty was preserved amid a Barbarian deluge. Early in the eighteenth century Italy stopped looking to Venice for a lead; its hope was in Savoy, which did not fail the country when the Risorgimento came.

In a twilight period of humiliations, however politely disguised they might be, Carlevaris was proclaiming Venetian pomp in its ceremonies and pride in its buildings. He himself was patronized by the aristocracy in a way that later view painters were not to enjoy; in their palaces he was probably tutor of mathematics and perspective; he was friendly with the rich and distinguished Zenobio family, one of whose members stood godfather to his son. It seems certain that foreign patrons on their visit to Venice knew Carlevaris was the painter to commemorate the scene of their arrival. When the Earl of Manchester came on his anti-French embassy in 1707, Carlevaris painted the scene (Fig. 59), and the Earl took it back with him to Kimbolton. Nothing could look more splendid. The Ambassador has arrived in an elaborate gondola decorated suitably with St George and the dragon, and his presence has attracted crowds on the balcony of the Doge's palace and on the quay; only an excreting dog, positively gazing at the Ambassador, mars the dignity of the occasion. In reality the embassy was a failure, Venice evasive, and the Earl successful only in bringing back to England this picture and some others, as well as Pellegrini and Marco Ricci. The Earl's secretary, Mr Cole, later published a description of the embassy for which, as for all such occasions, the Venetian protocol was lengthy and elaborate. Significance was muffled in display; policy became an excuse for pageantry. 'The whole Town is in Mask for two days,' Mr Cole writes of the Venetian custom, 'and there is Musick all night in the Ambassador's House.'

When the Imperial ambassador, Count Colloredo, came on his visit to Venice in 1727 Carlevaris was again available; again the picture returned

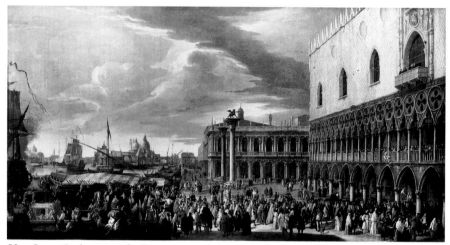

59. Luca Carlevaris, *The Procession of the Earl of Manchester*. Birmingham, City Art Gallery.

with the ambassador and is now at Dresden. Carlevaris carefully records the decoration of the ambassadorial gondola, and this in turn had been the work of a decorative painter, a certain Paolo Ovio, who had designed for it a complicated allegory of Peace between Spain and Power. Carlevaris' picture was engraved and itself became almost a piece of Venetian protocol: in later similar scenes Canaletto, for example, always uses the composition Carlevaris had devised. And the same is true of Carlevaris' composition for regatta pictures. He, it seems, fixed the composition always afterwards observed when he painted the regatta given in 1709 by Venice in honour of King Frederick IV of Denmark (who took home a version of the view). That design too was engraved and thus easily available for copying.

An amusing reference to his activity as painter of ambassadorial arrivals is made by the keen nineteenth-century searcher in Venetian archives, Rawdon Brown, who was for long resident in Venice. Brown has noted on his copy of the record of Alvise Pisani's embassy to England in 1707 that the Pisani family then still possessed a painting of Pisani landing at the Tower of London, and he thought this might be by Carlevaris. He has been proved correct, for the painting (Fig. 60) has come to light. Carlevaris was of course never in London; he had to do his best about the Tower, but he certainly managed to suggest the pageantry of the scene. And it is interesting that Pisani's embassy to Queen Anne was painted as a record

for the ambassador himself, a future Doge – another example of Venetian pride in recording topical events. Rawdon Brown also records that the Pisani family had two other pictures of their ancestors' embassies, both by Carlevaris.

These scenes, though a speciality of the painter's, were only part of his view-painting activity. The ordinary busy life of the Piazza S. Marco and the Piazzetta – everyday Venice – he has recorded in pictures which have rather more vivacity than his pageant scenes. He was actually capable of very great freedom, in occasional sketches, like that at Birmingham (Fig. 61), which probably were studies for himself for use in paintings rather than paintings in their own right. Just as Constable's sketches may seem to us preferable to his finished pictures, so the lively observation of Carlevaris in sketches such as the Birmingham one are preferable to his rather cool completed views. What certainly was a private sketch-book of studies of people for insertion in his pictures is now in the Victoria and Albert Museum; here a lively, economical line vividly evokes traders and gossips (Fig. 62), Turks and seamen, anticipating in rapid handling the figures of Guardi.

It is odd that with such talent Carlevaris did not achieve better results in his etchings; but probably the Victoria and Albert sketch-book is considerably later than the etched *Fabriche* of 1703. The architecture in these – and they are chiefly of buildings – is very feebly conveyed, while there is a

60. Luca Carlevaris, *Alvise Pisani Arriving at the Tower of London*. Munich, Staatsgalerie Schloss Schleissheim.

61 (above). Luca
Carlevaris, *Boats and
Figures*. Birmingham,
City Art Gallery.

62. Luca
Carlevaris,
Figures. Drawing.
London, Victoria and
Albert Museum.

monotony about the views that they certainly do not possess in reality. But at the same time the etchings are much more dramatic in their tonality than the pale tones of most of Carlevaris' paintings. In place of the milky skies of those, these skies are sometimes the scene of baroque dramas of clashing shadow and light darkly reflected in the water of the canals. Carlevaris shows in them how much in fact he still belongs to the tenebrist tradition of seventeenth-century Venetian art, a tradition that in figure painting is chiefly continued into the eighteenth century by Piazzetta. As Piazzetta may be contrasted with Tiepolo, so the thundery skies of Carlevaris' etchings are replaced by the placid skies of Canaletto's etchings and the pastel skies of Guardi's paintings. In an etching like that of the *Rio de' Mendicanti* (Fig. 63), where floating filaments of sunset cloud fleck the dark sky, Carlevaris catches transitory effects of cloud that recall Tintoretto, and the otherwise static scene is given a momentary vivacity. It is probably because the book of etchings was intended to be a useful work of topography rather than art that he did not attempt such exciting effects more often – which is a pity.

Although Carlevaris was the prototype for a number of painters who followed, he was rather an unacknowledged prototype. Such fame as he may have possessed was to be totally eclipsed by the fame of Canaletto

63. Luca Carlevaris, *Rio de' Mendicanti*. Etching. London, British Museum.

and, despite some foreign patronage, he was really a private Venetian phenomenon. Carlevaris suffered in fame not only through the rise during his lifetime of Canaletto but through the comparative rarity of his paintings. Probably he did not live by his work as painter, though it does not seem clear how he acquired the tolerable sums that he was able to bequeath to his son and daughters. He seems to have written no mathematical works, despite that claim under his engraved portrait of being *Mathematicae cultor egregius*, and our sole piece of evidence to justify this intellectual claim is the fact that he is shown there holding a pair of dividers. It is probably not very wrong to see Carlevaris as partly the amateur, talented but by no means exclusively a painter, still less exclusively a view painter.

The gossipy abbé Gian Antonio Moschini, who wrote about Venetian *settecento* literary life early in the nineteenth century, told a story that Carlevaris' death in 1730 was occasioned by apoplexy at Canaletto's success. Canaletto had been successfully practising view painting for some ten years when Carlevaris died, so the apoplexy was not sudden; more interestingly, Moschini thought, or said he thought, that Canaletto was Carlevaris' pupil, and there seems a vague tradition – but no evidence – of this. For Moschini of course it made a better story, and art history is full of legends of artists' fury at their pupils' success, though actual apoplectic death is rare. If Carlevaris did teach Canaletto, the evolution of view painting is neatly linked, for Guardi was hailed early in his view painting career as a 'good scholar' of Canaletto. And these three figures span by their activity ninety-three years of the eighteenth century.

From the first Giovanni Antonio Canaletto (1697–1768) was a professional, one of a family of professionals. His approach to view painting must certainly have been influenced by his early training in stage design, upon which he was collaborating with his father Bernardo and his uncle (or elder brother) Cristoforo by the time he was nineteen. Although no actual designs have survived, we know the names of certain plays for which Bernardo and his sons are recorded as having executed the scenery; and the type of scenery can be gauged well enough. The chief exponents of theatrical *décor* at the time were the Bibiena family, whose complicated architectural perspectives provided the setting for every type of play. One of their favourite devices was the *scena all'angolo*, whereby the stage setting was constructed at an angle, which gave the spectator a more lively and interesting vista down the pillars and porticoes and balustrades that represented the inevitable location of most plays: a palace interior. The same methods could in any case equally serve to show an outdoor scene,

usually a palace garden, where trees and shrubs and statues were arranged in an ingenious perspective. In both cases the audience was treated to a grand panorama before which the actors were dwarfed, and in fact the actors were essential only for the impression of grandeur – just as somebody standing outside St Peter's is essential to convey the height of its façade.

This sense of 'theatre' Canaletto was to bring to view painting. However, he was not yet a view painter. The staging of plays at the time, and not only in Venice, was an extraordinary business of collaboration rather resembling the mounting of a ballet to-day. The demands of the playwright, of the actors, of the designer, of the manager and usually – since so many plays were accompanied by music – of the composer, had each to be adjusted, and the project proceeded in a very *ad hoc* manner during the first rehearsals. The resultant quarrels had various results: actors withdrew to Dresden, playwrights sulked, leading ladies had hysterics. As for Canaletto, he quarrelled with a playwright and consequently, in words reported by Zanetti and probably his own, 'he solemnly excommunicated the theatre.' That was in 1719 and it seems likely that he left Venice at this point for a visit to Rome.

Whether or not he paid attention to the Roman painters of the period, he certainly must have made a number of drawings of Roman scenes, chiefly ruins in the Forum, which were a stock subject for any visiting artist. The next year he was back in Venice and is listed for the first time in the artists' guild records. Seven years later he had achieved such a position that a contemporary records that he has 'more work than he can do'. Thence onwards for forty years Canaletto remained busily at work.

Quite early he was associated with Joseph Smith and also with the ex-bankrupt McSwiny. Canaletto was included with other artists working on those extraordinary 'Tombs', two of which were by the Ricci. Canaletto's share in them seems to have been restricted to some figures on some of the Tombs themselves, and his collaboration would hardly be supposed at all were it not recorded in engravings after the compositions. Much more importantly, he produced for Smith over a considerable period of years a wide range of views and caprices, most of them acquired by George III and now in the Royal Collection at Windsor.

'His excellence lyes', McSwiny wrote acutely in a letter to England, 'in painting things which fall immediately under his eye.' This remains probably the most succinct summing up of Canaletto's genius. In those early days it was by no means the Venice of Piazza S. Marco that always fell under Canaletto's eye. He did not yet work for the tourist market, but

64. Antonio Canaletto, *View of the Carità*. Private collection.

rather for private patrons – like Stefano Conti of Lucca, who commissioned two views in 1725 and a further pair in 1726. These show the extraordinary vivid freshness of Canaletto's eye when he was still young; they are full of an exciting if unsteady tonality as in the *View of the Carità* (Fig. 64), which recalls the thundery effects of Carlevaris' etchings and is far more atmospheric than any of Carlevaris' paintings. A little later, probably, Canaletto went further. He was now total master of his powers of observation and he produced '*The Stone Mason's Yard*' (Fig. 65), unique in his work for its genre qualities, and certainly among his masterpieces. Again the view includes the church of S. Maria della Carità, but seen across the untidy area of the 'Stone Mason's Yard'. The view is not of a famous sight; it is rather an intimate behind-scenes view of a Venice seldom seen by the tourist. There is an almost Flemish sense of realism in, for example, the child who has tumbled over and is urinating while its mother gesticulates dramatically. The men hammering the blocks of stone, especially the kneeling man in the foreground (Fig. 66), and the broken column with a pair of calipers resting against it, are painted with a serious and almost touching attention anticipating Chardin. And the Venice rising about this

106

65. Antonio Canaletto, 'The Stone Mason's Yard'. London, National Gallery.

'yard' – actually the Campo S. Vidal, the church adjoining which was then being rebuilt – is the weathered shabby city of fact, with peeling walls (Fig. 67) whose colouring gives the picture a sense of being rain-washed, as does the sky from which the smoky clouds are gradually clearing.

With that painting finished, Canaletto's potentiality to be a great artist was realised. No better painter of townscapes has ever existed, and even when his style grew tamer, neater and – it must be admitted – more mechanical, he did not lose his passion for the facts of Venice: from a flowerpot on a barred window-sill to a well-head, including the stance of a gondolier, and the set of a mask and cape, as well as the sequin-like flicker of light dotting a steep, tiled roof or a statue gesticulating whitely against a crisp blue sky. And his instincts made him also – as tends to be under-stressed – a keen observer of Venetian people of all classes. His is indeed the work of someone who was 'origine civis venetus', and could never

66 and 67 (following pages). Canaletto, details from Fig. 65.

68 (above). Antonio
Canaletto, *Campo S.
Angelo*. New York, private
collection.

69. Canaletto, detail from
Fig. 68.

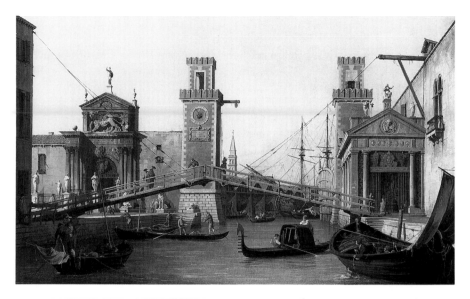

70 (above). Antonio Canaletto, *Venice: the Arsenal: the Water Entrance*. Bedfordshire, Woburn Abbey. By kind permission of the Marquess of Tavistock and the Trustees of the Bedford Estates.

71. Antonio Canaletto, *The Great Gate of the Arsenal*. Drawing. Venice, Accademia.

forget that origin. Yet although detail proliferates in his pictures, he knew how to subordinate it to overall grasp of the scene. At their best, his pictures are built out of glowing light and strong shade (Fig. 68), which in turn model the buildings depicted, creating an uncanny illusion of looking into not just the view shown but somehow beyond: into the city, which is felt extending far outside the composition, around the corner of the canal or the angle of a church (Fig. 69), behind the last façade and the jumble of chimneypots and campanili on the horizon. Not only bricks and mortar but life itself is grasped – and felt to be going on with a serene assurance (Fig. 70).

Canaletto certainly drew on the spot (Fig. 71), but the sureness of his eye was matched by a sureness of mind. He believed implicitly in the truth of his visual sensations, untroubled obviously by doubts or waverings. The actual visible world *was* reality for him; and any suggestions of its being otherwise would probably have been refuted by him as robustly as Dr Johnson refuted Bishop Berkeley. Hence the conviction of Canaletto's art, which lifts it above any mere reproduction of picturesque sites. What sometimes seems his prosaicism is, in fact, his strength. That his views are seldom accurate topographically has been absorbingly and exhaustively demonstrated, and yet the demonstration remains oddly beside the point. It emphasises only what can be sensed in most of Canaletto's pictures, that he was complete master of his material subject-matter – constantly re-arranging it and ingeniously modifying it for his own pictorial ends. But the resulting paintings were intended to look overwhelmingly factual and 'true'. They do, and that they do so is the ultimate indication of their creator's confidence in his own artistry.

The years of his first fame are probably the time when he began to assemble some pupils and co-workers in his studio; for vast as was his own output, he can hardly be responsible for all the Canalettesque views we have, even after imitations and frank pastiches have been discarded. No doubt the studio helpers were useful in preparing pictures even when they did not really paint them, and examination of Canalettos of the late thirties and early forties seems to indicate attempts at mass production. Many of the scenes would already be recorded by an original sketch made on the spot by Canaletto and often worked up more elaborately in further drawing done by him in the studio. From this second drawing the paintings could be prepared. The practice seems to have been to paint in the sky, and even sometimes the clouds, across the whole upper area of the picture; presumably the buildings were then drawn in over this and certainly their outlines were incised into the sky paint so as to provide

guidance for the actual painting of them. Traces of incision are visible along roofs and cornices, semi-circular lines marking arches and domes, and though these are also present in paintings entirely by Canaletto, equally they are preparations that assistants could easily and usefully make for the final brush of the master. In fact, many Canalettos show fluctuations in quality within the one picture: now the figures are more clumsy than his, now authentic Canaletto figures enliven a dully-painted architectural scene.

While Canaletto and his assistants worked busily away, the topography of Venice was changing; a campanile fell, a further storey was added to a building, but the master-drawing in the studio remained the model and many paintings issued were in minor ways topographically out of date. At times Canaletto was scrupulously exact. He would paint in perfect detail the reigning Doge's coat-of-arms on the *bucintoro*, in an area smaller than a baby's finger-nail; at other times he painted, for instance, the interior of S. Marco and showed it as it had been thirty years before. Partly the immense detail of his pictures is deceptive, intentionally so, in giving us the impression of being eye-witnesses, and Canaletto invests with up-to-date vividness some ducal procession or some Venetian feast that he himself may not have witnessed for years.

In the years up to his English visit in 1746, while he was chiefly working for English tourists, he kept also that Venetian by adoption, Joseph Smith, as his patron. Quite what were the business relations of the two men we still do not know. The eighteenth-century English verdict on Smith was that he first bought up Canaletto and then sold his pictures to tourists. No doubt Smith somehow benefited financially from his patronage of Canaletto, but at the same time he clearly liked and collected Canaletto's pictures for himself. In 1735 was issued a volume of Canaletto views in Smith's possession engraved by Antonio Visentini, himself a painter of architectural scenes; in later years expanded editions of this followed, showing the range of views which Smith possessed. Smith collected the work of other painters, chiefly Venetian contemporaries, drawings by them and even caricatures, but Canaletto remained the painter he most extensively patronized. For Smith Canaletto produced a few *capricci*, views of Venice where famous landmarks are piquantly jumbled together to make a capricious non-realistic scene: so the bronze horses of S. Marco are found on pedestals along the Piazzetta, or the Redentore is transported to an island in the lagoon. These were paintings to be appreciated more by the resident or native than by the tourist: variations as they were upon themes that were familiar only to the former.

The intention behind them was sophisticated, just as was that behind the Palladian *capricci* of Zuccarelli and Visentini. Canaletto was really too attached to the beauty of facts to catch the potential enchantment of the idea – that was left for Guardi – and his imagination creaked only too audibly in constructing such things. But the work was a little more dignified than pure view painting, and on such work Algarotti was to employ him at a later date. Algarotti, with his ever-ebullient ideas, did not fail to have an idea about the *capriccio*; in his view it made the best of the two worlds of reality and the ideal: it united 'nature and art'. It was this synthesis that dignified the *capriccio*, making it a part of the eighteenth century's campaign to reconcile what it considered two opposites. Nature, in fact, needed to be sieved through the fine mesh of art; the connoisseur who was not a tourist could only tolerate a Venetian view that was more than a view. In Algarotti's case, he himself chose the buildings to be juxtaposed and so became more than a patron who merely pays: the pictures he commissioned were painted by Canaletto but the ideas were Algarotti's.

The instance was rare, if not unique, in Canaletto's career. Before that he had sought a respite from Venetian views, while continuing to enjoy English patronage, by a visit to England. Armed no doubt with letters of introduction from Smith, he arrived in 1746. By general account the visit was a disappointment to the painter and to his potential patrons; the quality of his work seemed to have deteriorated and soon the rumour arose that he was not 'the veritable Canaletti of Venice' at all but an impostor. And in fact it was a step of doubtful logic for Canaletto to come to England. The English had enjoyed his paintings of, for them, an exotic scene; Canaletto's style by itself hardly lent interest to London views, despite his obvious fascination with the Thames – poor Northern substitute for the Grand Canal. There were possible jobs in painting country houses, a task other foreign artists, such as Wyck, had earlier been set by aristocratic patrons. Had he been a little more generally talented perhaps he would have been set to paint the aristocracy's horses and their dogs. As it was, he visited and recorded Warwick Castle, King's College, Cambridge, Eton and Windsor, in neat, rather inhibited views, often displaying his incomprehension of English architectural styles; it was only when he was safely back in Venice some ten years later, that he could use pieces of English Gothic in *capricci*.

Originally he was the painter of a city, Venice, and in England it was London that best brought out his gifts, not perhaps on every occasion but frequently enough to show his true painterly self. At the beginning of the decade of 1750 he was back in London after a brief interval in Venice, and

he seems to have come back with renewed feelings for a no longer unfamiliar city. That he could always respond to views that prominently incorporated the Thames is not surprising. Less expected was his ability to survey the broadest possible panorama of a London street scene, with the river subordinated to the point where its presence is not at once obvious, as in the magnificent, large-scale *View of Whitehall* (Fig. 72), painted about 1751–2. This is an unusual composition for him, organized more loosely, in a way that is akin to some of Bellotto's views, but given coherence and visual excitement by the strong sense of recession, with that central feature of a long, angular wall twisting deep into the far distance. The sweepingly bold 'bird's-eye' vision is typically combined with artistic bird of prey-like pouncing on myriad, minute details: cobblestones, a coach, scaffolding and the human element of strollers out on a day of bright weather. A vast expanse of sky arches over this urban view, creating an all-embracing atmospheric envelope in which each detail is held.

Topography enlivened and given significance by humanity, by society, is here his subject – as perhaps it always is in his finest paintings. He gives pictorial conviction to such trenchant eulogies as Johnson (in London from 1737) would utter: 'The happiness of London is not to be conceived but by those who have seen it.' Perhaps it is fanciful to think of the London Canaletto painted as more that of Queen Anne than of George II, but his counterpoint of careful light and shade over the bricks of a façade, or the tight pattern of the glazing bars of a window, seems to possess all the

72. Antonio Canaletto, *View of Whiteball*. In the collection of the Duke of Buccleuch, KT, Bowhill, Selkirk.

115

73. Antonio Canaletto, *Northumberland House at Charing Cross*. Alnwick Castle, Collection of the Duke of Northumberland.

precision of a couplet by Pope. Yet it is Johnson who once again comes vividly to mind when one looks at his *Northumberland House at Charing Cross* (Fig. 73). Here indeed is a sense of 'the full tide of human existence', in a view which is remarkable less for the ducal residence than for its half-untidy, essentially urban animation. There are shops, an inn (the Golden Cross, 'mouldy' but still functioning in David Copperfield's time), beggars, vendors and small knots of incident, commonplace but diurnal and thoroughly 'human', artfully spread across the arena of the wide area outside Northumberland House.

With a Dutch zeal for the pleasures of minutiae does Canaletto build in paint houses brick by brick, construct a line of iron railings and precisely delineate, against a clear though not cloudless, faintly lilac sky, a glittering weathercock or the sharp point of a steeple. All this is animated by the bustle of contemporary activity: 'Streets, chairs and coxcombs rush upon my sight.' Canaletto is like the diarists of the period, a gossip too in his way, happy in recording day-to-day events, quite unconscious of any larger sphere. His view of nature is always an urban view. Just as

Wilde's Gwendolen Fairfax was glad to say she had never seen a spade, so Canaletto would have been glad to say he had never seen a tree; nor, from the sticks of broccoli he puts up as trees, would one suppose he ever had. Once or twice he strays further into nature in the environs of London and paints a cow. There his studies of natural phenomena stop, and it is easy to see why Ruskin got so angry with him. Against Turner Canaletto can be made to seem a mechanical purveyor of mechanically produced views: to the nineteenth century Pope appeared mechanical against Shelley. Turner's over-white dream of Venice is far more of a vision than reality as Canaletto depicted it. Yet Turner himself respected Canaletto, and paid him a ludicrously touching homage in that picture *Canaletto painting Venice*, where Canaletto stands in a topographically very inaccurate city working at a gold-framed painting.

Canaletto was about fifty-eight when he finally left London for Venice, after a period of some ten years, on and off, in England. Back home his activity continued ceaselessly. He still was the most celebrated view painter in Italy, still was the 'famous Canaletti' whose pictures visitors bought and brought back. It was not until 1763, however, that prejudice against his type of art softened enough for him to be admitted to the Venetian Academy. And at Rome during the eighteenth century, the Director of the French Academy refused rooms to landscape painters, reserving them for students of that much higher branch of art: history painting.

It was, therefore, tactful of Canaletto, if not obligatory, to present as his *morceau de réception* not a view but an architectural caprice (Fig. 74), still in the Accademia at Venice. Here only some of the motifs are Venetian, and Canaletto turns back to the theatrical architectural settings of his youth. There is no obvious effort at fantasy or picturesqueness; the intention is rather to invent an impressive vista in the grand manner, splendidly lit, and based on the dignified principles of perspective. Three of Canaletto's contemporaries practising as view painters followed each other at different periods as official teachers of perspective at the Academy, and this science could be used to elevate the otherwise humble one, view painting; even at its best that was merely a form of copying and lacked 'invention'. Algarotti had employed Canaletto on those unions of invention and fact which put the Rialto, the Pantheon and some ruins altogether in a caprice setting. Canaletto's *morceau de réception* is something much more ambitious, though not unique in his late work: the creation of a scene which should appear realistic but which is in fact totally invented. The result, large, elaborate, carefully designed and carefully painted, now seems to us (not surprisingly) academic. Yet even there

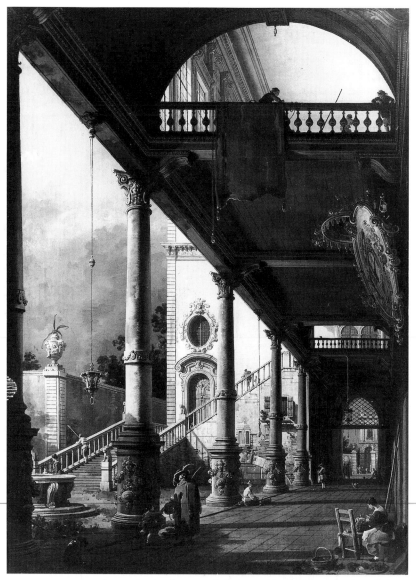

74. Antonio Canaletto, *An Architectural Caprice*. Venice, Accademia.

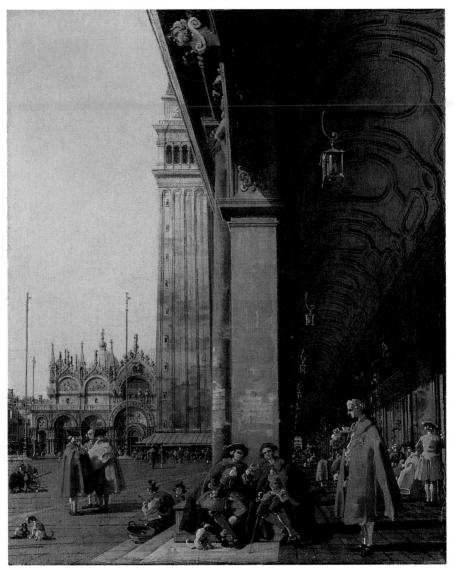

75. Antonio Canaletto, *Piazza S. Marco*. London, National Gallery.

he cannot forgo a touch or two of genre, and the woman seated at the far right might have been seen at work in any view of a humble Venetian *campo*.

His view pictures did not cease. He continued his *reportage* of Venice, and was occasionally to be found recording the city from life, as it were. While a certain John Crewe and his tutor were staying in Venice in 1760 on the inevitable Grand Tour, they found one morning on the Piazza a little man busily sketching the Campanile; they stopped, and he introduced himself: he was Canaletto. His paintings had become more mannered than ever: tighter in handling, the figures convulsed by a sort of arthritis, with mere blobs for faces. The scale of these late pictures is a good deal smaller than had been usual in pre-London days. In fact, apart from his *morceau de réception*, Canaletto hardly attempted elaborate pictures again, pre-ferring small, often upright canvases, such as the pair in the National Gallery, both views of Piazza S. Marco (Fig. 75). Whereas X-rays of, for example, the *Stone Mason's Yard* show how he altered the buildings as he painted, an X-ray of one of these two views reveals no alterations or second thoughts at all. From the first, everything was painted in as rapidly and neatly and surely as appears on the surface; Canaletto had been so long at the task of view painting that his hand possessed an assuredness which age had not weakened. Certainly he was vain – justifiably – of the ability which time seemed to leave untouched. On a drawing showing the interior of S. Marco with the choir singing (Fig. 76) he notes his age ('Anni 68') and the date 1766, and adds the proud words 'done . . . without spectacles'. The drawing is very careful, almost indeed laboured, full of his late mannerisms but a final testimony to the microscopic accuracy of an artist who had so early been summed up as one whose excellence lay in painting what fell under his eye. Two years later he was dead.

What Carlevaris had adumbrated, Canaletto fully and exhaustively ex-pressed. In the iceblock of his later style, he has marvellously preserved the Venice of his day. His pictures are among the few topographical paintings where accuracy and aesthetic pleasure blend, and he created something which even his fellow-artists were forced ultimately to recognize: the view picture as a work of art. An interesting tribute to him is paid by Mrs Thrale (later Piozzi), who bought seven of his pictures when she went to Venice some years after his death. Discussing Fanny Burney's novel *Cecilia* she speaks of it as a mere picture of topical life, not derived from study. 'Burney's Cecilia is to Richardson's Clarissa,' she goes on 'what a camera obscura in the window of a London parlour – is to a view of Venice by the clear pencil of Canaletti.'

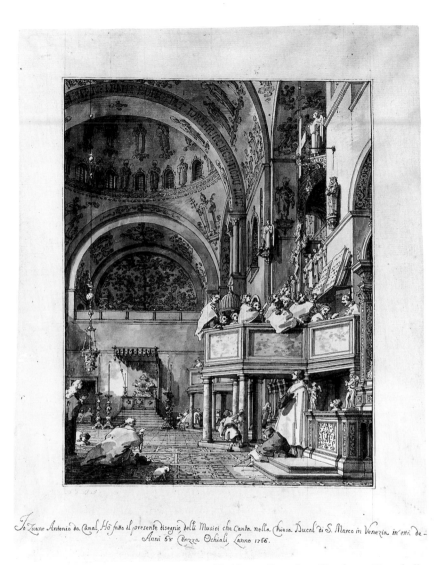

Io Zuane Antonio da Canal, Hó fatto il presente disegnio delli Musici che Canta nella Chiesa Ducal di S. Marco in Venezia, in età de — Anni 68 senza Ochiali, l'anno 1766.

76. Antonio Canaletto, *The Interior of S. Marco*. Drawing. Hamburg, Kunsthalle.

And if only because of his value as a witness, Canaletto was bound to be remembered and to be required. Unlike the history painters in Venice he was at least 'true', and such an exponent of the neo-classic as Angelica

121

Kauffmann owned two 'very fine views' by him. Even in the Romantic period he was not neglected. 'Your own Canalettos' writes Byron's friend Rose to Henry Hallam in 1819, 'will have given you a better idea of the gondola than I could convey. . . .' And in some sense Venice was still his city: 'Avec ses palais, ses gondoles', Gautier's poem expresses it, 'La ville de Canaletto!'

Although the most famous of the view painters, Canaletto was at no period the sole practitioner in Venice. His own fame attracted others to the subject, and they even imitated his manner as well as his matter. Some of these figures are now hopelessly shadowy; we hear of their names, but can hardly distinguish their works amid the mass of Canalettesque pastiches. A certain Moretti, who was a scene designer, is mentioned and praised by Algarotti for a picture where 'l'auteur a parfaitement imité la manière de Canaletto' – though Algarotti has overpraised his imitative gifts to judge from such Morettis as we know to-day. And there are other more shadowy figures still, while there remains the evidence of activity in those Canalettesque pictures not by Canaletto.

One or two figures, however, are clearly defined personalities who have largely been recovered from oblivion in the last fifty years. Closest to Canaletto is his nephew Bernardo Bellotto (1720–80), who at twenty-seven quitted Venice for Northern Europe never to return: a retreat which is probably a tribute to Canaletto's exclusive grip on the Venetian view painting market. Bellotto began with views of Venice, of Lucca, Padua, even Rome, which counterfeited his uncle's manner as closely as possible – to the annoyance of art historians now working on the problem of which painter painted what. But there can be no doubt that Bellotto is the creator of the splendid, panoramic *View of Verona* (Fig. 77), less patently 'composed' than a Canaletto and a challengingly bold achievement for a painter in his early twenties. Bellotto's talent was sufficient for a Venetian to note him at twenty-three, with his uncle, both as '*rinomatissimi*' for view painting. Gradually he drew away from Canaletto's manner, distinguishing his pictures by pinkish sky tones, cold blues and greens of foliage and trees; then he withdrew physically in 1747 to Dresden. That city too inspired fine views by him, painted in cool tones that are unmistakably his own. His final and most interesting phase was at Warsaw, where during the remaining twelve years of his life he was employed by the unhappy last king of Poland, Stanislas Poniatowski, painting views of the city whose genre qualities seem to prelude Goya and whose strong naturalism is like a breath of the nineteenth century, almost of Courbet (Fig. 78). Bellotto no doubt found it convenient to leave Venice but equally he found it con-

77. Bernardo Bellotto, *View of Verona*. Private collection.

78. Bernardo Bellotto, *The Church of the Reformed Friars, Warsaw*. Warsaw, National Museum.

79. Michele Marieschi, *View of the Rialto*. Bristol, City Art Gallery.

venient to air his association with Canaletto; after his departure he began to sign himself 'Bellotto de Canaletto', and in Poland in fact he was and still is called Canaletto. While his uncle in London was being supposed an impostor, Bellotto was doing his best actually to be an impostor and pass under the more famous name.

Bellotto's retirement from Venice removed one possible rival; another was removed for Canaletto by death. A talented young Venetian, Michele Marieschi (1710–43), reversed Bellotto's career by returning from Germany to Venice about 1735; previously a scene-designer and painter of harbour scenes and vaguely landscape caprices in Marco Ricci's style, he now turned to view painting. And in 1741 he published a series of twenty-one etched views of Venice.

Marieschi painted few views, though his name is often used to pass off work too indifferent to be by Canaletto and Carlevaris, but the handling of the paint is lively and fresh in a manner of his own. And the people he sets in his views are, like those in his earlier work, brightly coloured, vivacious and with something of Zais's Frenchified elegance. Marieschi's nervous, rapid manner is a contrast to Canaletto's at the very moment when that was growing stiff and mechanical. It anticipates Guardi who must have

taken some hints from Marieschi, but it is much less calligraphic. His *View of the Rialto* (Fig. 79) has a vividness which Canaletto had once possessed, but had lost. Guardi was still working away as history painter. Marieschi's sudden adoption of view painting seems to show that the genre had become popular during his absence in Germany. Perhaps he too would have achieved popularity, if he had not died prematurely. Even as it is, his name occurs frequently in English sale catalogues from about 1760 onwards, and Marshal Schulenburg, owning a dozen pictures by him (five of them *vedute*), was a chief patron of his in Venice.

There were other artists at work, occasionally practising as view painters but more often concerned with perspectives of ruins and architecture: *prospettive* of a type that really go back to the Renaissance and to the ideal cities painted and planned by Piero della Francesca. In these pictures the figures were occasionally by another hand – even Tiepolo, at Algarotti's request, painted small figures into some ruin-pieces. Among the minor men at work, Gian Francesco Costa alone actually created a new subject-matter by depicting – in a series of etchings – scenes outside Venice: the villas of

80. Gian Francesco Costa, *View of the Palazzo Marcello. Delizie del fiume Brenta*, no. 7. Etching. London, British Museum.

Venetian nobles along the Brenta canal (Fig. 80). In one or two etchings Canaletto had strayed outside a city (usually Padua), but Costa's *Delizie del fiume Brenta* were really an extension of the topographical etchings of Carlevaris, and a glorification of Venetian aristocracy. The sumptuous villas had impressed an early English traveller, Bishop Burnet; they are palaces rather than villas and, as he says, 'built with so great a variety of architecture that there is not one of them like another.' No doubt Ruskin never heard of Costa but he knew the villas well enough, passing them as so many travellers still do on the road between Padua and Venice, and they too earned a sneer: 'This is the architecture to which her studies of the Renaissance have conducted modern Italy.' Once again, in such remarks, the nineteenth century sets out to demolish its prosaic, wicked old father: the eighteenth century.

The humblest rivals of Canaletto, or perhaps rather his copyists, decorated such eternally Venetian souvenirs as fans with festival scenes, usually the Ascension Day ceremony. Cheaper and more portable than a picture, these tourist products probably followed the vogue that Canaletto had virtually created; and in a way the idea behind the picture and the fan is the same. Only a few views are to be found on porcelain of the period, perhaps in part because there was little export of it. Some *capricci* do occur, but these are anyway more usually based on standard Delft designs than on anything specifically Venetian.

Canaletto's great successor was to come to view painting comparatively late. Francesco Guardi certainly inherited the tradition of Canaletto and patronage by the English, but achieved something quite different. The informative Strange, patron himself of Guardi, supplies a fragment of explanation in his catalogue: 'Guardi is a painter still living at Venice; and who, though he has taken to Canaletto's department, has still followed a particular manner; which is spirited and quite his own.' The truth is that Guardi lacked the technical mastery to imitate Canaletto very closely, even if he wished to. Although he began by imitation of it, he was actually a rebel against the Canalettesque set-piece of hard light and shade, complicated composition and elaborate theatrical perspective.

His creation was more personal and more truly capricious. Canaletto's static scene was replaced by an evocation more of fantasy than fact, in which nothing is ever quite still. Strong contrasts of light and shade are softened to a suffused pale glow which bathes the whole picture; the composition itself is often stripped of people and buildings until there is no more to it but a stretch of water and a single gondola under the empty atmospheric sky. The bold copperplate of Canaletto's calligraphy is dis-

missed in favour of an erratic and flickering scrawl. A bomb has exploded softly in the middle of Canaletto's careful constructions; they are broken up, just as the compositions of Titian had been broken up by Tintoretto. And in the touches of splintered light with which Tintoretto heightened his figures and scenes we see a source for Guardi's figure painting – and his view painting.

Guardi's career as a figure painter had been shared with his brother Gian Antonio, and has already been discussed. In 1760 Gian Antonio died, and very probably about that date, or not long before, Guardi began his view painting. Then in 1764 the diarist Gradenigo noted that he had exhibited in Piazza S. Marco two views commissioned by an Englishman; it is Gradenigo who glosses the name Guardi with the phrase 'good pupil of the famous Canaletto'. Since Guardi was very rarely referred to by his contemporaries during some thirty years of view painting, the reference is the more valuable. Whether it should be taken literally to mean that Guardi had really been a pupil of Canaletto is a vexed point; Guardi did many times copy Canaletto designs – just as Canaletto had copied those of Carlevaris – and his earliest views are certainly the closest echo of Canaletto's handling which he can manage. These pictures are straggly attempts at architecture, with a few scratchy figures littering the untidy scene. But already there are signs of Guardi's later development in the vivacity of these figures: they prophesy freedom, even as do the wavering black outlines of the buildings, from the straitjacket of Canaletto's style.

Soon Guardi replaced his own flat and dull blue skies by an awareness of light and shade, which seemed a return to Canaletto's early manner: thundery effects which had long ceased to appear in view pictures.

What Guardi's comparatively early views were like is conveyed on an unusually grand scale by the *Basin of S. Marco* (Fig. 81) where the Canalettesque idiom is apparent but has now been partly absorbed by Guardi's greater vivacity. The untidy effect is the untidiness of Venice, of boats and rigging and seamen. Already his sensitive awareness of atmosphere can be appreciated and his frank delight in the marine world of his adopted city. His later pictures simplify subject-matter in contrast to the busy scene here, but although he occasionally celebrated special events (Fig. 82), sky and water remain his real subject; Venice raises its façades and towers almost tentatively into this stormy, atmospheric world where the elements buffet what man has built. Always composing less firmly than Canaletto, he set the city floating, frail yet with bubble-like buoyancy, between great expanses of water and watery sky (Fig. 83). In such pictures

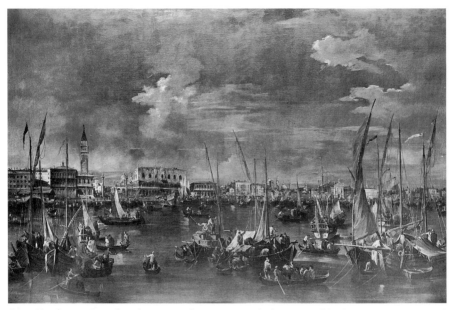

81. Francesco Guardi, *The Basin of S. Marco*. Aylesbury, Waddesdon Manor, National Trust (Rothschild Bequest).

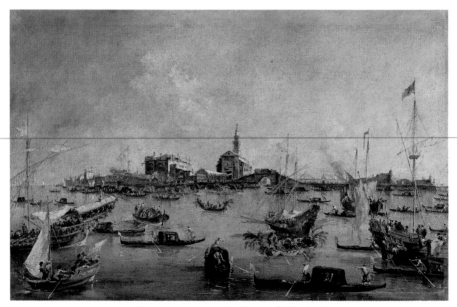

82. Francesco Guardi, *The Bucintoro at S. Nicolo del Lido*. Paris, Louvre.

83. Francesco Guardi, *The Rialto, Venice*. London, Wallace Collection.

nothing is quite still. Boats dart, flags flap, and the buildings themselves seem to unwind like so much ribbon along the Grand Canal.

It was in the caprice view where Canaletto had so often failed that Guardi so splendidly succeeded. But with Guardi the caprice became much less obviously – and clumsily – a juxtaposition of various monuments. Inspired by the ruins on islands in the Venetian Lagoon (often the old fortifications of the city now fallen into decay), he painted ruin-pieces half real and half imaginary, in which it is difficult to say quite what is invented. These ruin-pieces are barely melancholy; rather are they enchanted archways and weed-overgrown pillars poised against a pale sky and about to lapse into the pale water. The century loved such effects; its taste for ruins had been decorative and partly architectural (resulting in the capricious ruin-pieces assembled by Marco Ricci) and finally became sentimental. What was, for instance, evoked in Diderot by ruin-pieces was almost a nostalgia: 'Tout s'anéantit, tout périt, tout passe.'

Guardi's pictures seem a part of that taste; but they are also seascapes as

well as evocative *capricci*, and he was the first painter to look outside the city of Venice and to paint the water that lay around it. He seems to have had an instinctive gift for transposing literal topography into scenes which have a poetic reality even while clearly in part fantasies. A view like Fig. 84 at first sight looks like a scene on an island in the lagoon, but is full of romantic half-invented elements such as the arch at the left and the Palladian building behind. In no pejorative sense, this blended truth and fiction is 'picturesque': the house in the centre, itself so ravishingly painted, becomes an object of romance, and the washing hung out from it to dry is like some mysterious signal in a fairy-tale. Even the activity of the tiny figures remains mysterious, as they rush about ant-like, enlivening the scene. From the first Guardi perhaps intended to *interpret* Venice rather than *reproduce* it, and his best views of it capture a sparkle of light and a sense of eternal movement which Canaletto never caught, and which is certainly part of the city (Fig. 85). The ubiquitous water of Venice,

84. Francesco Guardi, *A Caprice Landscape*. Almelo, Collection of H. E. ten Cate.

130

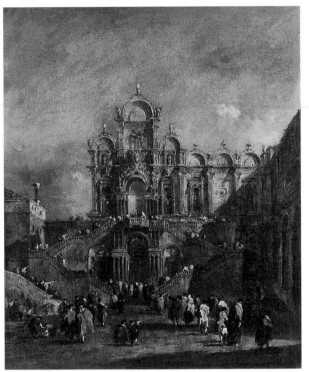

85. Francesco Guardi, *Campo SS. Giovanni e Paolo.*
Washington, D.C., National Gallery of Art, Samuel H.
Kress Collection, 1939.

mirroring palaces and bridges, receiving the slowly subsiding foundations
of stone and rotting wood, is evoked in its flash and ripples and ready
movement. As Gian Antonio Guardi had taken and softly blown up for
his stylistic purposes engravings after Piazzetta (cf. p. 61), so Francesco
utilized engravings connected with Canaletto showing ducal ceremonies,
investing the results (Fig. 82) with his own airy, atmospheric style and
excitement.

Canaletto had devoted himself to painting each ripple as if it were a
brick on a façade. But Canaletto was the product of an earlier period
and kept always something of sobriety before the extravagant spectacle of
Venice. As the century advanced, the tendency was towards lightness and
grace: asymmetry replaced symmetry, not only in furniture and books but
even in the detail of the decoration of Venetian visiting cards (on which

131

capricci often appear). Whether or not we care to call it rococo, this new grace and airiness was at work expanding the bubble of late eighteenth-century Venice before it finally burst. Guardi had an example personally close at hand in his brother-in-law, Tiepolo, whose own style shows the same progression from darkness into light and whose silvery landscape backgrounds have affinities with Guardi.

This mood perhaps suited visitors to Venice during the last two decades before the fall of the Republic: in those years when Venice could no longer conceal from itself its degradation and decay. This was the time when the Doge could refer in a speech to the Senate to the many difficulties of the day, the contemporary inertia, the languor, the mental and physical sluggishness of the nation; and that speech was meant as a defence of Venetian policy. There were many sympathizers with French thought, the more prominent of whom were in these years arrested and imprisoned. Such priests who attempted to take the part of the people against the nobles found themselves equally accused; there were, however, few of them. While Guardi evoked more and more airy caprices, where the ruins have hardly more solidity than clouds, and the clouds themselves are pale breaths on the horizon, Venetians began gradually to replace religion by rationalism. Cases arose of workers who were reported as believing only what they saw; at Murano the State Inquisitors in 1779 reported, for example, a glass worker who thought the soul merely air which was exhaled at death. And two years before, a liberal Venetian had presented Voltaire with a medal showing Philosophy overthrowing Superstition.

At Venice the Carnival continued but the gambling place, the Ridotto, had closed. Visitors came as frequently and as numerously as ever to the city; its attractions did not pall, the automatic cycle of its annual feasts went its course – though religious feasts were diminished in number in 1787 – and Guardi painted. Canaletto's late paintings had been on an unusually small scale – for him – and now Guardi specialized in small pictures, flickering enchantments of ruins along islands in the Venetian Lagoon or a roofless hall set against a breezy sky of blue and white, sometimes painted on wood hardly larger than a matchbox: pictures which when framed in the delicate gilded frames of the period must have seemed more trinkets than proper paintings (Fig. 86).

With time his style increased in allusiveness. The people who had played such a part in Canaletto's pictures, even when given only the mechanical vivacity of puppets, dwindled in Guardi's work until they were mere specks of colour, a running squiggle of white paint, a black dot, short-hand to express the population of the most moribund of European states.

86. Francesco Guardi, *Caprices with Ruins*. London, National Gallery.

Canaletto had always liked to introduce some touch of genre – a man with his steaming coffee cup as in that view of the Piazza (Fig. 75), or the woman sewing in his *morceau de réception* (Fig. 74), but on the tiny scale of Guardi's late pictures there is no room for such personalities. Animation is general, and the effect is rather similar to Dufy's paintings of events. Like Dufy, Guardi often achieves a sort of spontaneous wit. Where Canaletto had been particular and specific, Guardi was content with a hieroglyphic symbol. In Canaletto there are nearly always small passages of delicate but solid painting enlivening vast areas of topography: the stretched yellow silk of a sunshade or the folds of a furled sail.

Such detail has no place in Guardi's paintings, where the oil paint is in fact often diluted to almost water-colour thinness; the view is glimpsed in a single *coup d'œil*, becoming almost an impression. This 'impressionism' has sometimes led to the idea that Guardi anticipated the French Impressionists (whose views of Venice are mostly so bad) and Turner. But Guardi's handling is really an inspired accident rather than a scientific method of vision, and his attitude to Venice is neither romantic nor sentimental. He never heightens the shimmering nobility of Venice to make it the dream city of Turner's pictures; his Venice is slightly raffish, lopsided, now noble, now squalid. It is true that he seems to express a fresh awareness of atmospheric effects and already to agree with Constable's remark that the best lesson he ever had was 'Remember light and shade

133

never stand still'. But Guardi's love of movement, of pale tones and luminous skies, is based less on naturalism than on the heightened rococo of his century: its love of lightness, elegance and grace.

To his period he was an unimportant view painter and no doubt it would be amazed at his fame to-day. Such patronage as he received cannot have made him very rich. Little is recorded about who patronized him, and an example of employing him on the sort of thing which really suited his talent least seems to have been Thomas Moore Slade's commission given about 1775. Of this we hear that the result was a 'Bird's eye View of all Venice. Composed and painted for Mr Slade'. Whereas Canaletto could charge a hundred sequins or more for a picture, Guardi (it is said) charged one. There was probably no Guardi studio in which assistants could prepare pictures that the master finished – only Guardi's incompetent son Giacomo (1764–1835), who later specialized in gouache views of Venice often derived from his father, but without any of Francesco's sparkle. To-day even Giacomo's gouaches have come into favour and we have eclipsed even the eighteenth and early nineteenth centuries in our passion for Venice and Venetian pictures. A good number of his father's pictures seem to have been left on Giacomo's hands, and he probably made a little money by trading these; one or two of them were bought from him by a priest at Ancona from whom they were later acquired for an English collector and so arrived in this country.

It is a picture such as the *Tower of Malghera* (Fig. 87) that shows us Guardi at his most personal in a straightforward view. The tower itself, which was destroyed in the nineteenth century, was a relic of the ancient Venetian fortifications on an island in the Lagoon; Canaletto had used it as motif in one of his etchings, but Guardi does not depend upon that. He clears his composition of all that Canaletto would have filled it with, and achieves a Corot-esque simplicity. The painting is all sky and water, and the thin crisp shell of the foreground boat, with its graceful arc of mast emphasizes the space of the picture. It is a grey-blue atmosphere, a tone painting in which drawing is kept to a minimum – at the right a few hasty scratches with the brush's point serve to evoke a bit of land and hint at another boat.

In such pictures Guardi seems to dismiss all the eighteenth century's interest in mankind and attempt a purer type of landscape for its own sake than had been attempted before. Certainly such a change was realized at the time; whether it was appreciated is a different matter. When Strange writes of Guardi from England to his Venetian agent Sasso it is to warn him that Guardi needs watching: the painter must not be allowed to

87. Francesco Guardi, *The Tower of Malghera*. London, National Gallery.

follow his fancy but must stick to the truth. Strange is going to order from
Guardi two more views which must be clear, well-executed and a pair,
but also coloured *exactly* – Strange's italics. That is the voice of the
eighteenth-century English patron.

In the last years of his long life – *vedute* painters seem to have enjoyed
longevity – Guardi, almost like Gainsborough, escaped from reproductions
of reality into fancy pictures where he could be his own master, and into
little, rapid, luminous sketches in oil paint which hit off Venice without
attempting to be 'well-executed' as Strange used the words. He really
could not help his lyrical gift for transcribing reality in his own highly
personal terms, and his many drawings show this spontaneous freedom
almost better than his pictures. In his drawings he need please only himself.
Spontaneity, sketch-like character, evocation rather than steady realism,
these are the virtues which the eighteenth century did not easily pardon in
Gainsborough, nor the nineteenth century in Constable. Both painters
were too free; Gainsborough refused to conform and Constable conformed
only in his big public pictures, which are often rather heavy in handling.
Guardi does not seem to have been deterred too much – and we are the
gainers. With the coming of the nineteenth century he became more
popular; it was only unfortunate that he was already dead. Then his name
fell into oblivion, and was hardly revived again seriously until George
Simonson wrote a pioneer monograph in 1904.

135

Guardi nearly, but not quite, lived to see the fall of the Republic. He died in 1793. The duration of Venice's enchanted life was speedily coming to an end: the burning of the *bucintoro*, the theft of the Horses of S. Marco. But his views kept until the finish a gaiety and a busy vivacity which are now almost ironic. Four years later the Senate resolved to accept the provisional government of Napoleon; the Doge abdicated and shortly after died.

Venice survived as a city, however, and view painting too did not quite cease. It staggered on inevitably, as the demand did not slacken. Canalettos and Guardis changed hands, and when there were no originals available imitations of both painters answered the demand. One of the most successful combiners of the two styles, a postscript himself to that century, was Giovanni Migliara (1785–1837), whose work is interesting for the divided homage he paid to the twin poles of Venetian view painting. In the nineteenth century Venice continued to be depicted – perhaps interpreted would be a better word – but the finest painters were foreigners like Corot, as well as Turner, the Impressionists, Whistler and Sargent, all artists very much more than view painters.

It was science not politics that destroyed the view painter's livelihood and made his art redundant. The camera was invented.

4

Genre

Pietro Longhi (1702–85) virtually *is* genre painting in Venice for the major portion of the century. Although by no means a great or good painter, he did manage to invent a sub-division of the genre picture that had not previously existed there and which died with him. Painters, like other people, must have their antecedents; Longhi of course had his, but less than with most painters do they satisfactorily explain what he invented and what he achieved. With all his aesthetic deficiencies, he is a sort of diarist or chronicler in paint of contemporary Venetian life – nothing like as wide as Canaletto in his range of social observation but penetrating into palace rooms and conveying something of daily existence lived in such circumstances.

He did not, however, begin as a genre painter. Trained under Balestra, he began first with figure painting for which he was to remain unsuited. At intervals throughout his career he continued to practise as a figure painter: frescoing a ceiling in Palazzo Sagredo and some religious scenes in S. Pantaleone, and executing occasional poor oil paintings of historical or religious subjects. Balestra seems to have recognized Longhi's unsuitability for any of that type of work and he sent him off instead to Giuseppe Maria Crespi (1665–1747) at Bologna. While Longhi was to remain very much a private and unpublicized phenomenon of Venice, Crespi was a painter patronized by popes, foreign princes and Italian princes beyond Bologna. As well as portraits and subject-pieces, he did practise a sort of genre painting; and his *Family Group* (Fig. 88), which is of him and his family, is a good example of the intimate, original manner of his genre work which must have provided Longhi with at least some useful hints. This picture itself was not available for Longhi to see, as it had been given by the painter to Grand Prince Ferdinand de' Medici at Florence in 1708. In point of fact it was a good deal more vivid and intimate than Longhi

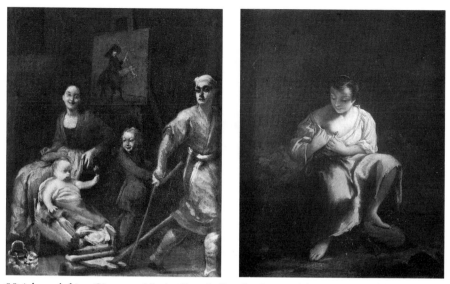

88 (above left). Giuseppe Maria Crespi, *Family Group (The Painter and his Family)*.
Florence, Uffizi.

89 (above right). Pietro Longhi, *A Peasant Girl*. Bassano, Museo Civico.

ever cared to be (suggesting rather the attitude of Piazzetta), and it is an
impression of domestic reality that remained altogether unusual in Italy.

Outside Venice but throughout Northern Italy there had for long existed
a tradition of genre which took its subjects deliberately from low life. The
origins of this type of painting are obscure, but its products are many; it
certainly played its part in Crespi's development and through Crespi it
influenced at Venice Piazzetta as well as Longhi. Not content with low life
subjects, it chose to emphasize the sordid and sickly side of them whenever
it could. There can be little doubt that the great attraction of such pictures,
and the pleasure they gave, was – and is – sexual. That taste for dirty
washing, which impels Zola to such elaborate physical descriptions of
soiled laundry in *L'Assommoir*, in Italy found its pleasure in flea-ridden
peasant girls and seductively ragged urchins whose clothes and persons
promised a good dose of *nostalgie de boue*. Such a painter as Giacomo
Ceruti, wandering about Northern Italy in the first half of the eighteenth
century, added his own twist to such objects by choosing often to make his
peasants and scavengers diseased, while proclaiming his own unpleasant

138

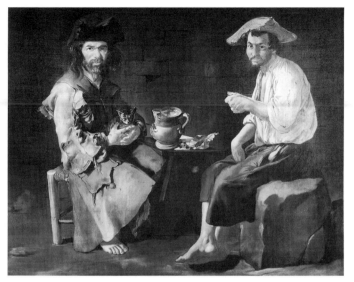

90. Giacomo Ceruti, *Two Poor Men*. Brescia, Pinacoteca Tosio Martinengo.

preoccupations by the browns and yellows in which he painted. All grotesques are obscene fundamentally, as is the taste which finds them either funny or appealing: the stunted and afflicted people of Ceruti, as we see them in his *Two Poor Men* (Fig. 90), are a sharp reminder of how uncivilized the supposedly civilized Italian eighteenth century could be. Perhaps it is too harsh to say they are painted without sympathy, but they lack the charm of Murillo's poor or the dignity of peasants by the Le Nain brothers; yet Ceruti represents a vein of art in the eighteenth century.

Longhi did not remain quite indifferent to this sort of art, as it reached him through Crespi. Crespi had occasionally taken a single peasant figure, perhaps a girl searching herself for fleas, and placed it in a plain shadowy setting, very much as Longhi did in some of his early pictures, like the *Peasant Girl* (Fig. 89), which is close in style to the pictures produced by Piazzetta after his apprenticeship to Crespi. Longhi's girl is not at all disgusting; she is, rather, healthy and alluring – at least by intention – and is painted in soft, vague brush strokes that show a good deal of affinity with Crespi's work.

This picture is a timid exercise in genre of a kind not really sympathetic to Longhi. He is here following a vogue which he does not properly

139

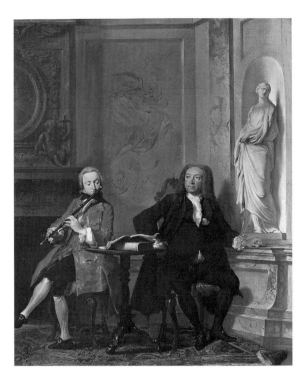

91. Cornelis Troost,
Two Dilettanti. Dublin,
National Gallery of
Ireland.

understand; it was to be left to Piazzetta to take up Crespi's people and
make of them something quite novel. Longhi, untrained by his training
under Balestra and not properly orientated by working with Crespi, arrived
back in Venice in the autumn of 1732 (if not before) and soon after began
the long series of domestic and public Venetian scenes by which we know
him best.

Although the invention of such work at Venice seems to be Longhi's
own, the taste of other cities and countries was also independently turning
towards private life interiors often similar to Longhi's, though technically
much better. The 'conversation piece' was developing, to reach in England
the awkward felicity of Gainsborough's early pictures and the precise
intimacy of Zoffany's interiors. In Holland the painter Cornelis Troost had
already embarked on his career, and a picture like his *Two Dilettanti* (Fig.
91), painted in 1736, is already a vivid combination of personalities and
surroundings: a tribute, even if a mildly satiric one, to new conceptions of
civilized ease. It is at once dignified, cultured and informal; the setting is

140

92. Pietro Longhi, *A Concert*. Venice, Accademia.

minutely particularized, as are the costumes, and we are shown a private moment of music-making – in its way as personal as somebody singing in his bath. Troost of course had a long and distinguished ancestry in painters of interiors like Vermeer and de Hoogh, and he also is respectful to the actual medium of paint, which he handles until it resembles enamel. The picture is finished and neat, and charming partly because of its intense clarity.

Longhi's *Concert* (Fig. 92), painted five years later and the first dated domestic scene by him that we know of, is vivid enough but depressingly clumsy; even his musicians seem to lack the quick-fingered deftness of Troost's amateur flautist. The paint surface is messy, as so often in Longhi; time and practice never taught him how to apply paint. But despite the clumsy drawing and the totally unorganized composition, there is a perhaps greater talent for lively observation than Troost was ever capable of and a greater vivacity through the very spontaneous, slap-dash paint. And while Troost was drawn away into painting scenes from harlequinades and

141

plays, Longhi was to devote virtually his whole production to scenes of contemporary life like this one. There is a sort of candour in the slightly ridiculous trio of musical amateurs and a sort of pungency in the pair of clerical card-players, one thin and eager, the other fat and porcinely benevolent.

The suggestions of unorganization in the scene, both as a composition and as a subject, are typical of Longhi and raise the question of whether he was naïve or just falsely naïve. Where every clumsiness is supposed a touch of genius, and where Longhi is coupled with Watteau (to be fair, this dreadful analogy was started by Mariette), it is not likely that he will be appreciated justly or reasonably. Because he is unique, it has been presumed that he is invaluable. But it seems as if his clumsy handling of paint, his inability ever to establish the planes of a picture, and his incapacity to draw properly, were honest defects that he could not over-come even after many years of practice.

His pictures are therefore, with all their undoubted charm, lazy little pictures: just as the society he pictures is lazy. The world he sees is in general the enclosed one of affluent people trying to pass the time. The rooms they inhabit are enclosed too, and always windowless; they them-selves are barely in contact with each other but are placed, like dolls, in a proximity physical rather than emotional. *The Visit* (Fig. 5), of only a few years after the *Concert*, is like an illustration of the theme of vapidity; one feels the man at the left bends down to welcome with relief the lively, frisking dog – the sole lively creature in the room. But this is already reading too much significance into Longhi. Although his aristocrats seem to linger aimlessly over their toilet or sip their coffee wearily, they are not observed with any of the biting irony that Parini was to use in indicting high society in his set of poems *Il Giorno*. Outside Venice social conditions occupied the thoughts of Italians and other Europeans. Before Parini, Pietro Verri at Milan had satirized various aspects of contemporary life: from absurd social prejudices to the sort of education girls were given in finishing schools. At Milan a whole enlightened group of people existed, publishing a journal *Il Caffè* (modelled on *The Spectator*) and in it vigorously denouncing the idleness of the nobility and the state of the country. From out of the ideas of that group came Beccaria's famous proposals for the abolition of capital punishment – a treatise which the Venetian State hastened to have refuted by a tame priestly pamphleteer.

Longhi does not run counter to the Venetian climate of the period; nothing accuses or upsets the placidity of his people, so conscious of their elegance and so assured of their charm. It is not surprising that he was a

142

painter much patronized by the Venetian aristocracy. By 1748 he is found writing that it is difficult to borrow his own pictures (required for a project of engraving some) as they are chiefly in noble households; and he is recorded as working for families like the Grimani, the Pisani and the Sagredo (for whom he also acted once as picture valuer). It is through engravings that he is mentioned in England – perhaps for the first time – in 1750: by Vertue who calls him 'Petri Lungi'. By 1753 we hear from an Italian source that his pictures fetch *grossi prezzi*.

As well as pictures of his betters, he painted in the same intimate calm manner scenes of Venetian low life, low without being vulgar. These are often street scenes, airless as had been his interiors, set against a plain wall or under the arcades of the ducal palace, and emphasizing some picturesque aspect of Venetian life. He records thus the various animals brought to Venice at carnival times, perhaps the most exciting of which was the rhinoceros which arrived for the carnival of 1751. It was centuries since a rhinoceros had been seen in Europe; Dürer had recorded the last specimen and now the arrival of a new one created a sensation so great that one of the distinguished scholars of the day, Scipione Maffei, solemnly set down his thoughts on the subject in a pamphlet. Other animals might be popular, but this was the most popular of all; Longhi painted the subject at least twice, and pupils or imitators painted it more often. And Alessandro Longhi, Pietro's son, engraved yet another composition of it. Then it went off to Verona, where once again it was sketched.

After this hubbub the poor creature seems tame enough, as it placidly stands with a wisp of straw in its mouth (Fig. 93). Its journey from Africa via Nuremburg to Venice is perhaps a symbol: something primitive and grotesque coming from that continent so long thought of as productive of novelties, and being welcomed as 'a change'. There is an element of sadness and futility in the onlookers; the rhinoceros once seen, there remains no more entertainment to be extracted from it, and despite the gesticulating showman, this group seems already to have exhausted its emotions of wonder and surprise.

Hogarth (Longhi has been compared to Hogarth) would have wrung something savagely satiric out of such a scene, sympathizing with the beast or with the onlookers. There would have been, in brief, a point to the picture above the mere record-making task of painting what the rhinoceros looked like. Goya (Longhi has been compared to Goya) would have seized like a terrier upon the very vacuity of the people he had to depict, enjoying their emptiness as a child enjoys the emptiness of a balloon: he could have blown it out to monstrous swollen proportions. Longhi no doubt had to

tread more carefully at Venice, while at the same time his mind had shown neither desire nor ability to express anything other than what it registered as *seen*.

What there was for him to see often, fortunately, possessed charm and attractiveness and even a simple harmless humour. So he managed to invest his pictures with those qualities *trouvés*. He was popular with his contemporaries because of the mirror he held up to the nature all around them. Gradenigo records that he is the painter *per attitudini naturali* and for *parlanti caricature*. Gasparo Gozzi thought that Longhi could usefully and suitably be compared with Giambattista Tiepolo; for him Longhi was a painter who had evolved from scenes of figures dressed up in historical costume and who, instead of imagining how people looked, painted what he saw 'with his own eyes'. That was Gozzi's own talent too – not for nothing was he a journalist and a witty critic of contemporary manners; his 'own eyes' noted the behaviour of crowds on the Piazza S. Marco, or followed, with the rest of Gozzi, a pair of modern lovers whose antics struck him as diverting. And Gozzi went out of his way to say that Longhi's kind of art was no whit inferior to Tiepolo's.

Gozzi's attitude is a sign of the times: that people were beginning more and more to tire of imaginative painting and its themes of gods and goddesses and hero-worship. What concerned the age more intimately was itself. At one level records of its daily existence were prized in themselves: memoirs and journals and diaries, engravings of state occasions and of street cries too, plays of contemporary life with characters often recognizably derived from well-known living people. In place of *opera seria*, the 'Beggar's Opera' was preferred. Grimm, for instance, who certainly preferred the latter, pointedly remarked of those deities from machines who had made such frequent appearances in opera, 'Un dieu peut étonner, mais peut-il intéresser?' A new tendency is crisply expressed there.

Eighteenth-century Venice proliferated with forms of self-presentation, wrapped in a fantasy existence in which it was still a proud and powerful republic. The amount of detail crammed into their pictures by the view painters is almost neurotic, but the Venice they delineated was a public city. Longhi's care is to take us behind the crumbling palace façades, into rooms where the sun never strikes; everything he sees there is minutely and carefully observed, and his drawings (Fig. 94) show what meticulous attention he paid to details of furniture and ornaments. His drawings show him also a rather more capable artist, with quite a sharp eye for people (Fig. 95) as well as things. In cases where a drawing can be checked against the final painting, there is nearly always a loss of inspiration in the

144

93. Pietro Longhi, *The Rhinoceros*. London, National Gallery.

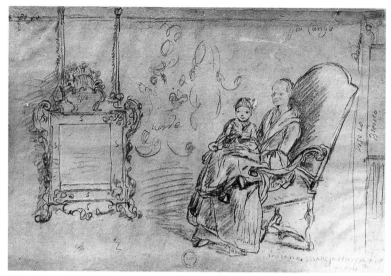

94. Pietro Longhi, *Furniture and Figures*. Drawing. Venice, Museo Correr.

95. Pietro Longhi, Drawing for Fig. 96, *The Masked Visit*. Venice, Museo Correr.

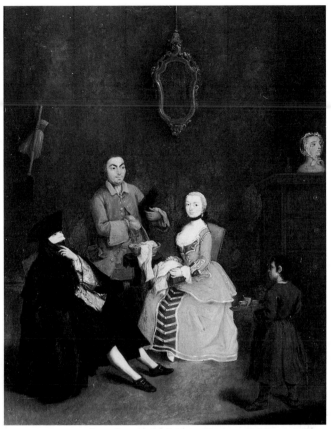

96. Pietro Longhi, *The Masked Visit*. Venice, Ca' Rezzonico.

latter, a fumbling from which the drawing was free. The *Masked Visit* (Fig. 96), especially the lounging 'mask' himself, previously studied in the drawing, has a rather flat, insipid air.

Outside Venice the eighteenth century was profoundly occupied by morality, and it was increasingly on a moral level that the century interpreted works of art which were records of itself. For painters like Hogarth and Goya, their art is a trenchant comment on their age; not content with seeing with their own eyes, they also utilize their brains. Longhi never risked any comment on his age, if we except one mildly satiric picture of the clergy, and it is significant that Gradenigo should speak of his *parlanti caricature* when he probably means no more than topical allusiveness and

147

vivid depiction of fashions and manners. Satiric pictures were certainly not very well received and an unfortunate Veronese artist (himself a Franciscan) who had the lively idea of painting the four classes of his Order as the four seasons found himself banished to an obscure monastery, after complaints had been made at Venice.

In a much-quoted but possibly not too serious sonnet Goldoni greeted Longhi in 1750 and associated them together as seeking truth through their sister muses: 'you call my muse sister of your truth-seeking brush.' In a slightly less quoted passage he praised Longhi for having found a new way of expressing in pictures 'the characters and passions of men'. Goldoni's praise is more interesting as revealing, once more, Longhi's fortunate position at the period than for any inherent truth. Literary men often seize on non-existent parallels in painting, as Diderot stooped to praise Greuze. No doubt Goldoni was pleased by the aptness of Longhi's pictures which do indeed seem to offer the playwright a widely representative group of *dramatis personæ* – but no plot. Even the innocuous quality of Longhi's scenes would not disturb Goldoni, whose own nature was of the least progressive or revolutionary. Like a good citizen he saw that the Republic should be careful not to offend, for example, its source of revenue – tourists – and he wrote a pamphlet of protest against the satire of Chiari's play *School for Widows* which was full of wounding references to Protestants and to the English. Had Longhi ever permitted himself comment of that nature his fate would perhaps have been similar to Chiari's (and Goldoni's, too): from 1749 onwards all comedies had to be submitted to the Venetian equivalent of the Lord Chamberlain before they might be performed, and doubtless a form of censorship could have been invented for paintings.

Longhi never incurred that risk. He remained content to the last with his own way of recording life about him; his style of painting did not change either, and there is scarcely any trace of evolution in his work. Engravings after his pictures executed at the time are one testimony to his popularity, and the number of Longhi-pastiches from the same period are another. In his limited field he remained the master. His official career was considerably more distinguished than, for instance, that of any view painter; he was a founder member of the Venetian Academy and was asked to present a reception piece in 1762. He was also an instructor there, as well as being head of the academy of art founded by the Pisani family. He lived long enough to attend the session of the Venetian Academy in 1779 which elected the young Canova, and long enough to see the major part of his son Alessandro's successful career as portrait painter.

While Pietro Longhi represents genre painting as it appealed to aristocratic Venetian taste, there also existed one or two other much humbler essays in genre. Hardly to be ranked as pictures at all are the series of semi-votive panels which showed the various trades and professions at Venice and which were set up in the offices controlling trading in the city, those of the Giustizia Vecchia. The building was placed, suitably enough, near to the centre for the humbler trades' activity, the Rialto. The Giustizia was concerned with barbers, tailors and so on; each of these guilds had long before the eighteenth century deposited a panel showing their own trade at work, often with some saintly protector beaming down approvingly from the clouds above. During the eighteenth century the earlier panels were not replaced but were repainted, as inscriptions on them record. One such, *ristaurato* in 1750, depicts a rosary shop (Fig. 97) and has been converted into pure eighteenth-century genre with its periwigged customer being shown a handful of ornamental rosaries. The picture has been rightly connected with the two Guardi brothers, who either together or individually painted one or two other genre pieces, sometimes taking – in their magpie way – the design from Pietro Longhi, as for other pictures they took from Tiepolo and history painters.

The *Rosary Shop* associates the trade, as usual in these panels, with Venice, and the picture is rather like an offering made at a shrine, a sort of token in the hope of continued patronage. At the same time it is part of the

97. Gian Antonio or Francesco Guardi, *A Rosary Shop: 'L'Arte dei Coronieri'.* Venice, Ca' Rezzonico.

extensive representation of everyday life in eighteenth-century Venice, and for this reason the earlier scene was 'restored' and brought up to date in 1750. A further development of this aspect of genre was the collection of drawings by Gaetano Zompini (1700–78), an otherwise quite uninteresting provincial artist, of the various traders and hawkers who went their rounds in Venice. Zompini was living poor and obscure at Venice, and it was apparently at the suggestion of Zanetti that he made these drawings, which were later engraved and published in a book, *Le Arti che vanno per via nella Città di Venezia* (1753). Some rather equivalent 'Street Cries' had been drawn by Amigoni when in England (and engraved by his pupil Wagner). He painted one or two genre pictures, too, including an 'English sweep chimney boy' which does not appear to have been seen by anyone since Dr Burney saw it in Farinelli's villa outside Bologna.

Zompini seems to have felt considerable sympathy, and affinity perhaps, with the rather sad people he drew: lugging their baskets of coal or poultry, selling clothes or telling fortunes. One or two scenes show masked carnival figures, but the theme of the book is an everyday, indeed workaday, Venice, seen at every season of the year in the lives of those perambulating tradespeople whom Zompini drew so badly and yet with a clumsy, forceful actuality (Fig. 98). Their lives were not picturesque, nor does Zompini try to pretend they were. In December, 1779, Carlo Contarini spoke publicly in the Great Council on the state of Venice and the plight of the ordinary people. He was angry and rhetorical, but his speech evokes Zompini's world – or rather, a stratum of society below that. Those gay masked figures so dear to the tourist and to Italian historians, passed by night other figures sleeping on the stones of the bridges: figures, Contarini declared, of whom it was not possible to be sure if they were citizens of the Venetian Republic or stray animals. To understand how dangerous comment of this nature was, it is enough to note that Contarini was later arrested and the Inquisitors instrumental in his arrest were declared to have deserved well of the Republic. So the failure of eighteenth-century Venice to produce any open painted comment upon the state of the city and society was not quite an accident; the artists, unconsciously perhaps, conspired with the government to agree to ignore certain things and to emphasize others. The band played louder to drown the pistol shots.

Isolated from the topicality of Longhi and Longhi's imitators, Piazzetta pursued a very different idea of genre which probably found more patrons among foreigners than Venetians. In the years when Longhi was just starting his proper career, Piazzetta was withdrawing further into his

98. Gaetano Zompini, *A Manure Collector*. Etching.

private world with its melancholia and its long delays. His training under Crespi – a much younger Crespi than the rather imperious old figure known to Longhi – had probably only accentuated his feeling for a special kind of realism. And, as he was a Venetian, his 'realism' was tinged with a certain fantasy that gives his best genre pieces an extraordinary poetry. Just as Tiepolo is always the conforming genius of the period, so Piazzetta is the nonconformist; Tiepolo was brilliantly speedy in work, Piazzetta neurotically slow; Tiepolo was in the light and of the light, Piazzetta amid the gloom and obviously hugging the gloom.

The same patrons who commissioned from him altarpieces for churches would retain his genre pictures for their private collections. Thus the Elector of Cologne, Clemens August, through whom Piazzetta's altarpieces reached Germany, had some ten genre pieces, chiefly heads, acquired for himself. For such heads, either painted or drawn, Piazzetta seems to have fused fact and imagination; his boys in exotic fur caps and his sulky peasant girls are recognizably of a type that is Piazzettesque rather than, in any way, *real*. There is a haunting quality to the faces that look out from the not ostensibly attractive subject of a hunter of small birds and two girls with a birdcage (Fig. 99); and the subject perhaps has some symbolic, even moralistic meaning, which only increases its strangeness. The figures seem to have only the faintest connection with either Venice or the eighteenth century. They belong really in a timeless world even while they are genre, and in his large pictures in this vein Piazzetta went further to emphasize their bizarreness and their lack of 'reality'.

For another foreign patron, a committed collector of his work, Marshal

99. Giambattista Piazzetta, *Two Girls with a Birdcage and a Hunter*. Drawing. The Royal Collection © 1994 Her Majesty Queen Elizabeth II.

Schulenburg, Piazzetta painted about 1740 a pair of large genre subjects unique at the period and, perhaps by accident, a last thunderous blow against the increasing light and grace of young painters. The so-called *Idyll* (Fig. 101) which is taking place, or is supposed to be taking place, on the seashore, has no subject which can be defined and yet is clearly not a piece of 'real life'. The picture's mystery is increased by its being slightly worn and also possibly unfinished. Where is the 'seashore' and what are these people clad in anachronistic costume doing? The unexpected cow's head at the right adds a final touch of the bizarre.

Such a picture is really a fantasy, a *capriccio*, on a genre theme. The actual 'subject' of the picture is for us to supply, rather as in certain paintings by Picasso like the *Saltimbanques*, where a group of travelling players stands in a deserted landscape. That picture made a powerful and haunting impression on Rilke who based a poem upon it. Like Picasso's picture, Piazzetta's seems to raise the urgent question of identity: of the people we look at, and then of ourselves. Again, like the *Saltimbanques*, the *Idyll* seems to preserve a single moment of time while the boy gesticulates to attract our attention, and it too has an element of wistfulness and evanescence. These are people 'a little more fleeting than we ourselves'. In Piazzetta's painting, with its sombre reddish tones that make the figures seem as if lit by firelight, we are free to imagine any combination of circumstances which has temporarily brought together these four people and the cow. For the painter it is enough to emphasize the charm and the incongruity of the group, and there is a touch of mysterious poetry in the figure of the girl with the parasol who turns her back and gazes into the turquoise patch of sky. The whole composition reminds one of the capricious genre scenes that Piazzetta devised, most irrelevantly, for Albrizzi's edition of Bossuet's *Oeuvres* and also for his edition of Tasso's *Gerusalemme Liberata* (Fig. 100); fantasy could hardly be more free – and Bossuet's astonishment would have been great – but there is no flippancy in these groups, for all their artificiality.

Despite Piazzetta's thundery tonality, bold shadows and deliberately plebeian people, his affinities in such work are with Watteau who also had so often avoided a 'subject' in the literal sense. Piazzetta's peasants have nothing in common with the sordid peasants of Ceruti; his peasants, if indeed one can call them such, have all the picturesqueness and the 'privateness' of gipsies – and they give the same sense of impermanence.

Pictures like the *Idyll* are rare in Piazzetta's work, but the people in them are virtually the same as those he had postulated as saints and kings in his 'history' pictures where French critics like Cochin had found them so

100. After Giambattista Piazzetta, illustration for Albrizzi's
edition of Tasso's *Gerusalemme Liberata*, Venice 1745.

distressingly undignified. It is doubtful if Cochin knew Piazzetta's genre
work other than, probably, his 'Peasant' heads; but he at least had no
illusions about Piazzetta as a realist. It was a pity, he thought ironically,
that Nature, though so beautiful, was not nearly as beautiful as 'the
pictures of Tiepolo and Piazzetta'. The age that, with Diderot, pre-
ferred Teniers to Watteau could not perhaps be at ease with the fantastic
imaginative genre of Piazzetta, a genre that had exceeded nature and, in
fact, no longer tried to be natural.

101. Giambattista Piazzetta, *An Idyll on the Sea-shore*. Cologne, Wallraf-Richartz Museum.

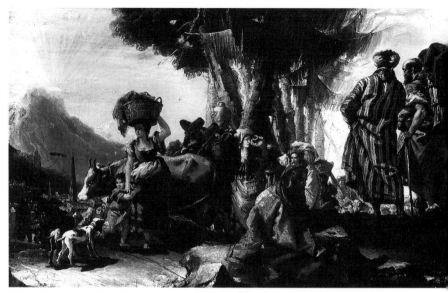

102. Domenico Tiepolo, *Lot and Abraham*. Rome, Carandini Collection.

But genre in the sense of topical comment upon daily life did find a final rather private practitioner, working much more swiftly and satirically than Longhi, in Giambattista Tiepolo's son, Domenico Tiepolo (1727–1804). Domenico's natural talent for genre was for years kept under while he worked as his father's devoted assistant in so many decorative schemes. In those years he had to take his opportunities where he could find them, or invent them. The passage at the left in one of his religious pictures, the *Lot and Abraham* (Figs 102 and 103), shows where his real interest lay; in fact he builds up a whole irrelevant genre incident which displays an ability unequalled by any of his contemporaries in its depiction of North Italian country life. He has not Piazzetta's forceful poetry (though his cow is like a borrowing from Piazzetta's cow (Fig. 104)), but he effortlessly avoids the commonplaceness of Longhi, whom he shames again in his dazzling draughtsmanship. The nearest parallel to the genre-religious treatment here is in the work of the seventeenth-century painter Castiglione, a person much appreciated in eighteenth-century Venice. Domenico suffered, and still suffers, by juxtaposition to a genius, his father. Fastened to those chariot wheels, he was forced into regions where he could barely breathe and his art was forced to posture and pastiche in mistaken filial devotion.

156

It is not very easy to see why Domenico remained confined, unless it was because little patronage was available for the type of work at which he excelled. As assistant he had a hundred uses and he was occasionally rewarded, it would seem, by being given a free hand to insert lively topicality amid the cloudy imaginative splendours of his father's work. The age looked upon Tiepolo and his sons as *one* painter, a firm in fact, and the very distinctions we now try to draw were concealed beneath a single identity. 'Tiepolo' was all the more versatile, in the eyes of the age, that he could fresco you a mythological scene or a witty piece of contemporary life.

A very few years after the *Lot and Abraham*, the firm received its most balanced commission: to decorate the Valmarana family villa (just outside Vicenza), and the adjoining guest-house. In the villa the vast majority of the frescoes, taken from Homer, Virgil, Tasso and Ariosto, are by Giambattista Tiepolo. But in the guest-house, the *foresteria*, all but one of

103. D. Tiepolo, detail from Fig. 102.

104. Piazzetta, detail from Fig. 101.

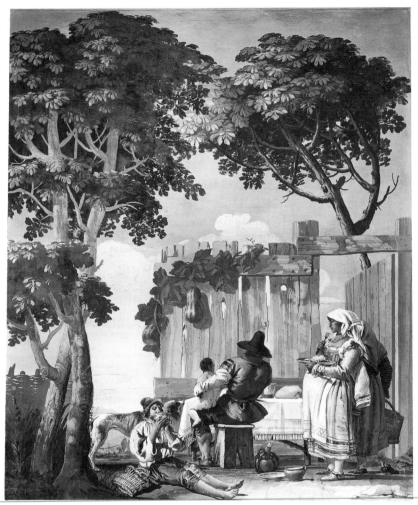

105. Domenico Tiepolo, *The Peasants' Meal*. Vicenza, Villa Valmarana.

the seven rooms were given to Domenico, who signed and dated a fresco there 1757. The scheme was begun by the villa's then owner, Count Giustino Valmarana, who died in 1757 and may not have lived to see it completed. Domenico's frescoes have an enchanting gaiety and wit and freshness, which suggests grateful release from the bondage of being elevated and serious. He proliferates in peasants and pumpkins and meals

out of doors, as well as including some scenes of city life – that is, life at Venice.

Never again anywhere else, not even on the walls of the Tiepolo's own villa, did Domenico portray so extensively and romantically life of the time; he did in fact pass out of being observer of genre into being creator of a world as enchanted in its way as his father's. The *Peasants' Meal* (Fig. 105) is not just country manners charmingly delineated, but is an almost sentimental pastoral that anticipates while surpassing nineteenth-century ideas of the rustic. It has only to be compared with the efforts of Ceruti for Domenico's delight in pleasing to be apparent. His graceful green and bronze trees and the exquisite strip of fencing are illusionist: beautifully painted and deceptive cardboard. The peasants are wittily observed, a pregnant silhouette in the woman at the right, the tall-hatted shape of the man at the table, and painted in pastel blues and browns and white. Though there is artifice here, it is not the over-rouged artifice of Boucher's pastorals but the blended sophistication and naïveté that Mozart gives his peasants; and the world of Domenico's imagining anticipates that of Masetto and Zerlina in *Don Giovanni*.

Domenico's power in such scenes is in his control of the artificial element, so that looking carelessly we accept his scenes as of 'real' life. And he remains all the time acutely aware of people and landscape to an extraordinary degree. The *Peasants Reposing* (Fig. 107) is a type of pastoral never attempted before, balancing as it does on a razor's edge between naturalism and idealization. It is a fresco of a siesta that will never end: where the trees, half touched by premature autumn, will never lose their leaves. The pale, drowsy, flat landscape of the Lombard plain, which is suggested, shimmers in the sunlight which has washed the honey-yellow and white clothes of the elegantly nonchalant peasants into such purity of tone. Domenico makes marvellous use of his father's lessons in flooding frescoes with light and air. Both these frescoes are on walls of one quite small room, and in both Domenico dissolves the wall into these light-filled landscapes with their wide expanses of nearly cloudless sky. Other, less elaborate scenes complete the room; in one Domenico's favourite device of showing people from the back is used with devastating effect upon two peasant women in flat hats and high-heeled shoes (Fig. 106), the right-hand of whom, as they set out along the sunlit road, seems already to be tottering in that way Italian women so often do, their shoes seeming always too small.

Wit and observation drip from Domenico's brush. Freaks of fashionable costume, the trivia of muffs and umbrellas and fans, striped stuffs, absurd

106. Domenico Tiepolo, *Two Peasant Women*. Vicenza, Villa Valmarana.

107 (facing page). Domenico Tiepolo, *Peasants Reposing*. Vicenza, Villa Valmarana.

silhouettes: his eye misses none of them and his satire gets mingled with delight at them. The other rooms of the *foresteria* are full of gaiety, though nothing approaches the limpid pastoral mood of the room of country scenes. But Venice is there with a fresco of the masked crowds at the popular diorama, the *Mondo Novo*, and in another with a quack advertising his wares at carnival times; both subjects sound like those of Longhi, but their brio easily eclipses his pedestrian approach. In another room, decorated in the Gothic manner, Domenico contrasts winter and

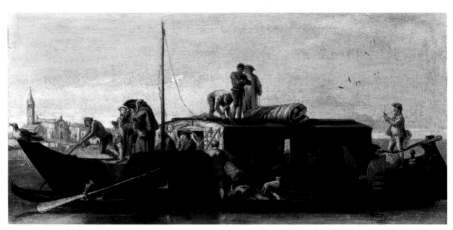

108. Domenico Tiepolo, *The Burchiello*. Vienna, Kunsthistorisches Museum.

summer in two groups, one aristocratic, the other rustic. At each turn his mind takes effortless flights of fancy. He could have painted twenty villas like Valmarana, but he was not required to, unfortunately. Occasionally he painted a typical Venetian scene (Fig. 108), revealing how easily he might have challenged Longhi. Further testimony to his fecund gift for genre is in his many drawings, private expressions, for the most part, of his personality. Follies and fashions continued to divert him, and topical moments like visiting the lawyer or the dressmaker (Fig. 109) are seized in drawings of comic opera vivacity, where life is seen as at once absurd and delightful. The sharpness of his eye takes in furnishings too, as Fig. 109 shows. Yet all this enchanted accomplishment was doomed to remain private. Valmarana remained unique, and largely unknown. Goethe penetrated there in 1786; unaware of anyone but 'Tiepolo' he preferred in fact Domenico's frescoes to Giambattista's and caught their joyful mood.

Domenico Tiepolo lived long enough to see not only the rise of a neoclassic style but its firm establishment. When, after the death of his father at Madrid in 1770, he returned to Italy it was a return to a colder and more factual world: one actually in which he was more at home. Only once again, and then not at Venice, did he undertake a scheme of decoration in his father's manner. Instead, his talent for topical observation at last found free play, and new subjects for satire. At his own private villa at Zianigo he frescoed everywhere: on the walls, between windows, above doors, and some traces of his work remain *in situ*. Animals and birds and the half-wistful white *punchinelli* appear, and frescoes of genre –

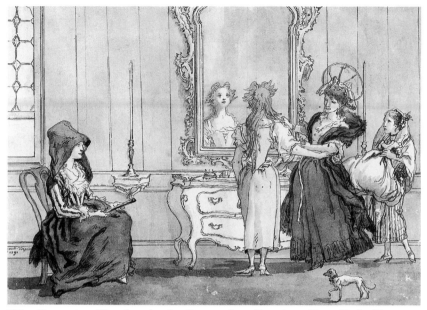

109. Domenico Tiepolo, *At the Dressmaker*. Drawing. New York, Pierpont Morgan Library.

the figures tricked out in the very latest fashion of the 1790s. Domenico was sixty-four when he dated his repetition of the *Mondo Novo* fresco of Valmarana on his own wall. Working so late in the century, and linked to Spain by his last journey abroad, he inevitably recalls the fact that Goya had by that time already completed his genre cartoons for so many tapestries, and those subjects are the nearest parallels to Domenico's work. New requirements and new ideas had altered the subjects of Spanish tapestries from heroic and mythological scenes to scenes of daily life in Madrid and in the countryside, just as taste had shifted in Italy.

Domenico remains of the eighteenth century in his uncomplicated belief that people, and the clothes they wear, are funny. His *Trio out for a Walk* (Fig. 110), which is probably from the very last years of the century, shows him once again indulging in the simple device of seeing his characters from behind. The fresco is from Zianigo, and in it Domenico is painting solely to amuse himself and his family. His three smart yet absurd figures walking off into the eternal Tiepolesque landscape, accompanied by the servant and dogs, are almost the last Venetian eighteenth-century depiction of its people and their world.

163

110. Domenico Tiepolo, *Trio out for a Walk*. Venice, Ca' Rezzonico.

The faint light above the background hills is the light of another century and, like the final shot of a film, these figures are advancing into that dawn. Domenico's affection for his own world is impossible to resist; it is already nostalgic, looking back over its shoulder – like the man at the left in the fresco – and full of the feeling of time past, never to be regained.

5

Portrait Painting

The portrait was probably the most popular category of painting through-out eighteenth-century Europe. Yet, when the century was over, and there remained only the thousands of portraits it had produced, these seemed to have lost even *human* interest. A new generation looked, and found many of them pompous and heavy and ridiculous.

And so Coleridge – discussing art as he discussed everything – thought of the period as decadent and as a good example of decadence he not very accurately cited Francesco Algarotti's tomb at Pisa, with 'its portraits in periwigs sculptured realistically'. They alone are enough to damn it, and by the time of Coleridge's comment the periwig itself has become almost a symbol of a pompous, florid style of portrait, whether sculpted or painted, which a new and easier age found artificial and repellent. And well before the end of the eighteenth century voices had been raised against the pomposities of the period, and protests made specifically against the florid artifices of certain portrait painters.

The general trend, and the reaction, are certainly to be found in eigh-teenth-century Venice. But the portrait painters in Venice were not on the whole particularly distinguished, nor important, nor – with one ex-ception – were they particularly famous. Outside Venice, they were ignored; nor was there reason to pay them any attention, for they were easily eclipsed by the brilliant variety of great portrait painters in England and France, and even, to some. extent, the rest of Italy. When Allan Ramsay arrived in Italy quite early in the century it was to Rome that he chose to go – not Venice – and when he moved from Rome it was to Naples, where he became Solimena's pupil.

The attitude of Europe is understandable. Whereas Italy was still the true home of history painting, portrait painting had been superbly well practised outside Italy during the seventeenth century and the tradition

was firmly established. It was not likely that later Italian painters would contribute importantly to the tradition in portraiture, and Allan Ramsay's training in Italy with 'modern' painters is an exceptional case rather than the rule.

But of course Italy remained the home of the Old Masters, and the greatest contribution made by Venice was that it had been the home of Titian. It is of him that painters like Reynolds and Wilson speak when in Venice; they do not make notes about contemporary portrait painters and probably hardly noticed that there were any. The Venetian portraitists could be said to have worked quite unnoticed and unapplauded were it not for the extraordinary and immense fame enjoyed throughout Europe by Rosalba Carriera (1675–1757). Rosalba initiated something quite new in portraiture, and it is partly the fault of history if it is now hard for us to share the eighteenth century's enthusiasm. She is perhaps the first 'rococo' artist, and the lightness of her style is welcome among the shadows of the seventeenth century into which she was born. The great tradition of Venetian Renaissance portraiture had been carried on, mechanically but not altogether pointlessly, by Domenico Tintoretto in a style that vaguely recalled his father's. His death in 1637 marks the extinction of the real Renaissance tradition; but a shadowy sort of activity continued in the production, often by anonymous painters, of state portraits and senatorial portraits, dim, dull journeyman work which is hardly connected with art at all but is mere effigy-making. An exception is the work of Strozzi. While official portrait painting was being practised in obscurity at Venice, the example of Titian and Tintoretto and Veronese was exciting great artists from beyond Italy: Van Dyck, Velázquez, Rubens, Rembrandt being the greatest. The artistic hegemony had passed entirely from Venice, and very largely from Italy.

Typical in composition, but well above the average aesthetically, is *The Procurator Querini* (Fig. 111) of Sebastiano Bombelli (1635–1716); this smoky crimson and scarlet figure is distantly related to Titian, and retains the traditional opulence of Venetian colouring even though it is colour seen through a tenebroso mist. The conception, however, is really quite unrelated to the portraits by Titian and Tintoretto which had shown the officials of Venice in moments of private repose, and presented them too with penetrating insight. Such intimate portraits had most often been bust lengths, but now the full length, which Titian for instance had reserved for his very grandest sitters, was used for every senatorial and procuratorial portrait. And instead of Titian's combination of intimacy with dignity, as in the *Charles V* at Munich, the new conception emphasized the sitter's

166

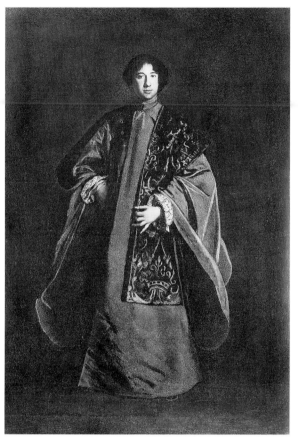

111. Sebastiano
Bombelli, *The
Procurator Querini.*
Venice, Galleria
Querini-Stampalia.

importance and distance from the beholder, who was now inspired by
feelings of respect and awe. Titian's picture is of a tired old man who is
also a monarch, but Bombelli's is – despite the moody characterization of
the face – the portrait of an official first and last.

These full-lengths, which were to become so frequent and popular in
eighteenth-century Venice, derive in the first place from the big votive
paintings of the Renaissance, in which senators and doges solemnly kneel
before an altar or a divine personage and in which they personify Venice.
Everything in those pictures emphasized the hieratic: the grave profile and
dignified gesture, the rich official clothes, all subduing the personality so
that each man becomes a symbol of the Republic itself.

But in the later work, the divine element has disappeared. The direct personal intervention of the Madonna or the patron saint could not be so firmly guaranteed; the fashion for officialdom and families to be painted enjoying a private vision (of which the last great example is Rubens' now dismembered votive picture of the Gonzaga family) began to dwindle. It is true that during the seventeenth century at Venice, as elsewhere, a sort of semi-votive type of picture continued to be painted for state officials, most often for the 'Avogadori', and examples of such pictures by, for instance, Domenico Tintoretto survive in the depths of the Doges' Palace; but gradually the divine element in them becomes only a slight symbol which the kneeling figures virtually ignore. By the time of Bombelli's double portrait of the *Avogadori Pietro Garzoni and Francesco Benzon* (Fig. 112), painted about 1683–4, we have only the undramatic Dove in the sky above the two men, one of whom rather shyly indicates its presence. The picture is frankly a double portrait, a vividly human one in which the celestial appurtenance is barely a distraction; and in other portraits of similar personages by Bombelli even this last faint intrusion is replaced by a plain setting about the figures. People can no longer feel sure of being singled out by heaven. But while the idea still persisted that such heavenly machinery dignified the portrait, a curious solution was arrived at by Francesco Maffei (1600–60) who, though largely active in his native city of Vicenza, also worked at Venice and was influenced by the Venetians. Evolving his own remarkable iconography for such official events as the election of mayors, Maffei conceived full-length portraits in which the personage is wreathed about at times by non-sacred but still moral personifications. The *Glorification of Alvise Foscarini* (Fig. 113) is typical of this work, and Foscarini stands stiffly encircled by cloudy abstractions like Nobility and Clemency – but he alone is felt as *real*.

After Maffei the last step was to dismiss abstractions of every kind, and the worlds of supernatural and natural are kept apart except occasionally in some allegorical ceiling. There are no portraits of donors introduced into religious pictures in eighteenth-century Venice and no patron saints proffer their namesakes to God or the Virgin. Official portraits are most often full length, and the sitter occupies as much as possible of the picture area, the setting being no more than a loop of tasselled curtain and a fragment of balustrade. The same frontal pose goes on being repeated with hardly any variation, and the official confronts us, one hand clasping his gloves and a thin smile of ambiguous benevolence on his full lips. And their perpetual smiles recall how struck Goethe was by the benevolent aspect of officials in a procession he saw at Venice.

112. Sebastiano Bombelli, *The Avogadori Pietro Garzoni and Francesco Benzon*. Venice, Palazzo Ducale.

113 (below). Francesco Maffei, *The Glorification of Alvise Foscarini*. Vicenza, Museo Civico.

To Rosalba this formal world was quite alien, and undoubtedly one of her gifts in the eyes of her European contemporaries was the intimacy and charm of her art. Her work was on an intimate scale, suitable for any cabinet or boudoir, and she worked fast – or at least industriously. She first drew attention to a new and graceful renaissance of the arts in Italy. Born as early as 1675, she was active as the new century opened. The patrons of Watteau, and Watteau himself, welcomed her for bringing back a beauty which had not been seen since Correggio died; they did not hesitate to compare her with Correggio, and the comparison was not altogether ludicrous.

Rosalba had begun very humbly at Venice before the eighteenth century by designing patterns for lace, that *point de Venise* which formed an export and a source of revenue for the city. It is part of the waning of the Republic that its exports too collapsed, and the lace trade slumped while Rosalba was still quite young. She then took up the painting of snuff boxes whose ivory tops offered scope for decoration, work hardly more remunerative than Renoir's apprenticeship to a Parisian firm of painters on china; but, as with Renoir, this early training influenced her style, and to produce a decorative effect remained one of her aims in portraiture. Soon she was painting miniatures on ivory ovals separated from the snuff boxes. The soft caressing effect that she sought could in fact be better conveyed in a different medium, pastel, and so Rosalba took up pastel portraiture, perhaps under the influence of Felice Ramelli, a pastel portraitist of the day who was a friend of hers.

By 1705 she was already sufficiently established to be elected a member of the Accademia di S. Luca at Rome. Outside Italy, it was probably the English who first discovered her but it was the French who wooed her. When Pierre Crozat, the collector and amateur, was in Venice in 1715 he met Rosalba and on his return to Paris started that correspondence whose intention, and culmination, was Rosalba's triumphant arrival in Paris five years later. Once there she was fêted by all the most distinguished figures in Parisian artistic circles. But at Venice, during her early career, she did not live in such a very different milieu, close friends with the elder Anton Maria Zanetti, extensively patronized by Joseph Smith, and sister-in-law of Pellegrini who, having been carried off by the Earl of Manchester to England, became partly her agent in England. One of her sisters had shown an interest in the arts by marrying Pellegrini and another, Giovanna, studied pastel under Rosalba whose work she dutifully but lifelessly copied. Rosalba's household, presided over for long by her mother, was permanently and almost exclusively a studio. The mother was

a widow, and the two daughters did not marry; Rosalba's life was one of frightening activity, letter writing and music making alone interrupting her pastel work, and it is all the more pathetic that the blindness of her final years severed her from the only things she had ever done.

Not since Bernini had an Italian artist had such a reception as greeted Rosalba at Paris. During her stay, 1720–21, she kept a *Diario*, less a diary than a terse daybook of whom she saw and whom she drew, but it is a document of almost Proustian social implications, ranging from the very young Louis XV (of whom she executed two pastels) down to inevitable ubiquitous duchesses. Thus in August 1720 she noted 'Andata a Versailles', her return to Paris and start of a portrait of the king ('Incomminciato il ritratto del Re...'), and then two days later a meeting with Watteau: 'Veduto M.r Vato'.

The only disappointment felt was in Rosalba's appearance, for she was plain to the point of ugliness; yet her femininity offered opportunities at least for literary gallantry, and even Mariette composed a sonnet in Italian for her where the rose (Rosa) and the dawn (Alba) mingle in insipid imagery. She was made a member of the Académie Royale to whom, once back in Venice, she submitted a reception piece of a Nymph, one of those alluring 'fancy' pieces, blend of the real and the ideal which so titillated the amateurs of her age. In 1730 she was tempted abroad again, this time to Vienna where the Paris success was not eclipsed and where, despite appreciation, the atmosphere was less laudatory.

There is really no evolution in Rosalba's style, and only two types of pastel: portraits and 'fancy' pieces. She had quite a shrewd eye for character and, at least in her self-portraits, was capable of almost savage observation. That late self-portrait which she executed for Joseph Smith (Fig. 114) shows that she had observed herself quite clearly, with none of the softness and charm she liberally distributed to others; and the personality here is tragic, myopic, sober and unromanticized. It is almost too harsh a contrast to her conception of, for example, *The Allegory of Painting* (Fig. 115) with her sly seductiveness. We know that Rosalba intended the effect of tragedy in portraits of herself in old age, for in more than one of these she appears as the Muse of Tragedy, the only fictitious element a laurel wreath about her sparse grey hair.

For other sitters she contented herself with a good likeness without commenting on the personality. That was not her business, and she made little effort to alter her formula, which was to draw a bust-length portrait against a plain background, with only slight variations between a set of stock poses. No doubt the age appreciated the tact she showed in accepting

171

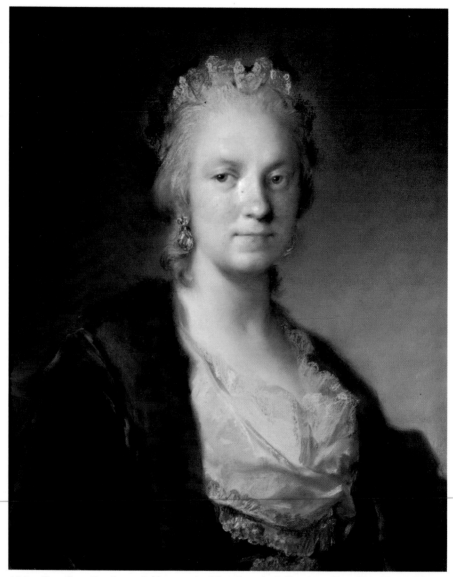

114. Rosalba Carriera, *Self-portrait*. The Royal Collection © 1994 Her Majesty Queen Elizabeth II.

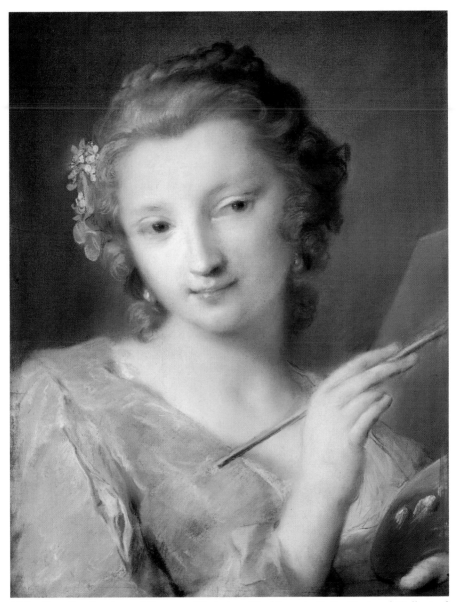

115. Rosalba Carriera, *Allegory of Painting*. Washington, D.C., National Gallery of Art, Samuel H. Kress Collection.

people at their face value, and when the occasion called for it she could positively flatter; so that one of her pastels of Louis XV showed the king in noble attitude, 'accompanied by a Victory which seemed to indicate the road to Glory'. In general, however, the medium of pastel provided its own flattery – rather like a peach-coloured mirror – and Mariette forgave Rosalba's incorrect drawing because of the beauty of her colour. Less professional people probably did not express even that mild demur but succumbed to her technique straightaway.

As early as 1719 Rosalba admitted to diverting to Paris an order for six pictures really meant for England. The English, so much more assiduous as tourists than the French, were then already patronizing Rosalba and many visitors brought back portraits of themselves by her. Such lists of her sitters as have survived from after her return from Paris show many more foreigners, named and unnamed, than natives. The great admirers and collectors of her work were no more Venetian than were the admirers and collectors of Canaletto, and Rosalba's postbag reveals her as besieged by potential patrons in Holland, Sweden, Germany and Austria, in addition to England and France.

Sometimes the portraits brought back by the English were copied at home by amateur pastellists, and these too in the course of time came to be supposedly by 'Roselby' – as we find her name spelt. Many young men doing the Grand Tour sat to her for a portrait which was also in part a souvenir. A more striking example than most is the portrait of Lord Boyne in Venetian masquerade costume (Fig. 116), which exists in more than one version. The picture has great charm, even if charm does not conceal a suggestion of silliness. In it Rosalba has pushed her technique to the utmost in delineating the different textures of the furred cloak, the domino's lace, embroidered waistcoat, all of which set off the blooming texture of the flesh. It is rare for her to draw anyone as so obviously a tourist; in many of her portraits in fact it is hard to say whether the sitter was native or visitor. This pastel seems to commemorate an occasion as well as record a likeness; it is easy to imagine the sitter in a colder climate and at a later time explaining what his costume is and why he was wearing it. The fragility of pastel gives rise to its own nostalgia, as de Nerval, poet of pure nostalgia, has not failed to notice in *Sylvie* where two eighteenth-century pastel portraits evoke the 'bon vieux temps' of youth and happiness. In Rosalba's pastel we are reminded how few of those visiting Italy in their youth were ever able later to return to Italy. Nor is this merely a modern reaction; thus, Sir Adam Fergusson of Kilkerran on his return from the Grand Tour ordered from Zuccarelli (then in London) an 'Et ego

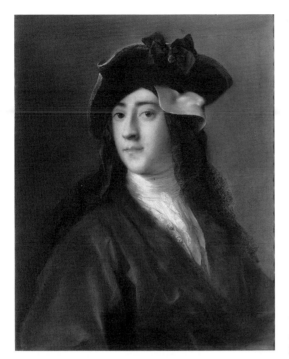

116. Rosalba Carriera,
Lord Boyne. London,
private collection.

in Arcadia', anticipating Goethe's use of the phrase in the same connection,
suggesting a marvellous experience that is past.

As for the faint suggestion of femininity, Rosalba spread it satisfactorily
over her whole art in a way that her period adored. However disappointing
she might be as incarnation of woman herself, she did not disappoint taste
in the women of her pastels. Apart from portraits, and perhaps in pre-
ference to them, there were her 'fancy' subjects, allegories of Art or the
Seasons or the Elements, all represented by piquantly sly girls whose
conscious allure anticipates the women of Greuze. Like him, Rosalba does
not make plain whether these are portraits or imagined beauties; Crozat
had a friend M. de Laporte who was on tenterhooks over this very
point – he longed to meet, he said, a particular one of these charming
people, if indeed the model was from the life. What Rosalba replied to
this is not, unfortunately, recorded, but the request alone establishes the
atmosphere of gallantry in which her pastels were enjoyed. The *Allegory of
Painting* reveals how little different her conception of subject pieces was
from her portraiture; the properties of brush and palette matter no more

than do elsewhere a bird or a flower in the hand. Eyes were concentrated rather upon the attractive coyness of the expression and the half-shielded interesting disarrangement of linen at the bosom.

The element of fancy in all this only made it more enjoyable. Autumn, a Muse, Virtue, were abstractions rather than realities in any sense; their personification as graceful and compliant girls was a fancy not a serious allegory, and part of the fun was seeing the disguise slip and the personification turn into a woman. Rosalba's ability to understand and satisfy this need was taken solemnly on a very high level. Crozat wrote to thank her for one of her fancy pieces just received at Paris and to say how impressed he had been, incidentally, by seeing the antique sculpture brought back from Italy by Cardinal de Polignac. But, he goes on to say, the pastel she sent is comparable to the finest busts ever made by 'those Greeks': a compliment he was under no obligation to make unless he meant it.

That was in 1732 when Rosalba was internationally famous. Boucher, for example, had hardly appeared on the scene and it was only in the light of the frivolous and lecherous graces of the next few years that Rosalba was to seem insipid. But she had been a pioneer in the style that succeeded in swamping her; pastellists more varied and better equipped arose in France, and even in England, and a whole galaxy of portraitists for ever beyond her emulation. Yet her ability was not negligible, and such a portrait as *Cardinal de Polignac* (Fig. 117) shows a sober, sure grasp on both physiognomy and character. Technically too, it is accomplished, with the pastel medium conveying a gamut of textures: fur and silk and skin, and the crisp, near-transparency of fine lawn. In Venice she worked very privately, and the great collection of her pastels was in Dresden where Augustus III assembled quantities; in Venice the most assiduous of her patrons was, once again, Joseph Smith. And at Venice, though she had portrayed Sebastiano Ricci, she does not seem to have been in touch with the famous painters of the new generation. It is another portraitist, not she, of whom we hear that Tiepolo and Piazzetta and Pittoni had begged their likenesses: Bartolomeo Nazari, who had also early painted Canaletto's portrait.

The isolation in which her last years were passed was final. Although Algarotti still wanted work from her for Dresden as late as 1743, her activity was cut short by blindness two years later. An operation temporarily relieved it, but it returned permanently shortly after and she retired into melancholy.

Outside Venice she was not forgotten. When Cochin came to Venice at the mid-point of the century he particularly hoped for an interview with

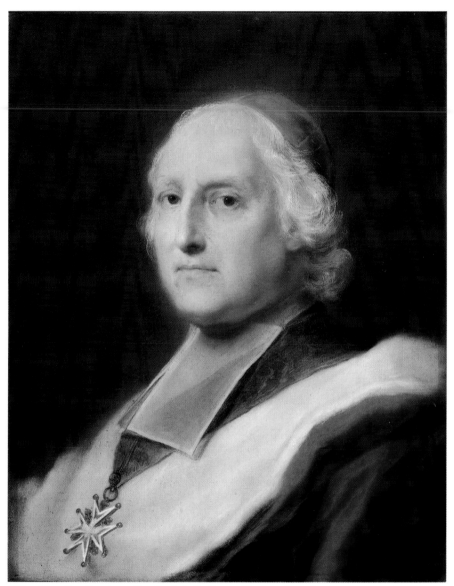

117. Rosalba Carriera, *Cardinal de Polignac*. Venice, Accademia.

118. Jacopo Amigoni,
*Frederick, Prince of
Wales.* The Royal
Collection © 1994 Her
Majesty Queen
Elizabeth II.

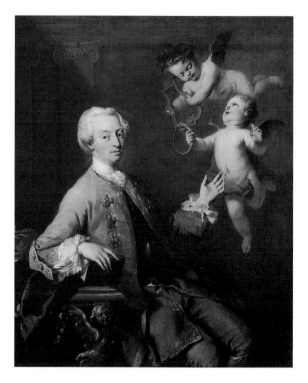

119 (facing page).
Jacopo Amigoni,
*Farinelli with a Group
of Friends.* Melbourne,
National Gallery of
Victoria.

her, but it was probably not granted. Some years after her death, her old friend Mariette was preparing an entry about her for his dictionary of painters but lacked the date of her birth. He was in touch with the Venetian architect and scholar, Temanza, who promised to send a copy of the document – but the promise was not quite fulfilled. Temanza repeatedly sent the birth certificate of Rosalba's sister, as Mariette patiently but firmly kept pointing out. And in the end, even the persistence of the Frenchman weakened; he compiled a highly complimentary biography of his friend without the relevant date.

While Rosalba had lived and worked entirely at Venice, apart from her visits to Paris and Vienna, there had been other early eighteenth-century Venetian portraitists at work, active chiefly outside Venice. Niccolò Cassana (1659–1714) had lived in London and been patronized by Queen Anne, and his style shows more trace of Kneller's influence than of any of the Venetians'. It has sometimes been said that he was among the first to anticipate the lightness and grace of the new century, but his pictures offer

178

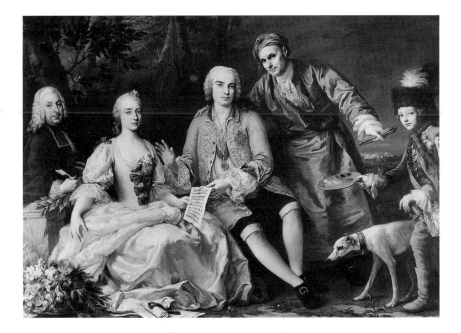

no evidence of this at all. His sitters, in heavy periwigs and plain dark clothes, are solid and dignified and very dull. Cassana's adventure in coming to England and obtaining royal patronage is chiefly interesting in being the prototype for a much grander and more international painter's adventure: that of Amigoni.

Like Cassana not a native of Venice, Amigoni when at Venice painted few portraits. But in the portrait, as in his other work, he pioneered a graceful rococo atmosphere – an innovation particularly welcome in England at the court of George II. His sitters remain rather stiff and flat and formal, but he attempts to enliven them by playful *putti* who float about with ducal coronets, coats-of-arms and various attributes (Fig. 118); while pale colour schemes of white and yellow and soft blue-grey enhance the gaiety.

Once, in a moment of sympathy, Amigoni created a portrait group of his friend the *castrato* singer Farinelli with Metastasio, Teresa Castellini, another famous singer, and himself (Fig. 119), a picture unique at the period and, unfortunately, never to be repeated in Venice. It is an example of relaxed portraiture, as the figures sit informally in the countryside beyond Bologna (seen in the distance). Nobody in Venice was to ask to be

shown so intimately, and Amigoni's picture was painted for Farinelli's own villa just outside Bologna where many years later, in 1770, Dr Burney saw it hanging. Against the felicitous ease of Gainsborough, for example, Amigoni is stilted, yet his picture is all the same a not unsuccessful attempt to show Farinelli and his friends as ordinary beings in a familiar setting, accompanied by flowers and grass and a favourite dog. Nothing so personal was to be painted at Venice, where the emphasis was upon the sitter's rank and position: his detachment from the ordinary world and yet his success in the world. There are to be no favourite animals, no suggestions of personal ease, and, despite all that is so often said of the city's reputation for civilized pleasures, very little of civilized pleasure in the portraits painted.

The intimate close-ups of Rosalba, so many 'snapshots' of her sitters, were not continued by any successor. The tradition of formal portraiture, which Bombelli had carried into the early years of the eighteenth century, survived until the very last years of the Republic, one more piece of ineffectual propaganda. For the official portraits of senators and procurators, even while remaining their private property, were really painted praise of the city itself and its government. The figures themselves have a curious lack of vivacity and vitality, as if drained of energy under the weight of periwig and ceremonial robes. There is a sense of being given the clothes not the man, and such a portrait as that of *Giovanni Querini* (Fig. 120) by a pupil of Bombelli, Pietro Uberti (*c.* 1671–after 1762?), is typical of this work in which there is a frightening airlessness and aridity. Such a picture is half portrait and half heraldic symbol. It is intended to decorate and dignify the room where it hangs; Joseph Smith singled out in his will just such a portrait of the last Doge Cornaro by Uberti (with a portrait by Dahl), bequeathing them to John Udny, his successor as Consul, and remarking 'not improper ornaments, I hope he'll judge, for the house he inhabits'.

The occasion for painting such work was usually an official event such as election to some office, and it was customary for the portrait to be engraved at the same time. In many cases too the actual portrait was set up on exhibition on the day of the subject's solemn entry into his office. This was the custom for Patriarchs and Procurators, and when Francesco Correr was elected Patriarch in 1734 he had three portraits of himself put on exhibition, each showing him in a different costume.

With such demands there came, inevitably, supply. Some painters specialized in official work of this kind, and the family of Nazari established themselves almost as 'court' painters, so many commissions for state and

120. Pietro Uberti,
Giovanni Querini.
Venice, Galleria
Querini-Stampalia.

semi-state portraits did they execute. Bartolomeo Nazari (1699–1763) was not a native of Venice but of Bergamo, and once again is an example of a portrait painter not trained at Venice. Records of what he painted have survived rather better than the pictures themselves, but his official work conformed to the accepted current style and it was in fact he whom the Patriarch Correr had chosen to paint the three portraits of himself. Nazari was a livelier artist than Uberti, and his pictures – unlike Uberti's – have shaken off totally the shadowy mists of tenebrism; and he was clearly a reliable sort of person to produce a perfectly adequate likeness, exactly the type of Royal Academician whose portrait of the local mayor could never give offence.

Nazari was actually capable of greater informality than his usual patrons demanded. He was patronized more than once by the English, and his relaxed conversation piece of *Lord Boyne with a Group of Friends* (Fig. 121), where the group sit talking in Lord Boyne's cabin, is a commonplace of English painting without parallel in Italian painting of the same date. It took very different patrons to produce such a very different picture as this. Equally out of the ordinary was an equestrian portrait of Marshal Schulenburg, that patron of Canaletto and Carlevaris, which Nazari is recorded as having painted – though the horse was not his work. One or two vague rumours reach us of other equestrian portraits painted at the period, but hardly anything has survived to substantiate these or suggest what style of picture they were. It is difficult to say if Gradenigo has made a mistake, or if his note that Tiepolo had received a commission from George II to paint an equestrian portrait of Frederick the Great does record a remarkably unique fact; if the latter, it is unlikely that the commission ever resulted in a finished picture, and perhaps with the subsequent death of George II the matter was dropped. Such equestrian portraits as were painted were

182

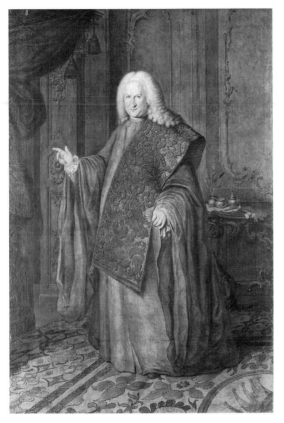

121 (facing page). Bartolomeo Nazari, *Lord Boyne with a Group of Friends*. Castle Howard Collection.

122. Nazario Nazari, *Andrea Tron*. London, National Gallery.

probably not great life-size pieces, but small semi-genre work of the type produced once or twice by Pietro Longhi. It is noticeable, too, that hardly any commissions were given at Venice, either by natives or by visitors, for portraits positively set in the city – as Batoni's sitters, for example, are very much set in Rome.

The more conservative tradition was inherited and continued by Bartolomeo's son, Nazario Nazari (1724–after 1793), who in at least one portrait has summed up finally the concept of the Venetian aristocrat as servant of the State: *Andrea Tron* (Fig. 122). There might seem at first glance little difference between Uberti's portrait of some fifty years earlier and this picture, painted about 1770. But apart from Nazari's more vivid presentation, there is also a more vivid sense of what may be called propaganda. The time had not yet come when David was to paint Napoleon

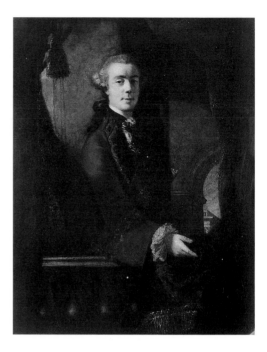

123. Joshua Reynolds, *Lord Cathcart*. Private collection.

working late in his study, while the candles gutter and the rest of France is asleep. Yet the intention behind this portrait is rather similar, with its complete evocation of an actual rococo-panelled room, its litter of documents and ink-wells and quill pens, and the imposing figure with a face of shrivelled benevolence who seems to occupy the whole space. Tron is not shown as Procurator, but he had as senator and ambassador already been long in service of the State and here he discreetly exudes that air of power which won for him the nickname of '*El Paron*', the patron who was also an *eminence grise*. His power is blended with that of the Republic, and officialdom is as clearly revealed by his wig (out of date in ordinary life of the period) as a judge's wig reveals it to-day. The spectator is reminded of what the archaic robes emphasize yet more, that Venice is here: busy and autocratically benevolent, ceaselessly active and always dignified. The carefully observed interior is all part of the scene, very different from Uberti's vacuous settings, and the detail of the littered documents plays its part just as those documents did which Fox, when sitting to Reynolds, asked to have shown beside him marked with titles of Bills he had initiated in Parliament.

184

The grand manner of Venetian portraiture could achieve nothing finer than *Andrea Tron*, and the whole style collapsed with the collapse of the Republic it celebrated. But there did exist one painter capable of loosening the tradition while it lasted, without quite departing from it. Alessandro Longhi (1733–1813), son of Pietro Longhi, possessed too lively an eye for the idiosyncratic in individuals to submerge it in conventional portraiture. In his hands something could yet be made of the portrait as a piece of intimate and human furniture and in this idea of the portrait as *genre* he had as predecessor his father. Their artistic relationship is still in a muddle, for it seems as if Alessandro's portraits began after a while to influence Pietro. However, Pietro's portraits are few and not particularly exciting. He executed on a small scale one or two family groups, which are blended *genre* and portraiture, and there are also acceptably by him a few rather flat single portraits. A puzzling point about these is whether, and how, they can have influenced Reynolds who was only once and very briefly in Venice, in 1752, and who returned to England to paint portraits which are said by scholars to show Longhi's influence. There can be no doubt of the 'Venetian' quality of such a portrait as Reynolds' *Lord Cathcart* (Fig. 123), painted in London a year or two after his return. There is nothing in Pietro Longhi really at all like this; but the manner anticipates Alessandro, who was only nineteen when Reynolds visited Venice. Both painters have gone back to the tradition of the earlier Venetian School and thus they achieve a similarity.

Alessandro was actually trained under Giuseppe Nogari (*c.* 1700–63), a painter who has only recently been given any coherent artistic personality. Nogari's portraits were competent as far as the head; for anything else, said Tessin, one should go to another painter. As well as portraits, Nogari painted in the *genre* way fanciful peasant heads vaguely Dutch or Flemish in character, watered down pastiches often of Rembrandt. Rembrandt's etchings must have been well known in Venice, and among nine pictures by or attributed to him, Consul Smith owned one, *The Deposition* (National Gallery, London), of which Tiepolo was aware (cf. Fig. 159). There was a taste for all such work in eighteenth-century Venice, and perhaps it helped Alessandro Longhi to flavour his work with a sort of gauche realism more Northern than Italian. While Reynolds was to progress beyond *Lord Cathcart* to a much grander manner and was to recognize the sitter's wish to have his character ennobled, Longhi was going to emphasize the quality and trade of his sitters with determined prosaicism.

Although by no means a good draughtsman, he had ability in the actual handling of paint and a sense of the aesthetic quality of the medium which

relates him to Bombelli and back to the great sixteenth-century Venetians themselves. Unlike so many of his Venetian contemporaries, Alessandro Longhi uses oil paint thickly and creamily, not dissipating it into pale mists of colour but achieving dark, rich, opulent tones. When he exhibited the portrait of an innkeeper on St Roch's day, 1760, critics immediately recognized a new and different talent. The picture was painted, so it seemed to Gradenigo, 'con nuova maniera', and even the choice of sitter, perhaps, had its novelty. One saw immediately that it was an innkeeper, for the accessories in the portrait, Gradenigo remarked, made clear that profession; and the innkeeper was shown with a knife in one hand, just about to carve a joint.

Gasparo Gozzi, then editing his newspaper the *Gazzetta Veneta*, was also struck by Alessandro's *Innkeeper*, and was led by it to remark that there is more than one type of beauty in Nature: his sympathy going out to the 'reality' of Alessandro's work as it went out to Pietro Longhi's 'reality'. Both painters, is the implication, paint what they see rather than what they imagine. Alessandro does not paint a scene, of course, but a person; his people are not shown mingling in society, but occupying their place in society: as innkeeper, writer, cleric or whatever it may be. To this extent, the individual is less important than his profession.

It is difficult, if not impossible, to avoid linking Longhi's intentions with the ideal of the portrait as expressed at almost the same time by Diderot. He had been horrified by La Tour's portrait of Rousseau with its combed and powdered appearance in place of the negligent and untidy figure of fact. Instead of portraits where reality is obscured by wigs and fine clothes, he asked for the moment of truth. He tells the anecdote of an iron-founder whose son asked that his father be painted in his ordinary clothes, with his apron and spectacles, perhaps sharpening or testing a steel blade. What was painted was a beautiful portrait of his father in a fine suit, elegantly holding a snuff box. 'Ah,' exclaimed the young man when he saw it, 'it's valueless: I asked for my everyday father and here is my Sunday father' (*mon père des dimanches*).

It is not surprising therefore that male sitters far outnumber female in Venetian portraits of the period, for the age conceived women's place in society as much more restricted. No woman in Venice, it appears, was ever painted in a large full-length portrait. Still less, one may add, are there any of those gallant female portraits, poised on the edge of pornography, which occupied the time of so many French artists of the period. And there is a certain justness in the fact that Alessandro Longhi never portrayed tourists or visitors, for he could know nothing about them. It does not

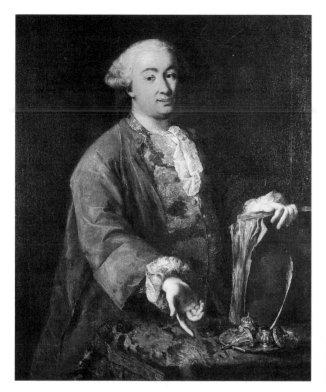

124. Alessandro
Longhi, *Carlo
Goldoni*. Venice,
Museo Correr.

appear that he ever worked outside Venice; he was chiefly the painter of
Venetians, not seen in carnival masks or in official robes but seen as
personalities and even friends.

His portrait therefore of Goldoni (Fig. 124) has an additional aptness
in uniting painter and sitter, for as well as being friends, their ideas
had something in common. Neither of course is a revolutionary; hardly
anybody in Venice at the time was. But both have a certain feeling for
personality, and Alessandro is a much more convincing parallel to Goldoni
in painting than the usual parallel of Pietro Longhi. Something of Ales-
sandro's interest in human nature is conveyed by his publication in 1762
of a group of biographies of important contemporary Venetian artists,
each life illustrated with a portrait engraving by him. And at a later date
we hear of him employed in re-creating personality, given the task of
painting for the newly founded Academy portraits of the great painters
of Renaissance Venice. Alessandro never possessed a part of Goldoni's

talents, but he can claim some affinity with the writer who said: 'rien ne m'intéresse davantage que l'analyse du cœur humain.'

His *Goldoni* has a spontaneous and penetrating air, even while negligently charming. There is nothing pompous in the portrait, but one cannot fail to take the hint that here is a writer. Like the innkeeper of a year or two before, Goldoni has his professional accoutrements scattered around him. He himself stands with a book, dressed in ordinary clothes, his features carefully and almost mischievously observed. Nothing could well be less rococo. No *putto* brings his inkwell or offers him a pen, and instead his sidelong glance of shrewdness seems to cross with the painter's glance as the two of them create a climate of scrutiny too cold for *putti* to inhabit. The thickly applied paint with its creamy impasto is at work too in building up a real image, clotted like lace to indicate the lace cravat and thickly rich on the waistcoat with the thickness of brocade. Rosalba would have used her medium to enhance Goldoni, but Longhi uses his to explore the nature of Goldoni.

The picture must be comparatively youthful work, for Goldoni quitted Venice in 1762 never to return. In the Venice he left, stirrings towards a new and better state of affairs had already begun, but like so much in eighteenth-century Venice they came to nothing. Nevertheless, it is hard to believe that the new ideas of humanity which were seeping in – even into Venice – did not play some part in Alessandro Longhi's attitude to portraiture. Alessandro was to live long enough to see the fall of the Republic, to see Napoleon and the French domination. Meanwhile, he painted in a world that was losing all its old assurance, a world rattled by the opinions of those whose books it banned, Rousseau, Diderot and Voltaire among them. Nowhere else, Rousseau thought, showed better than the Venetian Republic that though man is born free he is everywhere in chains. Even Venice could not check Rousseau's influence, and the different weapons of humanity, satire, scrutiny, scorn, were sharpened for attack on the State and the Church, both of which had failed mankind.

Longhi's *Prelate* (Fig. 125) is painted with as much frankness as his portrait of Goldoni, but the air of mild mischief there has here become almost malice. It is a portrait Flaubert would have enjoyed. Amid the priestly trappings, the face of peasant *bonhomie* has an expression of uncertainty: a doubt as to whether the dignified pose has not toppled, along with the sitter, into ludicrousness. Longhi has not the temper for satire, any more than had his father, but he paints here with a broad candour that makes one smile, even while he avoids caricature. There is, once again, a genuine sense of personality.

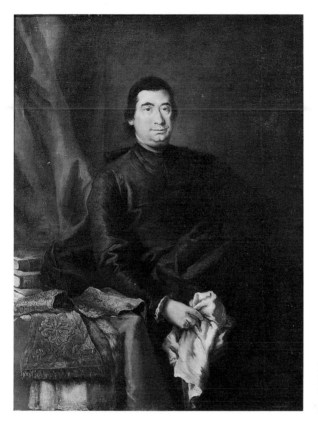

125. Alessandro Longhi, *A Prelate.* Venice, private collection.

Indeed, Longhi could not perhaps mute his sense of such things even when it would have been discreet to do so. A much later picture, probably of about 1780 or so, is the Venetian naval official *Jacopo Gradenigo* (Fig. 127), the design of which is the traditional type used by 'official' portraitists. Longhi's feeling for sumptuous colouring comes out in the gold-embroidered red robes, and the whole picture has an inflated swagger pricked by something indefinable into absurdity. Satiric intent has been suggested to explain the rather ambiguous appearance of Gradenigo, but that is already suggesting too much. It is quite true that the sitter seems to have affinity with some of Goya's portraits, pehaps because of the bland vacuity he has in common with the subjects of those. And one senses the impracticality of the sitter not only as a sailor but as a human being. A piquant contrast is obtained if he is compared with a real seaman painted

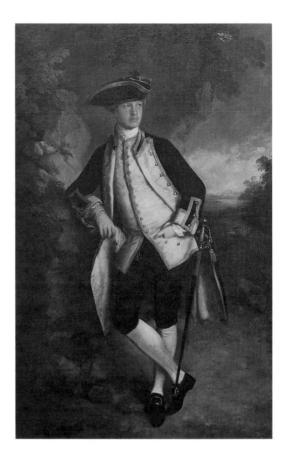

126. Thomas
Gainsborough, *Lord
Howe*. Private collection.

some fifteen years earlier by Gainsborough, the superbly nonchalant *Lord
Howe* (Fig. 126). No comment is needed to underline the difference
between these two full-length portraits from two eighteenth-century
climates. After Lord Howe's gracefully relaxed and capable air, Gradenigo
seems only a powdered periwig and some unnautical clothes, a pompous
pageant figure proclaiming his outdatedness and his fitness for destruction.
In the age of Louis XIV he would have been a trifle overblown and
opulent, but in the very late eighteenth century he is a smiling anachronism:
one of those portraits in a periwig from which Diderot and Coleridge
would have recoiled.

Inevitably, Venice evolved only after the rest of Europe evolved, but in
the end it too changed its taste and ideals. The coming of the nineteenth

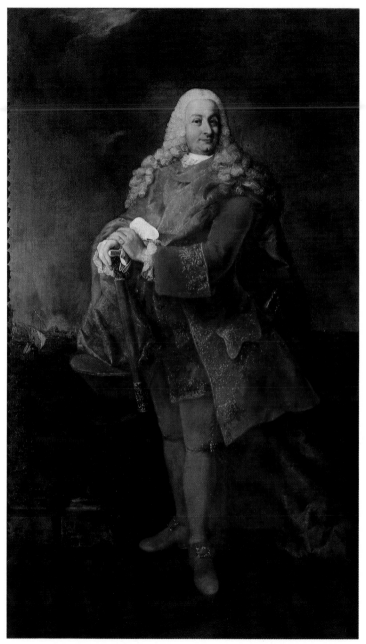

127. Alessandro Longhi, *Jacopo Gradenigo*. Padua, Museo Civico.

century meant a new shift in portraiture and in face painting of every kind. The Venetian portrait painters had been so attached to the reality of the face as it is seen: as a mere likeness. And yet perhaps there is more to it, since portraitists in eighteenth-century Venice had been expressing an interest in physiognomy and personality that seems typical of the whole century in Europe. The appearance of people as such diverted and interested society. Another aspect of the interest which produced portraiture may be seen in the witty caricatures of Zanetti. *Parlanti caricature* had been recorded by a contemporary as Pietro Longhi's forte, though in many ways the words apply much better to the lively, often sub-ironic portraits painted by his son. More highflown ideals reigned in the neo-classic period; the faces nature gave us, tricked out in the fashion of the moment, looked sadly prosaic when, for instance, Canova was alive to sculpt a nobler face, or ennoble an ordinary one.

As a sign of the close of the eighteenth-century Venetian portrait world, and as an expression of new devotion to the ideal, Byron's rhapsody before Canova's bust of Helen is not irrelevant. At Contessa Albrizzi's in Venice he saw it often and admired it more; classically calm and ideally beautiful, it raised new standards and new aesthetic problems for an age turning resolutely from the pastels of Rosalba or the portraits of Alessandro Longhi:

> In this beloved marble view,
> Above the works and thoughts of man,
> What Nature *could*, but *would not*, do,
> And Beauty and Canova *can*!

6

The Presiding Genius: Giambattista Tiepolo

At her death in July 1752 Tiepolo's sister Eugenia bequeathed him nothing. She explains why in her will: because he had so much already. However, she does go on to say that he may have one thing, if he wishes: the pair of portraits of their parents.

There are few other sidelights on Tiepolo's private life, and even this slight one has a certain vivid value. While there may be something of the eternal spinster sister in Eugenia Tiepolo's reference to her brother's prosperity, she gives us a brief glimpse into their family background with parents who were themselves prosperous enough and of sufficient social standing to have their likenesses recorded. And she pays tribute in her way to the colossal success of Tiepolo, actually busy at Würzburg on one of his greatest commissions when she died.

Success is certainly one keynote to Tiepolo's life. From the moment he appeared, as a very young man, on the artistic scene at Venice around 1716 until his arrival in Madrid in June 1762, nearly half a century later, he enjoyed fame, health, considerable wealth, and preserved intact his gift of brilliant virtuosity. Seldom ill and never idle, he was the greatest decorative painter of eighteenth-century Europe, as well as its most able craftsman. Vast fresco schemes or large altarpieces were undertaken by him as easily as small canvases, drawings, etchings; the sheer bulk of his work in all those media is terrifying to contemplate and assess. There was no artistic aspect of the period at Venice left untouched by him: history pictures, genre in the shape of some caricatures, landscape drawings of evocative economy (Fig. 128), even one or two portraits. It is true that he never painted view pictures, but his influence was felt by his brother-in-law, Francesco Guardi, and he at least collected some pictures by Canaletto.

Nevertheless, living and working over such a large part of the century, Tiepolo was inevitably faced with shifting taste. In the active period of his

128. Giambattista Tiepolo, *The Entrance to a Villa*. Drawing. Cambridge, Fitzwilliam Museum.

life – from about 1716 to his death in 1770 – he never managed to establish a reputation in England, nor was he much esteemed in France. And the Italy of that long period underwent changes which gradually obscured Tiepolo's merit and caused him to meet with open hostility. Summoned to fresco the Royal Palace at Madrid, where he had arrived in 1762, Tiepolo asked afterwards to remain in Spain and apparently preferred that life to returning to Venice. Even at the height of his success he was not in demand throughout Italy, but only in the North. Excepting the special circumstances of his Spanish journey, we can say that the kingdom he ruled was a Northern one, extending from Lombardy and the Veneto into Bavaria, and touching also the far Northern courts of Sweden and Russia. This is really more limited a field of activity than that of lesser people like Pellegrini and Amigoni. It omitted Paris and London.

But those capitals, with Rome, were centres of new ideas that heralded Tiepolo's neglect and disgrace. Paris possessed in Boucher a contemporary decorative painter who himself began to receive abuse by the very early 1760s; Rome was to become the home of Winckelmann and of Mengs; London was to see a dogma of aesthetics laid down in the *Discourses* of Reynolds where Tiepolo's name is never mentioned. Winckelmann mentioned Tiepolo, but only to compare him scornfully with Mengs: Tiepolo,

he says, paints more in a day than Mengs in a week, but the former's work once seen is forgotten whereas the work of Mengs is fixed forever in the memory. And before the end of the eighteenth century Italian critics were already discussing Tiepolo and the modern Venetian school in much the same terms.

It is against that shifting background of taste that Tiepolo's achievement must be seen. The denigration that he endured, especially that his reputation endured, continued well into the nineteenth century and is probably still with us today to some extent. There are reasons both good and bad for this. The most understandable is the fact that all Tiepolo's great work remains *in situ* in the churches and palaces of his artistic kingdom and must be seen to be appreciated; even the best photographs give poor indications of its settings and ambience. The least understandable of the prejudices against Tiepolo is against his virtuoso speed, something that his contemporaries enjoyed in the very different art of Metastasio ('I Pittori presti sono come i Poeti all' improviso,' a contemporary remarked) and were to enjoy in the music of Mozart.

Like Metastasio and Mozart, Tiepolo was brilliantly precocious. Born at Venice in the spring of 1696, he must have been early apprenticed as an artist. From the first he was a legend and is marked out as the genius which – almost surprisingly – he became. In so many ways Tiepolo is the last of Renaissance painters, and his precocity seems to belong in the Renaissance; his exhibiting with great success a picture at S. Rocco when only twenty, is the sort of story Vasari would have loved, and Vasari would have appreciated too Tiepolo's effortless facility.

It is part of the legend that this picture, a *Crossing of the Red Sea*, is lost, disappears, in fact, from history after a single mention at the period. Something of its style can be inferred, since a still earlier painting by Tiepolo has survived, and a number of pictures have survived by his first master Gregorio Lazzarini (1665–1730). Indeed, Lazzarini more than once painted the same subject as the lost work, and the dramatic Old Testament episode had already been the subject of a cantata performed at S. Giorgio Maggiore at Venice in 1682. More relevant, probably, was the existence of Renaissance treatment of the subject in the well-known and very large woodcut based on Titian. And the subject's overtones of grand manner continue into the nineteenth century; it was the very episode chosen by Marcel in Murger's *Vie de Bohème* for the picture he never finishes.

Lazzarini is yet one more of those awkward figures straddled between two centuries and two styles; his huge *Charity of S. Lorenzo Giustinian*

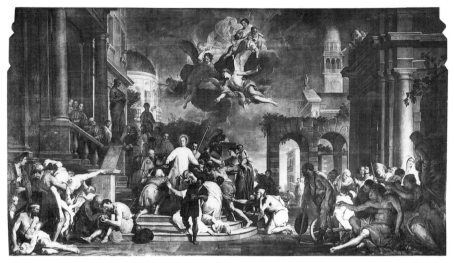

129. Gregorio Lazzarini, *The Charity of S. Lorenzo Giustinian*. Venice, S. Pietro di Castello.

(Fig. 129), painted for S. Pietro di Castello, and still *in situ*, shows a certain compositional grandeur and feeling for colour, much enhanced since cleaning. His studio was situated in the parish of S. Pietro, where the Tiepolo family also lived; apart from proximity, however, he offered Tiepolo some training in decorative painting and was himself popular and famous, much patronized by the aristocracy and still in vogue after his death. Thus Consul Smith, who seldom if ever patronized Tiepolo, possessed paintings by Lazzarini. John Strange recognized in him 'the first modern painter of the Venetian School, who, from that dark unpleasant manner, before used, changed his stile to the lively and graceful'. That testimony (of 1789) is early tribute to his importance at the period.

The Tiepolo family seems to have had its own patrons among the aristocracy. Although merely a plain citizen Domenico Tiepolo, the painter's father, was able to call on noble families for godparents to his children. And the name 'Tiepolo' is itself one of the very oldest and noblest of Venetian names; possibly some member of this family adopted an ancestor of the painter. Domenico Tiepolo was a merchant with a share in a ship, living in a comparatively poor quarter of Venice which retains today its own character. A tablet records the site of the house where Tiepolo was born. Domenico died when Tiepolo was barely a year old, but perhaps his connections were later of use. While still in his early twenties

the painter is recorded as 'curator' of the then Doge's art treasures, as well as working for him as an artist himself. And he was soon employed by other noble Venetians.

Apparently Tiepolo broke away quite early from Lazzarini, feeling no doubt that he had learnt all that the older, more conventional man could teach him. But from Lazzarini he had probably acquired a sound painterly technique and a knowledge of standard sources for subject-matter, secular as well as sacred (Lazzarini had a reputation as a 'learned' artist) and perhaps some familiarity with the Venetian nobility as patrons. Artistically, he turned from Lazzarini to Veronese for inspiration, forming what Alessandro Longhi would term a *'maniera Paolesca'*. Yet Lazzarini had not been indifferent to Veronese, it should be noted, and the architectural setting of his *Charity of S. Lorenzo Giustinian* is distinctly indebted to Veronese. A *maniera Paolesca* was exactly what Ricci had developed and was practising, though not always in Venice, during the time Tiepolo was growing up. His altarpiece for S. Giorgio Maggiore (Fig. 18) had been painted in or by 1708.

Yet Tiepolo's earliest known paintings suggest that he had paid no

130. Giambattista Tiepolo, detail from *The Sacrifice of Isaac*. Venice, Ospedaletto.

197

attention to Ricci and that his aims were at first very different. And when he came to create a *maniera Paolesca* it was with much greater verve and individuality than had Ricci. Before that he seems to have been attracted by the dark drama of late *seicento* painting, and its shadows hang around his *Sacrifice of Isaac* (Fig. 130), one of the series of paintings in the spandrels in the church of the Ospedaletto. This painting may date from as early as 1716. At first glance it does not much resemble the artist we know. The very type of Isaac, with his strong musculature, suggests that of all living painters Piazzetta was then the one who most interested him. The grim human scene of imminent sacrifice might also seem typical of Piazzetta. But the nervously-drawn head of Abraham is already recognizably from the hand of Tiepolo. He would learn to present his dramas more subtly (though it is fair to emphasize the problem here of the subject in such a restricted format) and paint more gracefully, but he remained essentially a dramatic artist.

Several of Tiepolo's other early pictures show him apeing the style of the un-rococo painters of the period, and show as here the almost brutally forceful way he then treated his subject-matter. It took time for his own true manner to evolve; when it did it was different both from the peculiar 'reality' of Piazzetta and from Ricci's plagiaristic pseudo-Veronese style. Nor was Tiepolo to be in any way a 'learned' painter. In approaching historical and religious subjects with a jaunty air he was in the best tradition of Venetian painting, which had always been unlearned.

One handicap to the evolution of Tiepolo's own style was the fact that oil painting on a large scale never suited him as well as fresco. Perhaps he never found totally sympathetic the technique of oil paint, and it remains true of all his work in the medium that the more he 'finishes' a picture the heavier it becomes. His sureness of touch and instinctive draughtsmanship show at their best in oil sketches and frescoes where the paint must be laid directly onto the wet plaster, and retouching is virtually impossible. There, as in his drawings, the light-coloured background was used to give light and space; it shines through the washes of colour and floods the whole composition with liquid air. No doubt to achieve a similar effect, Tiepolo seems frequently to have laid in a pale buff ground over his canvases before painting in oils; but a luminous effect is not properly achieved by this, and in large elaborate pictures little of the ground shows through under heavy layers of worked paint.

The division between frescoes and oil paintings extends beyond technique. Whereas frescoes were quite frankly decorative, oil paintings had often to be of sterner or more humble subjects. Again and again we find

Tiepolo producing an air-filled ceiling fresco, all shimmering colour and grace, while almost contemporaneously he is labouring at some altarpiece which has to be in a vein of more solid realism. Only gradually did he manage to invest his oil paintings with something of his frescoes' grace, and at last forget the seventeenth-century style training of his youth.

The connoisseurs who applauded him while still a young man indicated, even if they did not quite realize, his suitability as fresco painter. A connoisseur like Vincenzo da Canal appreciated in Tiepolo a manner that was 'resolute and rapid' and a nature 'all spirit and fire'. Tiepolo is by that time (1732) one more example of the new tendencies. By that time too he had, as da Canal was aware, given the most sustained proof of his genius as a fresco painter, both in and outside Venice.

In Venice he had frescoed a ceiling in a fairly obscure palace, the newly-built Palazzo Sandi, with a thrilling composition on the quite tricky subject of *The Power of Eloquence*. But it was at Udine that he had had even more exciting and testing opportunities, to work in the cathedral there and also in the nearby palace of the Patriarch of Aquileia, a member of the noble Venetian family of Dolfin, one of whom had previously stood godfather to a brother of Tiepolo's. In the documents of 1726 concerning the decision to have the chapel of the Sacrament frescoed by Tiepolo he is referred to as a 'celebrated' painter. By the time da Canal wrote, he had become 'most celebrated'. And so he deserved to be, and when one visits the gallery he frescoed for the Patriarch in his palace – a room fortunately preserved in all its crispness and sheer freshness – the effect is of total enchantment. Nobody, in Venice or elsewhere, was able to equal Tiepolo's instinctive, vivid, imaginative power to turn a room into a complete decorative whole. Narrow, high, although well-lit, the gallery was not the easiest space in which to fresco a coherent scheme which had, with its painted framework, to cover every inch of walls and ceiling. The theme was solemn and appropriate, dealing with Abraham and Old Testament Patriarchy. Tiepolo accepted it seriously in aesthetic terms, but could not – would not – restrain his invention and his youthful, gracefully flippant verve. If questioned, he could have stated that the Bible was his source but he was not working in an actual church, and by the time he had finished the Bible had been used more in the mood of a fairy-tale.

The ponderous effects of Tiepolo's early canvases are banished and replaced by a shimmering series of tableaux full of wit and elegance. Biblical personages are dressed in a romantic version of sixteenth-century costume, borrowed in bits from Veronese, and set in airy landscapes framed by simple fictive architecture. Like large pictures, the frescoes are

131 (following page). Giambattista Tiepolo, *The Angels Appearing to Abraham.* Udine, Archbishop's Palace.

painted down the longest unbroken wall and clearly lit by the windows opposite; their first effect is of colour rather than of design, colour such as had not been conceived by an Venetian for at least 150 years. The wall is dazzling in its greens and whites and pale yellows and mauves, and the colour alone prepares the onlooker for the enchanted treatment of the elevated theme.

For in this early commission Tiepolo was faced by a problem that faced all the decorative painters of the century, and which he alone triumphantly solved. The most commonly required themes – whether drawn from religion or history – could no longer be dealt with in a straightforward way; in an age of rational scepticism some method was needed to make many of the stories acceptable even as decoration. Other painters could be more frankly frivolous; many others were 'learned' and pompous. But Tiepolo alone induced credibility: not in the story, but in the world he imagined for the story. That is one of his greatest superiorities over Sebastiano Ricci. The boldness of his imagination shows itself already at Udine. Not only does he invent an annunciation not in the Bible, *The Angel Appearing to Sarah* (Fig. 132), but he treats the scene in a spirit of sophisticated enchantment. Sarah is clad in a costume exotic to eighteenth-century eyes – a Renaissance dress and ruff – but Biblical indications of her age are observed by leaving her only two teeth and a multiplicity of wrinkles; she kneels in a picturesquely tumble-down workman's shack hung with a piece of rope, some rag and a flask, and some fat, dark poppies bloom at the base of a tall tree. To her appears the elegantly posed angel in a Renaissance patterned robe hitched up to reveal a bare elegant leg. In the background is a mountainous North Italian landscape which may even be the countryside round Udine.

This mixture of nature observed and the Renaissance recreated is bold enough to compel us to accept its validity, regardless of what it illustrates. It is not so much doctrine in decorative terms as a scene from which doctrine has receded. The impression conveyed is not of solemnity, still less of reality. Tiepolo has no idea – still less any interest in – how the incident actually occurred in Biblical times. His theme is of a mortal honoured by a visit from an immortal, set in a transfigured countryside part Italy and part the landscape of imagination. This actual fresco was chosen by E. J. Dent as a parallel to the juxtaposition of serious and grotesque in Alessandro Scarlatti's operas; and Sarah suggested to him the same type of comic old woman who keeps appearing in these.

In another fresco, *The Angels Appearing to Abraham* (Fig. 131), the lulling incantation is so strong that the angels seem part of a hallucination

132 (previous page). Giambattista Tiepolo, *The Angel Appearing to Sarah*. Udine, Archbishop's Palace.

or a dream: they are born like a multi-tinted mirage out of the bare dry landscape where Abraham kneels rapt. The Bible did not guide Tiepolo (at least, not intentionally) to this view of natural and supernatural. His own taste was always for a moment of awe: the magic moment when the heavens open and celestial beings appear. And the frescoes at Udine are really closer in feeling to the mingled, ultimately magical world of *A Midsummer Night's Dream* than to any earnest religious-cum-historical thesis.

Whereas these two scenes are visionary but undramatic, the version on the ceiling of the *Sacrifice of Isaac* (Fig. 133) is a drama which prepares the way for Tipolo's later treatment of such moments of arrested sacrifice. It is in a very different mood from the Ospedaletto version (Fig. 130) that the fresco here is conceived. Instead of the intimate and desperate group of Abraham advancing the knife and Isaac fainting over the faggots, we are given a *gamin* Isaac sun-bathing in the sudden rays of divine light and a magnificently posed Abraham who is early checked by the angel's arrival.

133. Giambattista Tiepolo, *The Sacrifice of Isaac*. Udine, Archbishop's Palace.

The whole scene is set on a bare mountain peak against a vast expanse of cloudy sky; the composition is a tall, dramatically tilted triangle, its apex the source of the light that has suddenly split open the sky. Like a god from a machine, the angel whirls down so fast that his draperies fly out in a mushroom round his waist, and he comes borne by a spiral of smoky, cumulus cloud.

In some sense 'reality' may be said to be further away in this later version of the scene. But in its place we are given a moment of pure theatre: intervention by God averts a human tragedy. The ceiling becomes the site of a cloudy cosmic drama. Tiepolo has wonderfully conveyed a sense of Abraham and Isaac as the sole inhabitants of their world; Isaac is doomed; and then the tragic moment passes with the shafts of light cutting darkness and the angel's appearance. Before such scenes the eighteenth-century spectator certainly involved himself emotionally. Of a *Sacrifice of Iphigenia* – the classical counterpart of the Isaac story – the Comte de Caylus said that the spectator should not be struck before having shed tears.

'Theatre' is adumbrated in this fresco at Udine. A few years later, still outside Venice, Tiepolo expressed more maturely his sense of theatre in a fresco series of scenes from Scipio's life. In his altarpieces he was still conscious of the seventeenth century, even while showing some awareness of Ricci. His smallish oil painting of *The Angels Appearing to Abraham* (Fig. 134) in the Scuola di S. Rocco at Venice, painted about 1732, shows him returning to a sort of 'reality' very different from the dreamy air of the Udine version of the subject, and reveals how far apart he was still keeping his personality in oil paintings from that in his frescoes. At Udine he was uninhibitedly himself; in the Scuola di S. Rocco painting he acknowledges the influence of Piazzetta.

In 1731 two important commissions had taken Tiepolo to Milan. The first was a series of ceilings for Palazzo Archinto, destroyed totally in 1943. Because of that commission, he writes to Conte Casati, he cannot yet undertake the Conte's scheme; but with his usual speed he soon had the Palazzo Archinto frescoes completed and could turn to the *Story of Scipio* frescoes for Palazzo Casati-Dugnani. They too were completed in 1731.

Less witty and dashing than the Udine frescoes, these scenes are serious and elevated. The curtain rises on rococo drama and it is, once again, opera. The subject was planned no doubt as yet one more favourable aspect of rulers – in a century that was becoming increasingly sceptical of rulers. It would be a change, Cochin wrote some twenty years later, to

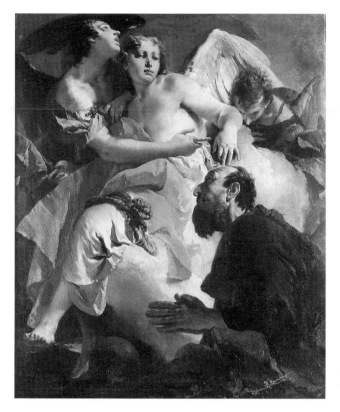

134. Giambattista
Tiepolo, *The Angels
Appearing to
Abraham*. Venice,
Scuola S. Rocco.

glorify a monarch not through battle pictures but through pictures of
royal mercy and generosity taken from history. And the theme of the
Palazzo Dugnani frescoes was stated in general allegorical terms on the
ceiling with a positive *Triumph of Magnanimity*, while the walls are
frescoed with episodes which illustrate the theme in detail. The decoration
was thus intended to form a coherent scheme, and in fact the century was
usually as careful as here to plan its decorations in units, which make up a
single theme or story.

And, as here, the ceiling usually becomes by a convenient convention the
sky. Heaven is needed, but it is more often a secular and moral heaven
where personifications of Nobility and Clemency and Magnanimity triumph
bloodlessly and totally over their opposing vices. Just as in the votive
portrait religious visions are replaced by moral visions – heroes borne to
heaven by their virtues – so here history is interpreted in terms of morality.

The triumphs of virtue over vice which are illustrated on so many ceilings of the period are almost like the medieval Psychomachia – the virtues and vices at war in the soul – and they are a sharp reminder of the period's preoccupation with the problem of being good without necessarily believing in God.

In one way of course such triumphs are truisms. But the age of Johnson never despised a sonorous commonplace, as its tombstones bear witness. A foundation of morality was needed to make art acceptable. When in 1753 there was a project for an Academy of Art at Glasgow, the prospectus stated succinctly the age's belief: 'Nothing is grand and sublime but what is highly moral. The fine Arts can never rise to their highest perfection, but when they aim at the moral perfection of Mankind.'

Like the other Venetian history painters, Tiepolo was not as solemn as this. He observed the grandiloquent conventions, but he did not believe in them, one might guess. Hence the criticism of him by people like Winckelmann was partly justified, granting their canon of aesthetics. When Reynolds wrote that the Venetian painters were not 'wholly serious' he might have singled out Tiepolo, though he was really thinking chiefly of Veronese. At Palazzo Dugnani Tiepolo demonstrates, for the first time on a grand scale, how he reconciles the 'moral' with decorative needs.

Three frescoes illustrate what the ceiling states more generally: Scipio is continent at the fall of New Carthage (the scene that Ricci had already treated (Fig. 20) and which remained so popular); Scipio releases a prisoner; and, a variation from Roman virtue, Sophonisba the Carthaginian receiving the poison sent by her husband, which will grant her death rather than dishonour (Fig. 135). Each scene is set in a painted architectural œil de bœuf framework very different from Tiepolo's later manipulation of the painted architecture to enhance the composition; here it serves merely as proscenium, and the eye passes on from it straightaway to what is happening beyond.

In the *Sophonisba*, everything is concentrated upon the heroine herself, and not even damage to her has spoilt the effect. The organization of the scene inevitably suggests the opera of the period; Sophonisba is the soprano, the 'star', and the people about her are no more than 'mutes or.audience to this act'. Like the chorus of an opera they react without interfering, and nothing distracts attention from the heroine. As the poison arrives she reaches out for it heroically, while consternation seizes her court. It is a moment of drama certainly, but poignant rather than horrific. The deaths and gruesome agonies which had so often been the subjects of seventeenth-century pictures are replaced in the eighteenth century by more affecting

206

scenes; Tiepolo shows us the sort of dramatic moment that Racine could have approved of and it was the French classical tragedy convention that opera had adopted. Needless to say, Tiepolo bothers no more than would an opera with Carthaginian costume and scenery; a mixture of Veronese and fantasy-Oriental costume serves him very well, and the scene is set in a Palladian-style palace. One has only to compare this scene with Pellegrini's version of the same subject (Fig. 136) to see how elaborate Tiepolo has become. Pellegrini is vague, though pathetic; but Tiepolo creates a grand structure – of people and architecture – about his Sophonisba. She is a public figure, acting out her drama before a large audience.

Operatic tendencies become yet more apparent in Tiepolo's later work. But the frescoes of Palazzo Dugnani show how early he had evolved an idiom for dealing with historical subjects and how he had already created his idea of a ceiling-heaven which, with variations, was going to be repeated again and again. He never failed to respond to the demand to dissolve, as it were, the expanse of a ceiling into a sphere of light where the figures recede from us, higher and higher, into infinity.

It is as well that he was not daunted, for the immediate years from 1730 onwards found him increasingly employed. As well as work in Milan, Venice, Bergamo and Vicenza – whence he writes that he is working breathlessly day and night – he was painting altarpieces for Germany. And he would have gone to Stockholm to fresco the Royal Palace, if the Swedes had been able to pay his high price.

These were the years when Tiepolo's fame began to be established beyond Northern Italy; by 1736, for instance, he was well enough known at Vienna for him to be strongly recommended to the Swedish agent on the way to Venice to look for a painter for the Royal Palace; and his altarpieces were reaching Germany by 1739. The immense number and variety of commissions could only be undertaken with assistance, and Domenico Tiepolo was of course still too young at this time to be of help. But Tiepolo did have pupils who worked for some years in the studio, and certainly some of the altarpieces for humble parts of the Veneto were executed with the pupils' help. Probably from quite early he also had the help of the architectural painter Girolamo Mengozzi-Colonna who was to design and paint for him so many frameworks for frescoes and pictures. And all this time Domenico Tiepolo was growing up. Like his father, he was early active; at sixteen years old he is mentioned by Francesco Algarotti as 'already beginning to follow in his father's footsteps'.

Contemporaries do not otherwise make any reference to the actual people employed in Tiepolo's studio; by and large, the studio remains a

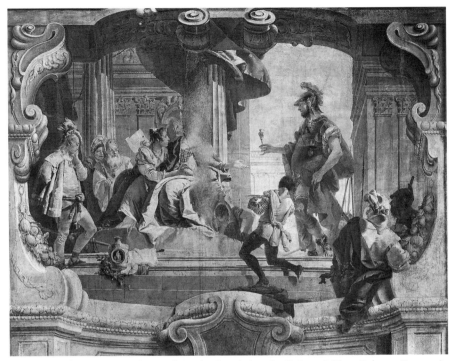

135. Giambattista Tiepolo, *Sophonisba Receiving the Poison*. Milan, Palazzo Dugnani.

mystery to us, almost as mysterious as the apparent inexhaustibility of the master-mind who ran it. A commission meant to most painters countless drawings, preparatory oil sketches and so on. Such sketches are often preferable to the completed work in which vivacity has been lost, and this occasionally remains true of Tiepolo. But Tiepolo sometimes cuts through the whole business of preliminary drawings and produces simply a *modello*, an oil sketch which is to be the 'model' for the large picture and on which the painter has worked out – and solved – his problems. Speed and spontaneity have made such work by Tiepolo the nearest to his frescoes, and the freshness of it made it appreciated at the time, as indeed today. Like Rubens, Tiepolo is at his most dynamic and direct – and often at his most intense – in sketches. It was an age, as Diderot remarked, for preferring sketches since these leave the eye something to imagine for itself, like, he says, children looking at cloud shapes. In Tiepolo's case a whole series of sketches related to a composition was often produced, but only

136. Giovanni
Antonio Pellegrini,
*Sophonisba
Receiving the Poison.*
Munich, Staatsgalerie
Schloss Schleissheim.

one of these would be the *modello*; the rest were variations upon the
original theme, done perhaps *after* the completed large picture.

The actual *modello* was more important, since it was submitted to the
patron who might comment on it and suggest alterations. The more
finished the *modello* the more it too existed in its own right. When
Sebastiano Ricci was once submitting a carefully executed *modello* he
pointed out that this was really the original; the altarpiece to be derived
from it would be the copy. And a busy painter might well be tempted to
submit a *modello* totally from his own hand but have the large picture
painted with studio help.

Tiepolo probably despatched to Germany a *modello* of, for example, his
Trinity Appearing to St Clement, an altarpiece painted in the decade of

209

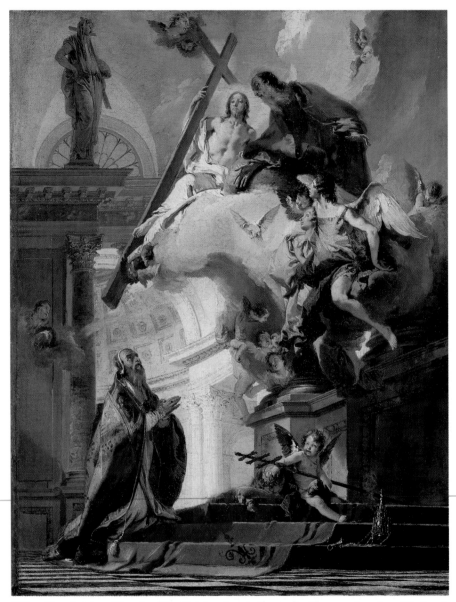

137. Giambattista Tiepolo, *The Trinity Appearing to St Clement*. London, National Gallery.

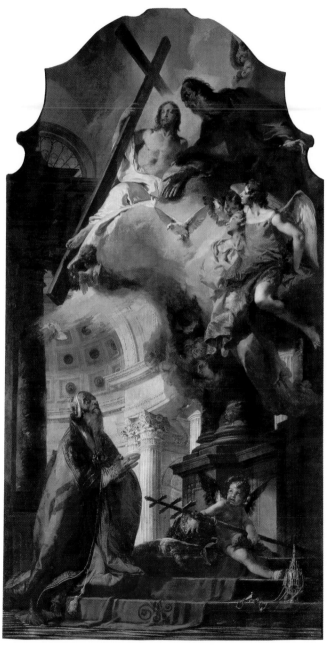

138. Giambattista Tiepolo, *The Trinity Appearing to St Clement*. Munich, Alte Pinakothek.

1730 for the Archbishop-Elector of Cologne, Clemens August, the patron of Piazzetta and Pittoni. What is almost certainly the *modello* (Fig. 137) shows very little variation from the final altarpiece (Fig. 138), which was for a chapel at Nymphenburg; and X-rays reveal that the *modello* was subject to very few alterations in the course of execution, being drawn in originally much as it appears now except that the figure of the Pope was larger and his head was not raised. There seem to be no preliminary drawings, and it would be untypical of Tiepolo if there were. From the first Tiepolo has his conception of the aged Pope to whom appears the radiant group of the Trinity with angels. But at least one other sketch does exist of St Clement, patently by Tiepolo, and showing his martyrdom; perhaps that scene was rejected in favour of the vision of the Trinity, which gives Tiepolo good opportunity for splendid and miraculous effects.

The St Clement altarpiece is not typical of the type of work Tiepolo was producing for Venetian churches, and a year or two later he was occupied by a very different religious commission. Whereas his great ability lay in creating a grand manner for sacred and historical personages, he was often called upon to express religious doctrine in more pathetic and human terms. After the brilliance and enchantment of the St Clement composition, his Passion canvases for S. Alvise at Venice may administer a severe shock. He had already harked back to Veronese, but here he was to recall the tragic religious pictures of Titian and more particularly Tintoretto.

There are two flanking pictures, of the *Crowning with Thorns* and the *Flagellation*, and a large central *Road to Calvary* (Fig. 139), which show Tiepolo passing from the extreme of drama into melodrama. In place of the almost arrogant, unscathed Christ in the *Trinity before St Clement*, is this broken Christ on the way to Calvary, felled under the weight of a sickeningly heavy cross, mocked by the watching orientals and mourned by St Veronica huddled in shadow at the right. The picture has an almost hysterical intensity that is disconcerting and can even seem displeasing. Tiepolo is employing a high degree of rhetoric here – rather more, in fact, than he had done in the preliminary *modello* (at Berlin), where Christ bows his head towards the ground with simple, tragic weariness. So much is going on in the final composition that the artist perhaps thought he must make the figure of Christ 'tell' forcefully amid the trumpets and eagles and excitement on the hill of Calvary. The combination he attempts, of pathos and grandeur in a religious subject, is one associated with Rubens, one of whose sketches of the subject may have influenced Tiepolo, and at the same time it represents an ambition of Delacroix's. When Ruskin bitterly attacked Tiepolo's pictures at S. Alvise as works that might be 'the product

of a modern Parisian academy student', one who had read George Sand and Dumas, he was being shrewd in his very abuse. Where he was quite wrong was in his implication that Tiepolo was false and even insincere.

Almost certainly Tiepolo was totally sincere. It is perhaps rather that he felt too much and allowed emotion to interfere with art. Yet even that needs qualification, for the impact of the *Road to Calvary* is tremendous, and the painter of it is clearly aiming at an ambitious and large-scale assault on the emotions. The vein of intensity in Tiepolo, most apparent in religious themes, was endemic; it is seen resurfacing, though in more restrained, arguably more subtle form, in his late pictures executed in Spain – for example *The Deposition* (Fig. 159). Violence and horror do occur in his art. He can make the blood flow in a martyrdom as bloodily as anyone. But earthly horror is more often, as it were, instinctively

139. Giambattista Tiepolo, *The Road to Calvary*. Venice, S. Alvise.

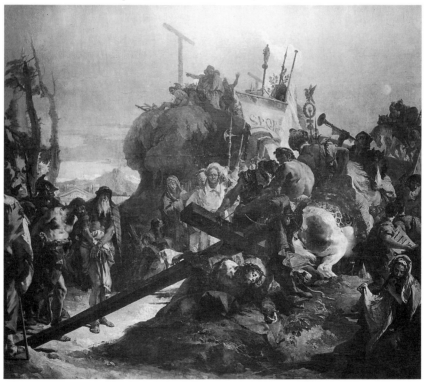

mitigated in his art by the presence of heaven. In his secular ceilings good always triumphs over evil, and that victory is not just depicted but really felt – or communicated. Christ's Passion had to be treated quite differently. A very few years after the S. Alvise pictures, Tiepolo received a religious commission which offered scope for him to unleash the full range of his imaginative power.

At the Scuola dei Carmini he decorated for the Carmelite confraternity a ceiling, the centre of which was to be 'a Madonna descending from Heaven, holding in her hand a sacred scapular which she proffers to St Simon Stock'. The terms of the commission were accepted by Tiepolo in January 1740, but it was two or three years before the central picture and its surrounding ones of *Virtues* were finished. *The Madonna of Mount Carmel* (Fig. 140) is a vision which eclipses the splendours even of St Clement's vision; indeed, it is probably Tiepolo's greatest surviving masterpiece in religious painting. He understood well enough what was required by the subject that was to some extent *his* subject: an assuaging vision of the supernatural to mortals.

The scene which he specifically illustrates here was a vital moment in the history of the Carmelite order. The Virgin is said to have appeared on this occasion to St Simon at Cambridge, though that detail has clearly not bothered Tiepolo. The scapular, two pieces of cloth joined by strings, is the means of obtaining an important indulgence according to a Papal Bull that is perhaps a forgery but which Tiepolo accepts: those who have worn the scapular will be liberated from Purgatory through the Madonna's intercession on the first Saturday after their death 'or as soon as possible'.

The comforting doctrine of this statement is carefully expressed in the painting. Purgatory lies all about St Simon, and the litter of tombstones, skulls, and cloudy horrors of yawning graves contrasts with the tall white figure of the Madonna triumphantly wielding aloft the Child and swept through the sky by attendant angels. The vision is almost a hallucination, and the figures of it are heightened beyond normality. We feel, and share, the saint's privilege as he crouches low before the air-borne apparitions; like him we seem annihilated before this infraction of Nature's order.

The picture certainly is a part of belief, shared by Tiepolo no doubt as strongly as he shared belief in Christ's sufferings and Christ as Son of God. Indeed, so pleased were the confraternity by his work that he was made a member of it, and could thus partake of its posthumous advantages. The S. Alvise picture presents a quite unmiraculous moment: when God was suffering as man, unaided by his divinity. But Tiepolo's mind is instinctively on the side of divinity, excited by triumphs, apotheoses and glories; he

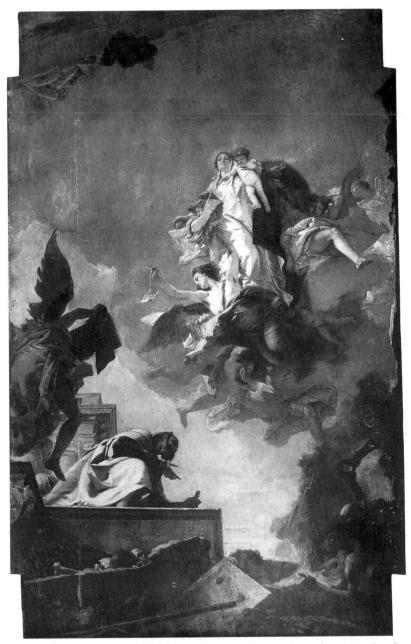

140. Giambattista Tiepolo, *The Madonna of Mount Carmel*. Venice, Scuola dei Carmini.

magnifies the whole conception of the Carmelite vision to his own more splendid dimensions whereby Cambridge sinks into being a Palladian-style cornice but heaven becomes a great space swept by agitated, graceful, feminine forms. In this world of celestial servants it is not the Madonna who holds the sacred scapular; the office is delegated to an angel who carries it in one hand while supporting the Madonna's draperies with another.

That picture was unveiled with public applause. At the same time Tiepolo had yet another and private vein, developed probably from his own drawings and sketches, with some reminiscences of the etchings of Rembrandt and Castiglione. A draft letter from the elder Zanetti to Mariette says of some of Tiepolo's etchings that he believes that if Castiglione and Rembrandt could rise from their graves they would embrace the man who created them. We have some reason for supposing that Tiepolo also collected engravings by earlier artists like Dürer. In the years about 1740 he began to produce his own etchings, blended in subject from his fancy and from half-remembered fragments of other men's work: soldiers and orientals, obelisks and urns enchantingly mingled into 'caprices' (Fig. 141). Ten of these etchings was published at the time, and later a further group was published. Nevertheless, these works are private fantasies of the artist's, revealing almost an obsession with certain motifs which possess for him personal meaning and magic: in some ways equivalent to the inspired doodles which Leonardo da Vinci repeated again and again in his note-books. They show Tiepolo escaping from the tyranny of subject-matter, as Piazzetta had done, and as Guardi was to from the tyranny of the recognizable view of Venice into his 'caprices'.

From these years too, sometime in the decade of 1740–50, date Tiepolo's grandest profane decorations at Venice: the Antony and Cleopatra frescoes in the ballroom of Palazzo Labia. There are unfortunately no references to when exactly these were painted, and little reference to them by later connoisseurs – though Reynolds bothered to sketch *The Meeting of Antony and Cleopatra* in 1752. Other evidence, though slight, suggests that the frescoes were painted, or being painted, no later than 1746–7. By the mid-nineteenth century the splendid room was virtually a ruin, a fact lamented by one of the few Venetians of the period to pay any attention to the last of the city's great painters.

The story of Antony and Cleopatra reaches its culmination in Tiepolo's work at Palazzo Labia. But this famous love affair, not previously popular with painters, had already preoccupied him and had resulted in drawings, oil sketches and at least one large painting, the Melbourne *Banquet of*

216

141. Giambattista Tiepolo, *Caprice Landscape with Figures*. Etching. London, British Museum.

Cleopatra (Fig. 142). The 'Banquet', derived in subject from Pliny not Plutarch, had occasionally provided an opportunity for seventeenth-century Dutch painters to depict a luxurious festival of still life, with peacock-pies and silver dishes laid out on Turkish carpets. Tiepolo is not interested in that *genre* aspect, but in the high drama of the moment when Cleopatra puts one of her fabulous pearls into the wine and astounds Antony by her reckless magnificence.

This aspect of the story fascinated Tiepolo, as did also the conception of the lovers greeting or saying farewell at a port. At Palazzo Labia the two conceptions are crystallized into two of Tiepolo's greatest frescoes; and they are there the chief scenes of an elaborate decorative scheme which has not only been left unexplained but has usually been left unnoticed as well. The real pinkish-orange marble used in the room is carefully matched by the simulated painted marble, and the illusionistic scheme surrounds the spectator on all four walls – the fourth, opposite the chief entrance, being

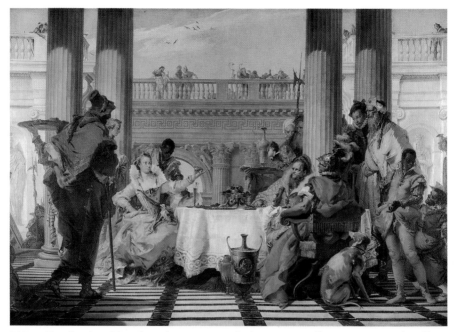

142. Giambattista Tiepolo, *The Banquet of Cleopatra*. Melbourne, National Gallery of Victoria.

frescoed to include a negro page. While the two main frescoes face each other on opposite walls of the high, cube-like room, the ceiling is alive with allegorical figures, Time and Beauty and the Winds, and Pegasus springing white into Olympus. Ravishing colours complete the enchantment, colours hardly susceptible of description for they are personal to Tiepolo. In the *Banquet* Cleopatra wears a dress whose colour resembles some *robe de chambre* of Madame Swann's as Proust describes it: 'vieux rose, cerise, rose Tiepolo...' The combination of history and decoration which was initiated excitedly enough at Palazzo Dugnani reaches heroic proportions here, as a whole world of figures look down on the two lovers, themselves moving in spacious architectural constructions.

Each of the end walls, pierced already by real doors and windows, becomes merely a façade, a pillared screen with a tall central archway leading into the fresco itself (Figs 143 and 144). This achievement is Girolamo Mengozzi-Colonna's, and it is his masterpiece; such painter-collaborators cannot expect to be singled out for praise, but his decor-

ations at Palazzo Labia quickly earned him special mention by at least one contemporary historian. And Algarotti in a fascinating letter of 1756 discussed the alliance of Mengozzi and Tiepolo, with reference to another scheme on which they collaborated, the Pisani villa at Mira. There, he says, all is harmony and shows that a third person must have composed the quarrels which 'in other enterprises those two famous painters have had'. No enterprise between them had until then been greater than Palazzo Labia; were their quarrels equally great?

Mengozzi-Colonna may also have been the designer and painter of the architectural setting of the Melbourne *Banquet*, a setting elaborate but enclosed. The same scene at Palazzo Labia (Fig. 146) is a complicated triumph of suggested space: steps lead through the façade up to a semi-circular platform where the actual banquet is set. This area is encircled but not enclosed by a row of double columns which support the gallery where the musicians play; beyond, against the chalky blue sky, rise the pediment of a temple and a tapering silhouette of a single obelisk. The eye quickly penetrates the painted scaffolding of Mengozzi-Colonna, led into the scene by such trick effects as the dwarf on the simulated steps, and comes to rest at the base of the obelisk where in fact is Cleopatra's hand with the pearl.

To an earlier age even the subject might have seemed vulgar. But Tiepolo delights in its ostentation and its romantic qualities; there is nothing of high Roman terms in his treatment of it, and little that is specifically Egyptian either. Although the story derives from Pliny, this does not hinder Tiepolo from evolving out of the joint Consul with Antony, Plancus, the bizarre oriental figure seated at the left of the table; and in the opposite fresco of *The Meeting of Antony and Cleopatra* one of the flags gaily bears an eagle which, coincidentally or not, is the motif of the Labia arms (a row of eagles is carved on their palace façade). The impression rather than exact fact is what matters to Tiepolo; ostentation is suggested, not painted literally. The location of Egypt is conveyed by the obelisk and a pair of statues; the attendant soldiers are indicated simply by the shafts of halberds rising into the sky; and down the long vista of the scene the two lovers confront each other.

Perhaps, as has been suggested, there are intended overtones of Venice itself in Cleopatra: just as the queen beguiled the man who had come to conquer her, so Venice in its splendour would beguile the Barbarians who plotted to destroy the Republic. What is perhaps more fundamental and certain is that Cleopatra, like Armida in the story of Rinaldo, is one of those enchantress-women whom the eighteenth century enjoyed and detested; at her worst (morally) this type of seductress is Madame de

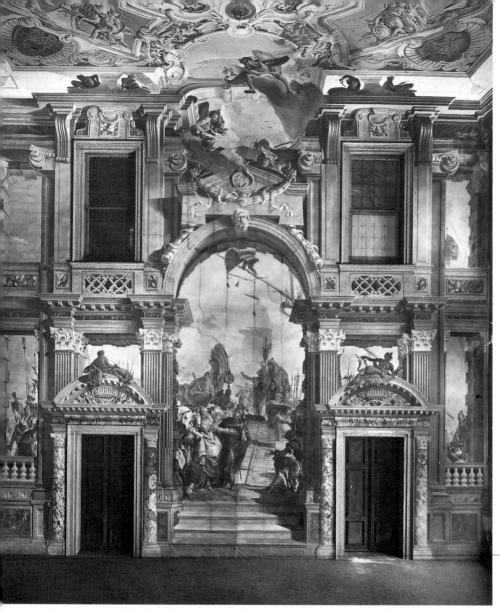

143. Wall with Giambattista Tiepolo's *Meeting of Antony and Cleopatra*. Venice, Palazzo Labia.

Merteuil in *Les Liaisons Dangereuses*. Cleopatra lured on a great man to his fall, and the *Banquet* shows her beginning to weave her spell about him. There is a moral here, and a tragedy also, for as Dryden says 'the

220

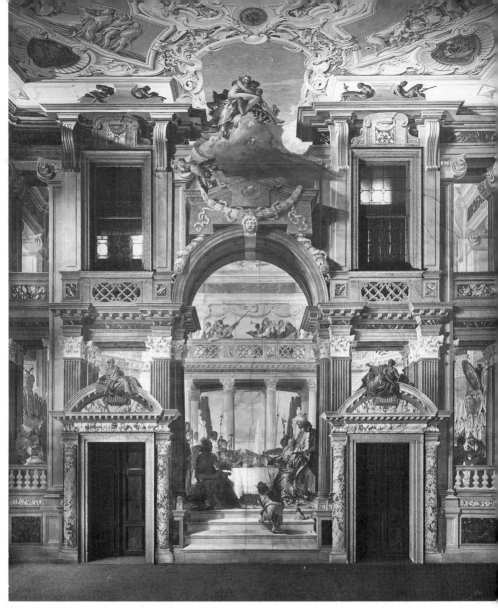

144. Wall with Giambattista Tiepolo's *Banquet of Cleopatra*. Venice, Palazzo Labia.

chief persons represented were famous patterns of unlawful love; and their end accordingly was unfortunate'. Perhaps the last person to paint the subject, Stothard, did so in strongly moral terms; it represented 'Intem-

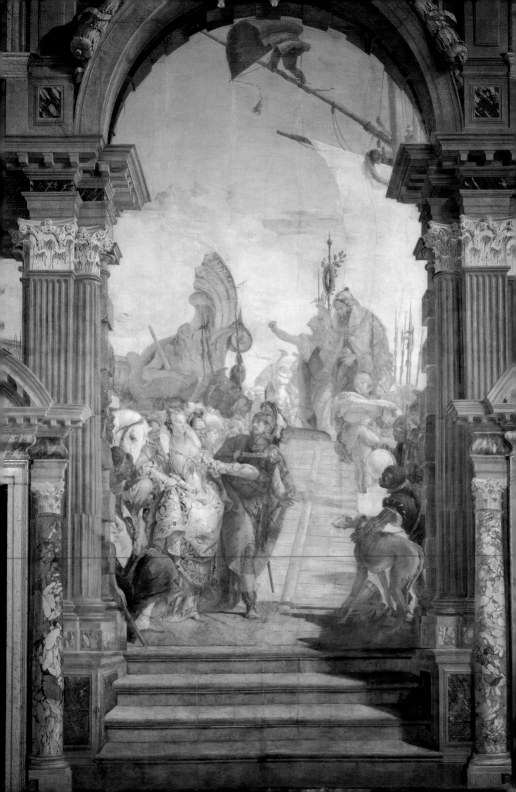

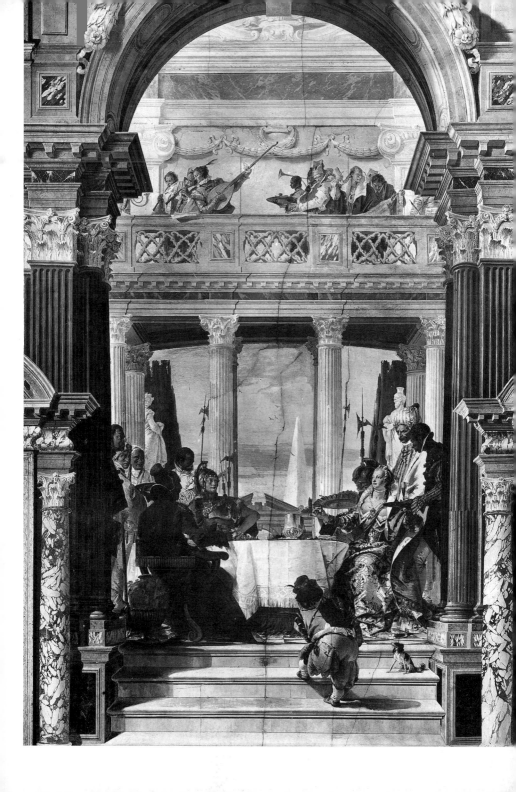

perance' (but whose is not clear). Ostentation for its own sake may also be the theme of Tiepolo's frescoes. The riches of the Labia family were notorious, and one of their ancestors had given a splendid banquet, served on gold plate later thrown into the Canal.

Whereas the *Banquet* had been the subject of at least one large picture before it became a fresco, the *Meeting* (Fig. 145) was virtually Tiepolo's first and final large-scale treatment of the subject. The treatment of it seems rather freer, and possibly it was painted rather later than the *Banquet*. However fast Tiepolo worked, Mengozzi-Colonna (perhaps with assistance) had, on each wall, a considerable task to finish first; and there may well have been some interval for Tiepolo between the two chief scenes. The *Meeting* is conceivably meant to show Cleopatra's landing after her triumphal progress up the river Cydnus, but Tiepolo does not bother to give very precise indications. The lovers advance – Cleopatra in patterned, very faintly pinkish-white brocade; their splendid cortège is suggested in small space by massed heads and one single noble horse; and behind them a gang-plank leads to the shell-like prow of a ship. Suggestions of a whole fleet are conveyed by purely theatrical means: brief glimpses of a mast and tackle and the huge sheet of a billowing sail. The space of sky here seems really wet and windy. The façade-frame of the fresco rises nearly to the ceiling, and there at its top astride the clouds the Winds themselves puff their cheeks to fill the sails (Fig. 147). The *Banquet* is an immobile and tense scene; but the other wall is all movement, from the lovers who swing out towards the room to the flapping flags and prancing horses which emphasize the restless shifting pageant.

These frescoes are the high point of Tiepolo's decorative art in Venice. Magnificent fresco-schemes still lay before him in another twenty years of activity; but fresco-schemes outside Venice. In 1750, with Palazzo Labia presumably completed, he set out for his first journey abroad: to Würzburg, where the newly built Residenz of the Prince-Bishop was to be decorated by him with the help not only of Domenico but also of his younger son, Lorenzo, then fourteen. Tiepolo had not agreed to take this commission without hard bargaining, but the Prince-Bishop gained Tiepolo's greatest masterpieces: the fresco scenes connected with Frederick Barbarossa in the Kaisersaal of the Residenz; and, vaster in extent and even more superb in effect, the Grand Staircase ceiling fresco. Despite heavy bombing of the Residenz in the second world war, the central block still stands intact and it is this portion which contains Tiepolo's frescoes. Nineteenth-century English appreciation of the rococo in any form is rare, and it is all the

145 and 146 (previous pages). *The Meeting of Antony and Cleopatra* and *The Banquet of Cleopatra*, Venice, Pazzo Labia.

147. G. B. Tiepolo, detail from Fig. 145.

more interesting to find Disraeli, writing from Potsdam to Queen Victoria in 1878, declaring not only a fondness for rococo, stimulated by his surroundings, but adding that he was reminded 'a little of the palace at Würzburg which I always thought the model of the style'.

The Kaisersaal was the commission which had brought Tiepolo to Würzburg. Superb as the frescoes there are, they are enhanced by the magnificent rococo room, designed by Balthasar Neumann, with its rich, reddish marble columns and its graceful windows looking over the Residenz garden (Fig. 148). The ensemble in fact eclipses both architecture and frescoes individually, until one turns from the star-patterned marble floor to the ceiling where Frederick Barbarossa's bride is conveyed across the heavens by Apollo (Fig. 149), dazzling interpretation by Tiepolo of Dark Age history. Nothing could be finer tribute to him than that he managed to produce great works of art out of the teutonically-learned programme drawn up by the local court-historian, whose idea of a fascinating subject was the homage paid by the Prince-Bishop Harold von Hochheim to Frederick Barbarossa at Würzburg in the twelfth century. Ignorant but

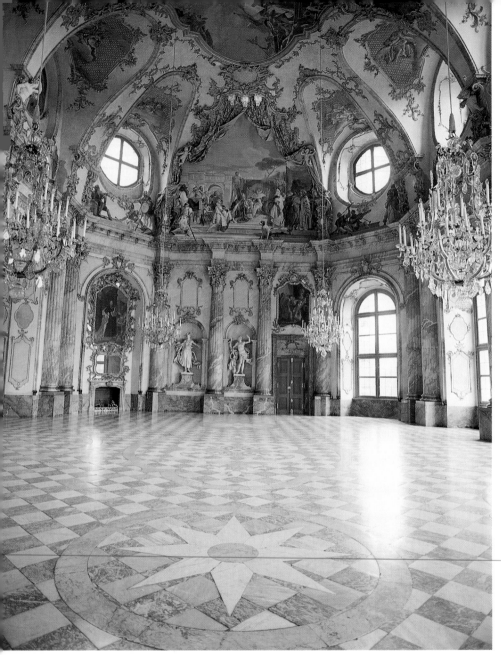

148. View of the Kaisersaal of the Residenz, Würzburg.

149 (facing page). Giambattista Tiepolo, *Apollo Bringing the Bride*. Würzburg, Residenz.

imaginative, Tiepolo placed the scene firmly in the world of sixteenth-century Venice, where for him all history took place, though a suggestion of Würzburg with its fortress high on the hill occurs in the background.

It was by a new contract, signed at Würzburg on 29 July 1752, that he agreed to fresco the staircase ceiling and accept twelve thousand florins for the task. No photographs unfortunately can give a proper conception of the ceiling as a whole, nor of the effect on the visitor slowly climbing the staircase as the vast fresco gradually expands before him. The decorative marriage here of architecture, stucco work and fresco eclipses even the Kaisersaal. Other delightful German rococo palaces exist; no other is frescoed by Tiepolo. Yet the fact that in them even mediocre frescoes take on some beauty and grace is oblique tribute to the genius of men like Neumann who created architectural settings which flatter the feeble and enhance the great. And so here, the staircase with its alternations of

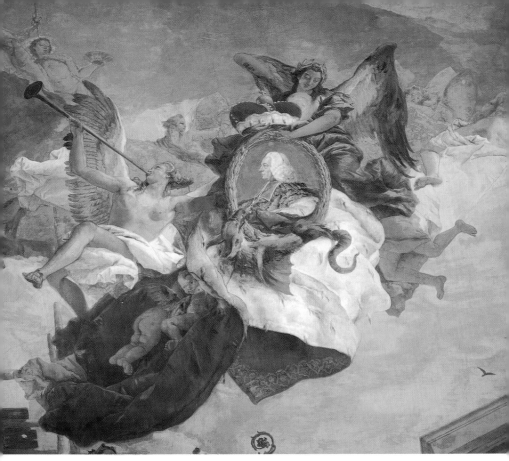

150.　Giambattista Tiepolo, portrait of the Prince-Bishop. Detail from the Staircase fresco of the Residenz, Würzburg.

states, vases, and lamps, guides one by easy stages to the landing where inevitably one pauses. Above, nothing less than the four Continents of the world are assembled to do homage to the reigning Prince-Bishop, Carl Philipp von Greiffenklau, whose ermine-draped portrait is upheld by *putti* while Fame trumpets his name to the ends of the earth (Fig. 150).

The extraordinary apotheosis of this petty and unimpressive person, one of a long line of Prince-Bishops whom the world has forgotten, is a triumph of sentiment over reason. So absurd, indeed, is it to suppose that the Continents would ever pay any attention whatsoever to Carl Philipp von Greiffenklau that the conception is almost imaginative. And, after all, the four Continents find themselves solemnly disposed at the base of the Albert Memorial. It was clearly quite unembarrassing to Tiepolo, who has,

228

munificently enough, given the Prince-Bishop the fame he desired. Within fifty years of the fresco being painted, events were going to make absolute princes rather less sure of themselves, and the simplicity of mind which ordered this ceiling fresco is almost medieval in its anachronism. Not for nothing, one might say, had the Prince-Bishop invoked the twelfth-century shade of Frederick Barbarossa in the Kaisersaal.

Yet the ceiling's iconography is not totally personal to the Prince-Bishop, for there was already a considerable tradition of representing in paintings and in tapestries the four Continents, groups offering every opportunity for the splendid and the exotic. Tiepolo's grandly grouped pageants of elephants, camels, birds and Orientals, Negroes and American Indians, all laden with the produce of their countries, do not fail in the exotic. But the idiom is uniquely his own, and in the midst of Eastern trappings and Asian refinements there are, for example, the sixteenth-century-costumed page-boys of his usual imagining (Fig. 151). And the detail of the iridescent striped sleeve here is one slight indication of Tiepolo's felicitous touch

151. Giambattista Tiepolo, page-boy. Detail from the Staircase fresco of the Residenz, Würzburg.

229

which kept the whole vast scheme fresh and lively and marvellously effortless. Never again could even Tiepolo express himself with such exuberance and enchanted virtuosity. Given the globe to create, his imagination expanded globally. Such an achievement could happen only once. Slightly out of the true centre of the heavens, at the point from which radiates the light which touches the groups of Continents, Apollo himself (Fig. 152) hovers in mid-air. Everything finally comes to this radiant circle and to the god who is the light of that world, the poised centre around whom revolve the *putti*, the Personifications, the Continents, even Carl Philipp von Greiffenklau. It is, in the end, the apotheosis of Apollo that we witness; and he as god of the sunlight may be claimed as Tiepolo's god. The Würzburg ceiling is an ode in his praise; not imperceptibly has it been claimed as Tiepolo's Sistine chapel.

In 1753 the vast task was finished, and in the November of that year the painter and his two sons set off for Venice. At Würzburg Domenico Tiepolo had not only collaborated with his father, but had undertaken by himself the painting of over-doors in the Kaisersaal. Although he served loyally, and adequately pastiched both his father's matter and manner, he was not of course at heart that type of painter. At Würzburg not only did he begin to have opportunities to show his real talent, but perhaps something of his more intimate style began to influence his father. Giambattista Tiepolo was now fifty-seven, and probably did not expect ever again to work on such an extended scale as at Würzburg. A tendency becomes apparent in him over the following years for more intimate treatment: of mythology and of religion. Perhaps it was initiated by Domenico.

Two years after the return to Venice Tiepolo was elected President of the Venetian Academy. Piazzetta had died in 1754 while the Academy was still more of an idea than an established fact. And now Tiepolo was created its first President, for Piazzetta's title had been Director. The year of Tiepolo's election is perhaps the *annus mirabilis* of his career and his fame. It was also the year of Winckelmann's appearance on the literary scene: with a work on how to imitate the ancients in art. Taste was shifting, and Winckelmann's slim, learned volume is an early sign of that shift. At Venice Tiepolo was busily employed as ever: so busy that he seems never to have bothered to obey the Academy's rule of presenting a reception piece. Indeed, though its first President, and the first painter of Venice, he seems to have had no relations with it once the three-year term of his presidency was ended. His imagination still dwelt most happily in a hedonistic, illusionistic mythological world which Winckelmann could

152. Giambattista Tiepolo, Apollo. Detail from the Staircase fresco of the Residenz, Würzburg.

never have respected. Tiepolo's ceiling (Fig. 153), for one of the Contarini family palaces at Venice, possibly dates from this period and shows what may be an allegory painted to celebrate the birth of an heir. Venus, Time, the Graces: classical antique figures depicted by the ancients take on the familiar appearance of everyone in Tiepolo's art, confidently astride the clouds in a climate instinctively superior to our own. Amid delicate, dawn-tinged draperies a bare-breasted, blonde Venus tenderly confides her son (*not* Cupid, because wingless) to the bronzed arms of Time who drops his scythe to cradle the child. Thus, it seems, the boy is destined for immortality.

As for the tendency in Tiepolo towards an intimate and even tender treatment of heroic themes, this finds expression in some of the scenes in the fresco series for Villa Valmarana, outside Vicenza, painted about 1757. Domenico's contribution to the series – the rooms of the guest house – has already been discussed. In the villa itself Giambattista Tiepolo frescoed the hall and the four downstairs rooms that lead off it. The *Iliad* and the *Æneid*, the *Gerusalemme Liberata* and the *Orlando Furioso* provided the subjects for the four rooms. Bettinelli, a poet of the day and one who had praised Tiepolo, explains in his *Dell' Entusiasmo delle Belle Arti* (1769) that what makes these poems immortal are 'le passioni d'Achille, di Didone, d'Orlando, di Tancrede. . . .' These are virtually the moving emotional subjects Tiepolo treated. In this way he becomes almost a historian of the sort Bettinelli mentions, whose duty is to paint, 'come in gran quadri', great personages in such a way that we seem to be present 'at a theatrical performance excellently played by excellent actors'. In the hall a whole long wall is decorated with one last great treatment of the 'sacrifice' theme, *The Sacrifice of Iphigenia* (Fig. 154). Here Tiepolo sounds the drums and trumpets of his grandest manner in the most perfect treatment of a theme which had often occupied him. It is a bloodless operatic drama, for even as Iphigenia raises her eyes to heaven in a last plea, Diana herself appears on the ceiling. The effect of theatre is heightened by that relationship of wall to ceiling whereby the whole room becomes, as it were, a stage. The front door of the villa opens on to this scene; the visitor steps at once out of the everyday world of a garden on a hillside near Vicenza into this illusionistic and static moment where for ever Iphigenia's sacrifice is arrested at the altar by divine intervention.

But in the small villa rooms Tiepolo adopts a simpler and more poignant manner. Taking a subject hardly ever, if indeed ever at all treated by another painter, he achieves in *Achilles on the Seashore* (Fig. 155), a sort of inlet into the poetry and pathos of Homer' s world. The hero mourns by

232

153. Giambattista Tiepolo, *Allegory with Venus and Time*. London, National Gallery.

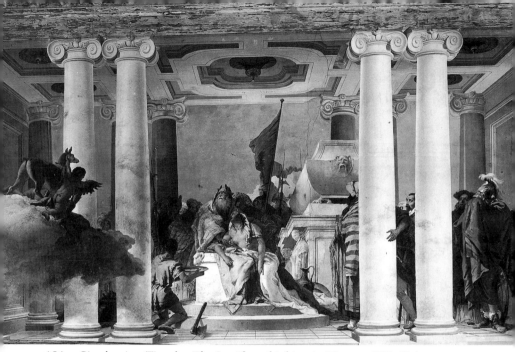

154. Giambattista Tiepolo, *The Sacrifice of Iphigenia*. Vicenza, Villa Valmarana.

the seashore – though the seashore is no more than an artificial platform – and his mother rises from the grey sea to comfort him. There are here no flourishes of the rococo, no drama; no triumph even. Under the shadow of towering rocks Thetis and her Nereid companion gaze mournfully at the brooding hero; and the note of pagan sadness looks back to early Renaissance treatment of the classical story: not to Veronese but to Botticelli.

Other frescoes at Valmarana are gayer or more dramatic. But the poignancy of the *Achilles* prepares the way for the poignant human feeling behind so many of Tiepolo's late religious pictures. In the single room he frescoed in the Valmarana guest-house, he chose *Olympus* as the subject: so many softly tinted clouds cover the walls, amid which recline the charming insouciant figures of his gods and goddesses, themselves so free from any serious classical overtones. In the midst of Domenico's scenes of everyday life, Giambattista assembled a pantheon and an anthology of the persons who had haunted him for so long: men heroic and healthy in armour and women with blonde flesh and hair, buoyant and at ease like the group of *Mars and Venus* (Fig. 156). When this was painted only Boucher could rival Tiepolo's mythological world with its constant air of being filled with people enjoying themselves and asking us to enjoy the

155. Giambattista Tiepolo, *Achilles on the Seashore*. Vicenza, Villa Valmarana.

156. Giambattista Tiepolo, *Mars and Venus*. Vicenza, Villa Valmarana.

spectacle of their so doing. Tiepolo quite lacks Boucher's erotic energy – he is far more decorous and far less flippant – but both painters aim to delight not instruct. Four years later Anton Raphael Mengs was going to execute his cold seriously classical *Parnassus* (Fig. 157) for Villa Albani at Rome: frigid rebuke in its absence of illusionistic tricks to the excesses of the rococo which was already marked as doomed. And a few years later still, Mengs and Tiepolo were to be brought into artistic rivalry at Madrid.

For Tiepolo remained as active as ever. After his stay at Vicenza, he was at Udine, then at Verona, then busy on a large ceiling for the country villa of the Pisani family at Strà. In March 1761 he wrote of this task as the

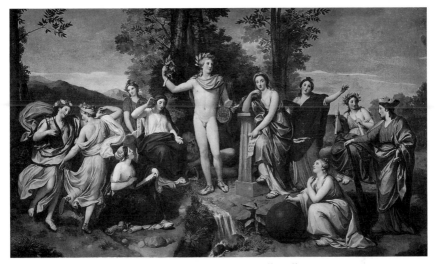

157. Anton Raphael Mengs, *Parnassus*. Rome, Villa Albani.

most important of all his commissions; at the same time he was working
on a large canvas for the Russian court and two pictures for S. Marco at
Rome, as well as – quite possibly – a never finished allegorical portrait of
Frederick the Great. But already a still larger task was being prepared.
Charles III of Spain needed a painter for the vast rooms of the newly built
royal palace at Madrid. He appealed for Tiepolo, and appealed through
his ambassador at Venice for the Senate to expedite Tiepolo's journey to
Spain. Tiepolo delayed, busy – and perhaps reluctant – as he was. But by
December 1761 he was resigned to going, and in the spring of the
following year he set out on the longest and the last journey of his life.

Ill and tired, he reached Madrid in June. There he once again repeated,
on the huge throne room ceiling, his vision of the heavens: this time an
apotheosis of almost the last great absolute monarchy, that of Spain. Once
more provinces drag their offerings of tribute, Apollo bestrides the cloud,
Spain (in the person of Neptune) rules the waves. Two more, smaller
ceilings were painted in the royal palace, with the help of Domenico and
Lorenzo Tiepolo.

Tiepolo had completed the mission on which he had come. Yet he
showed no haste, perhaps no inclination, to return to Venice. That seems
on the face of it rather surprising, and it is a pity there are no letters by the
painter explaining his delay or his preference for remaining in a foreign

country, and at an age when the uncertainty of his reaching home again must yearly increase. Possibly his health and the prospect of further work for the Spanish court combined to make him reluctant to leave Madrid. In any event, he chose to stay when the question was formally put to him in 1767, and he thanked the king accordingly. 'Esta bien', Charles III noted on Tiepolo's grateful reply, going on to make a memorandum that work should be allocated to the painter. It was Tiepolo who eventually drew respectful attention to the fact he had received no commission. Silence, procrastination and perhaps intrigue were weaving an atmosphere of uncertainty about the ageing artist. The king's confessor favoured Mengs, placed in the position of being Tiepolo's rival (unwittingly or unwillingly, it may be), whom Charles had previously patronized; and when finally Tiepolo received an important commission, for seven altarpieces for the newly-built church of S. Pascual Baylon at Aranjuez, his triumph was sadly short-lived. The altarpieces remained in position for barely six months before being removed. The commission was re-assigned, this time to Mengs, assisted by two Spanish painters, Bayeu and Maella. It was an extraordinary humiliation, unique in Tiepolo's career; but he never knew of it. By the time it occurred he was dead.

Partly damaged and mutilated, the now dispersed altarpieces survive, and they show marked fluctuations of quality, in handling and even in composition. It is clear that they were never entirely autograph. The brightest aspect of a dark and tangled story is that there also survive intact five of Tiepolo's own *modelli* for the altarpieces (they were once in the collection of Bayeu), the five chief ones. They show Tiepolo still a superb master, still inventive, and painting now with a nervous, almost fevered – and poignant – feel for paint that matches his saintly, mystic subject-matter. He still at times thinks in terms of glories and visions: an angel appears with the Host to St Pascual Baylon; angels float through the pillared room where St Charles Borromeo is in ecstasy before the Crucifix. Yet the subjects are no longer excuses for grand displays of celestial pageantry, but treated with a developed intensity of emotion: an agitation which is felt in the flickering touches of paint and in the faces of the saints, fretted by the agony of devotion. It is as if he recalled – and now totally understood – the achievement of Piazzetta's Gesuati altarpiece (Fig. 30).

A scene like the *Stigmata of St Francis* (Fig. 158) – a subject Tiepolo had painted once many years before for a Venetian church – is pathetic not grandiloquent. The angel is borne on no splendid sweep of cloud, nor surrounded by a circle of cherubs; instead, he embraces with a consoling gesture the saint seated in a harsh and arid landscape, and the stigmata's

158. Giambattista
Tiepolo, *The
Stigmata of St
Francis*. London,
Courtauld Institute,
Princes Gate
Collection.

infliction is treated almost as a human ordeal. Tiepolo had tried a way of
treating religious subjects in human terms in the S. Alvise Passion picture,
but without simplicity or poignancy. Christ's suffering became there
something of a spectacle. His late small sketches are moving because so
unmelodramatic. The *St Francis* could hardly well be quieter or less
rhetorical in its suggestions of the loneliness of sanctity; and the frail
wooden cross, drawn with nervously fluid strokes of the brush, rises tall
into the empty sky like a symbol of that loneliness.

In another very late sketch painted in Spain, the *Deposition* (Fig. 159),
the subject has resulted in a more stark and intensely tragic scene.
Domenico had painted a number of versions of the subject in which the

159. Giambattista Tiepolo,
The Deposition. Zürich,
Kunsthaus.

story is illustrated literally: orientals and soldiers, the thieves on their crosses and a reconstructed Jerusalem behind. But Giambattista's is not an illustration; it is a meditation on the story, mystic not literal. So there are no human mourners or spectators except St John and the Virgin; even the thieves' crosses are bare. Instead, the corpse of Christ is mourned and tended by angels, while the Virgin raises her grief-stricken face to heaven, seated as it were in eternal sorrow. Christ's suffering and death become timeless, as in those early Renaissance pictures where the Passion is set outside Florence or some other recognizable city; here the setting is Spain and in the background, between the crosses, appear the buildings of Madrid.

On 27 March 1770 Tiepolo died suddenly. His two sons parted immediately after: Lorenzo remaining in Spain until his death, Domenico setting off home for Venice. And Tiepolo's idiom died with him. No one was to attempt its resurrection, though the style continued to be reflected at Venice in the pale imitations of minor men. He died in a foreign country which was perhaps the only country left in Europe where he could be sure of a welcome, and even there he had met with opposition and neglect.

The greatest imaginative painter of the age was really outside the standards his age erected to judge painters. When Cochin said of one of Tiepolo's ceilings that it was 'more beautiful than natural' he indicated, as he thought, its failing. And against this canon of 'Nature', the great artists of the eighteenth century were often to seem culpable and even ridiculous. In England Gainsborough's portraits were to be called 'daubs'; in France Voltaire sneered at Watteau's work and Diderot said he would give ten Watteaus for a single Teniers. Tiepolo was, then, exercising his imagination in a chilly climate of critical appraisal. He might be popular with his compatriots, with aristrocratic patrons in *retardataire* countries; but two of his chief pictorial sources – religion and mythology – were themselves going out of favour. An age of intellectual scrutiny, as the eighteenth century increasingly was, could hardly be expected to take Tiepolo's work seriously, and the more imaginative he was, the more he invited criticism.

Canaletto, Francesco Guardi, Pietro and Alessandro Longhi, and Rosalba Carriera as well, all have some value as recorders, in varying ways, of their city and their century. Tiepolo is no less Venetian in his birth and in his art; yet he soars above its circumstances, as he soars beyond the restrictive, conventional concepts of the period as prosaic or an age 'of reason'. He is something of a mystery even as a personality. Little emerges from the anyway meagre documentation about him. He kept no diary – not even one as terse as Rosalba's. He was not the subject of any proper biography until long after his death. By contrast, Piazzetta's life was written by a devoted friend. Dying far away from Venice, after a considerable absence, Tiepolo had perhaps died to many of his countrymen several years before.

Although he stands above and beyond eighteenth-century Venice, he is nevertheless the best excuse for paying its art serious attention. Whatever its associations of the trivial or the superficial, or the doomed, it was the environment that bred him – which might make one pause. Of course, it does not 'explain' him. Nothing, ultimately, does explain genius. What genius like his asks supremely is to be appreciated. We must redefine our concepts of his city and his century to accommodate the radiant, confident and unique beauty of his art. No other painter ever matched his cosmic vision of blue skies and white horses and shimmering celestial personages, far exceeding the natural but given reality by the creative power of his intense imagination.

It is not only to Venice that he belongs but to the world.

Notes

For bibliography on the painters discussed in the text, the reader is referred firstly to that given under each in Thieme-Becker, *Lexikon*, supplemented by the bibliographies in C. Donzelli, *I Pittori Veneti del Settecento*, 1957 (where illustrations of pictures by the majority of painters discussed here will also be found). A more up-to-date bibliography is provided in E. Martini, *La Pittura del Settecento Veneto*, 1982, and see the Select Bibliography of the present book.

INTRODUCTION

For the general background up to and including the eighteenth century, see O. Logan, *Culture and Society in Venice, 1470–1790*, 1972; for the end of the century and beyond, see the exhibition catalogue *Venezia nell'età di Canova*, Venice, 1978. For eighteenth-century Venice see: S. Romanin, *Storia Documentata di Venezia*, VIII, 1859; W. Carew Hazlitt, *The Venetian Republic*, 1900 ed., II; P. Molmenti, *La Storia di Venezia nella Vita privata*, 1908 ed., III; M. Berengo, *La Società Veneta alla fine del Settecento*, 1956 (particularly important); *La Civiltà Veneziana del Settecento*, (Fondazione Cini), 1960. Chapters 44–6 of J. J. Norwich, *A History of Venice*, 1982 ed., pp. 575 ff., deal with the eighteenth century. For architecture in the century, see D. Howard, *The Architectural History of Venice*, 1980, pp. 193 ff., used here. The artistic background and the leading artistic patrons are studied in detail in

F. Haskell, *Patrons and Painters*, 2nd, revised ed., 1980, pp. 245 ff., and pp. 405–10, with a wealth of bibliographical references.

pages 1–7 Algarotti's comment on Italy's place in the world is in his *Pensieri Diversi, Opere*, 1764 ed., VII, p. 42. On the Inquisition, see G. Comisso, *Les Agents Secrets de Venise au XVIIIᵉ siècle*, 1944 ed. Northcote's shock is recorded in *Memorials of an Eighteenth-Century Painter* (ed. S. Gwynn), 1898, p. 179. Abbé Richard's comment in *Description... de l'Italie*, 1766, II, p. 419, note (*a*). For da Ponte's account of his escapade, see his *Memoirs* (ed. L. A. Sheppard), 1929, pp. 67–8. Da Ponte claims in fact that everyone else feared for him, but that he was sure he would be safe. The uproar occasioned by his verses is worth study by anyone supposing the climate of the city to have been liberal. Casanova records his own attempted paradox with Voltaire in his *Mémoires*

(and also some sub-acid comments on Algarotti): the passage conveniently in E. Bonora, *Letterati, Memorialisti e Viaggiatori del Settecento*, 1951, p. 739. Berengo, *op. cit.*, p. 195, has well observed how even the adventurers of the period at Venice, like da Ponte and Casanova, did not become political rebels.

page 7 On the chaos of the archives, see Romanin, *op. cit.*, p. 114: in 1761 three *Corettori alle Leggi* were appointed to deal with such questions and to propose a variety of reforms (but they had difficulty in agreeing with each other). On the book trade, see H. Brown, *The Venetian Printing Press*, 1891, pp. 193 ff., 'it (book trade) was choked by a multiplicity of laws relating to every conceivable phase of its existence' (p. 195); also G. Morazzoni, *Il Libro Illustrato Veneziano del Settecento*, 1943; by 1765 Gasparo Gozzi thought a crisis had been reached (Morazzoni, *op. cit.*, p. 51). Maffei's *Consiglio Politico* was first published in 1797; the title-page says, 'presentato al governo veneto nell'anno 1736.' Further discussion in G. Silvestri, *Un Europeo del Settecento: Scipione Maffei*, 1954, pp. 169 ff. The instructions given to the French ambassador in 1786 are quoted by Berengo, *op. cit.*, p. 10, note 2.

Connoisseurs and Patrons

pages 8–9 *L'idea generale delle scienze* is singled out by G. Natali, *Storia Letteraria d'Italia: Il Settecento*, 1929, I, p. 241. For Mariette's interest in contemporary Venetian painting, see especially his letters to Temanza published in the original (for the first time) by E. Müntz, *Les Archives des Arts*, 1890, pp. 101 ff.

pages 9–10 For the Président de Brosses' list, see his *Lettres Familières sur l'Italie* (ed. Y. Brizard), 1931, I, pp. 205 ff. Nor will Tiepolo's name be found for instance in any eighteenth-century editions of M. Pilkington's *Dictionary of Painters* (first ed. 1770); nor in Fuseli's revised edition of 1805 *sqq*. The complaints of Bergeret and Fragonard are in their *Journal inédit* (ed. Tornézy), 1895, p. 394; Cochin's comment in the *Voyage d'Italie*, 1758, III, p. 46.

pages 10–12 Vincenzo da Canal's *Vita di Lazzarini* was published by G. A. Moschini in 1809. His treatise *Maniera del depingere moderno* was published in 1810: for it and da Canal further, see N. Ivanoff in *Arte Veneta*, 1953, pp. 117 ff. Gradenigo's notes on artistic events published by L. Livan, *Notizie d'Arte*, 1942. Gasparo Gozzi's *Gazzetta Veneta* (1760) became in 1761 the *Osservatore Veneta*; for this aspect of his career, see for example G. de Beauvillé, *Gasparo Gozzi Journaliste Vénitien*, 1937. Baretti's comment is cited by G. Ortolani, *Voci e Visioni del Settecento Veneziano*, 1926, p. 26, who attempts to minimize it. Gozzi on the book trade, cited by Morazzoni, *loc. cit., supra*.

page 12 Strange's letter of 1789 to Sasso is quoted by F. Mauroner in *Arte Veneta*, 1947, p. 49. Mariette's in Müntz, *op. cit.*, p. 133. For Ricci's drawings after Watteau: A. Blunt and E. Croft-Murray, *Venetian Drawings at Windsor Castle*, 1957, pp. 61 ff. Some information about Pellegrini acting for Rosalba, and the mention of Zanetti staying at Mr Smith's, is in the important group of letters to and from Rosalba, published by V. Malamani in *Le Gallerie Nazionali Italiane*, IV, 1899, pp. 27 ff. See for these points *op. cit.*, pp. 112 and 117. The fullest publi-

cation of this and related material is now B. Sani, *Rosalba Carriera: Lettere, diari, frammenti,* 1985, with a useful introduction, I, pp. 1–41.

page 13 For the elder Zanetti see G. Lorenzetti in *Miscellanea di Storia Veneta,* 1917 (extract); further (with comment on his caricatures) see E. Croft-Murray, *op. cit., supra,* pp. 146 ff. See also the catalogue by A. Bettagno of the exhibition *Caricature di Anton Maria Zanetti,* Venice, 1969. For a portrait of him by Rosalba, see T. Pignatti in *Bollettino dei Musei Civici Veneziani,* 1956, pp. 53 ff. Further for the elder Zanetti, see Haskell, *op. cit.,* pp. 341–6. On the younger Zanetti's aesthetics, see M. Pittaluga in *L'Arte,* 1918, pp. 5 ff. and N. Ivanoff in *Atti dell' Istituto Veneto,* 1952/3. In general for the two Z. see also F. Borroni in *Amor di Libro,* 1955 (IV), pp. 195 ff., and *ib.* 1956 (I), pp. 12 ff.

page 15 For Joseph Smith, see K. T. Parker's introduction to his *Canaletto Drawings at Windsor Castle,* 1948, reprint, 1990, and A. Blunt's introduction, *op. cit.* The Longhi of Murray and his family was included in Joseph Smith's sale, London, 17 May (2nd day), 1776 (lot 81). Further for Smith, see Haskell, *op. cit.,* pp. 299–310, and especially the in-depth study by F. Vivian, *Il Console Smith Mercante e Collezionista,* 1971; F. Vivian, exh. cat., *The Consul Smith Collection: Masterpieces of Italian Drawings from the Royal Library, Windsor Castle ...,* Frankfurt; Fort Worth, Tex.; Richmond, Va.; Edinburgh; 1989–90, and an article, 'The Last Months of the Life of Joseph Smith', *Apollo,* CXXXI, 1990, pp. 309–12. *A King's Purchase, King George III and the Collection of Consul Smith,* exhibition, The Queen's Gallery, London, 1993, covers the whole

range of works bought by the King, including eighteenth-century Venetian frames, for which see P. Mason in the exh. cat., pp. 59–62.

A major foreign patron and resident omitted from this chapter but glancingly mentioned elsewhere (e.g. pp. 98 and 153) is Marshal Schulenburg (1661–1747), now studied exhaustively by A. Binion, see Notes to Chapter 3.

page 16 On Algarotti: best relevant discussion in Haskell, *op. cit.,* pp. 347–60 and 409–10. Algarotti's will published by G. da Pozzo, in an important article in *Atti dell'Istituto Veneto di Scienze, Lettere ed Arti,* CXXII, 1963–4, pp. 181–92. To the older literature cited below should be added, on A.'s own etchings, M. Santifaller in *Arte Veneta,* 1976, pp. 135–44; she also discussed the painting, of uncertain attribution, now at Berlin, on which Volpato's engraving of A.'s tomb is based, here Fig. 5: *Burlington Magazine,* CXX, 1978, Advertising suppl. to Feb. issue. Further on A: I. F. Treat, *Francesco Algarotti: Un Cosmopolite au 18e siècle,* 1913; also M. Siccardi, *Algarotti Critico e Scrittore di Belle Arti,* 1910 (neither very satisfactory, though considerable *MS.* references in Treat); G. Fogolari in *Bollettino d'Arte,* 1911, for some eighteenth-century Venetian pictures belonging to A. For A. and Dresden see L. Ferrari, *L'Arte,* 1900, pp. 150 ff.; and especially H. Posse in Prussian *Jahrbuch,* 1931 (Appendix); for the *Flora* (now at San Francisco, here Fig. 6) see M. Levey, *The Burlington Magazine,* XCIX, 1957, pp. 89 ff. Satiric comment on A. by his contemporary Girolamo Zanetti (and also complaint that A. is despoiling Venice) is in Z.'s *Memorie* published by F. Stefani in *Archivio Veneto,* 1885, pp. 93 ff. A.'s

comment on Maser: Bottari-Ticozzi, *Lettere Artistiche*, 1822, VII, pp. 461 ff. For A.'s own etchings: A. Ravà, *L'Arte*, 1913, pp. 58 ff. Apart from Liotard's pastel of A. (reproduced here Fig. 4), his appearance is recorded in two drawings by Jonathan Richardson (senior) of 1736: see *Portrait Drawings* (Victoria & Albert Museum booklet), 1953, pl. 13, and also R.A. exhibition, *Paul Oppé Collection*, 1958 (No. 119). For his relations with Lady Mary Wortley Montagu, see R. Halsband, *The Life of Lady Mary Wortley Montagu*, 1956, pp. 153 ff.

pages 20–21 On the satires directed at profane-style religious pictures see the unsatisfactorily brief reference of V. Malamani, *Il Settecento a Venezia, I: la Satira del Costume*, 1891 ed., p. 110.

The Painters

page 21 For the Venetian Academy: E. Bassi, *La R. Accademia di Belle Arti di Venezia*, 1941; and for its having lost Zuccarelli, Bassi, *op. cit.*, pp. 71–2. A good deal of useful information about the Academy was published by G. Fogolari in *L'Arte*, 1913, pp. 241 ff. Exhibitions in eighteenth-century Venice discussed by F. Haskell & M. Levey, *Arte Veneta*, 1958, pp. 179–184. Cochin's summing up. *op. cit.*, p. 159.

1 THE HISTORY PAINTERS

page 23 For Lessing on the musical pictures in Dryden's *Ode*, 'die den Pinsel müssig lassen', see *Laokoon*, 1881 ed., p. 95.

pages 23–5 For Algarotti's choice of Dryden's *Ode* as subject for Tiepolo, see Posse, *op. cit.*, p. 50, note 1. Some

frescoes by Longhi are in S. Pantaleon at Venice; more disastrous still perhaps is his ceiling for Palazzo Grassi, also in Venice. Canaletto's *Holy Family* is recorded by L. Crico, *Lettere sulle Belle Arti Trevigiane*, 1833, p. 297. In a London sale of 1766 (*i.e.* during his lifetime) Anon, 5 February (lot 41), was Canaletto, *A small picture of a flower and a bird*; lot 42, ditto, *its companion*; the latter reference is almost certainly an example of typical ignorance-cum-optimism in eighteenth-century English sale catalogues. For the seventeenth century in Venice, see the catalogue of the exhibition *La Pittura del Seicento a Venezia*, Venice, 1959, C. Donzelli & G. M. Pilo, *I Pittori del Seicento Veneto*, 1967, H. Potterton's catalogue of the exhibition, *Venetian Seventeenth-Century Painting*, National Gallery, London, 1979, and, most comprehensively, R. Pallucchini, *La Pittura Veneziana del Seicento*, 1981. For individual painters, cf. L. Mortari, *Bernardo Strozzi*, 1966, and K. Steinbart, *Johann Liss*, 1946, and especially the catalogue of the exhibition *Johann Liss*, Augsburg–Cleveland, 1975–6. Passed over, perhaps wrongly, in the present book is the interesting figure of the Dalmatian-born painter, Bencovich, only little of whose work was for Venice; on him see P. O. Krueckmann, *Federico Bencovich 1677–1753*, 1988.

pages 26–31 Freud's comments are in *Totem and Taboo* (transl. A. A. Brill), 1942 ed., p. 95; Valéry's *Pièces sur l'Art*, 1934, p. 104, for his summing up of these Veneto villas. Louis XIV's letter quoted in full by F. J. B. Watson, *Wallace Collection Catalogues: Furniture*, 1956, p. xxvi.

page 31 For some Veronese-style decorations on porcelain (Vezzi factory) see Arthur Lane, *Italian Porcelain*,

1954, pl. 11 C; his pl. 21 C shows a piece of Cozzi porcelain with Veronese's *Rape of Europa* (and Tintoretto and Tiepolo (?) medallions round it) reproduced here Fig. 16.

pages 34–40 De la Fosse's snub to Ricci is reported by Walpole, *Anecdotes* . . . , III, 1826, p. 282. Marco Ricci's letter to Gaburri is in Bottari-Ticozzi, *Lettere Artistiche*, 1822, II, pp. 129/30; S. Ricci's confession of his lust for cheese, Bottari-Ticozzi, *op. cit.*, IV, p. 96. The letter about 'Rizzi of Venice' is quoted by F. J. B. Watson, *Arte Veneta*, 1954, p. 295, note 1. N. Passeri's *Del Metodo di Studiare la Pittura* . . . , 1795, I, pp. 158 ff., for Ricci's defects and danger.

pages 40–3 On Pellegrini's and M. Ricci's scenery for *Pyrrhus* see M. Whinney & O. Millar, *English Art 1625–1714*, 1957, p. 307. For the chairs once at Kimbolton see the Duke of Manchester sale, Kimbolton, 18 July *sqq.*, 1949, pl. 3. Some appreciative comment on Pellegrini is in E. K. Waterhouse, *Painting in Britain 1530–1790*, 1994, 5th ed., p. 129; also Whinney & Millar, *op. cit.*, pp. 307 ff. The Johann Wilhelm allegories discussed and illustrated by M. Goering in the Munich *Jahrbuch*, 1937, pp. 233 ff. For the Banque de France ceiling described see *Vies des Premiers Peintres du Roi* . . . (ed. Lépicié), 1752, II., pp. 122 ff. It is valuably discussed by C. Garas in the *Bulletin du Musée hongrois des Beaux-Arts*, 1962 (No. 21), pp. 75–93.

page 45 Amigoni's work at Moor Park (and other places in England) is early mentioned, in B. Gamba, *Galleria dei Letterati ed Artisti Illustri delle Provincie Veneziane*, 1822, *ad vocem*. For Lorenzi's supposed aid to the illiterate Tiepolo, see Molmenti, *G. B. Tiepolo*,

1909 ed., p. 35 (citing Zannandreis, *Vite dei Pittori . . . Veronesi*, 1891, p. 429). Walpole's unkind comments in his *Anecdotes* . . . , IV, 1827, pp. 112 ff. For Amigoni supposedly producing decorative designs for furniture, see G. Morazzoni, *Mobili Veneziani Laccati*, 1954, I, p. 33.

page 45 For the English work of Amigoni and Pellegrini, see E. Croft-Murray, *Decorative Painting in England, 1537–1837*, II, 1970, pp. 163 ff. and pp. 253 ff respectively. A letter written from Kimbolton by Pellegrini's wife to her sister, Rosalba Carriera, on 11 February 1713, establishes that his work on the staircase was then finished ('una delle meglio opere che Toni abbi fatto'): B. Sani, *Rosalba Carriera: Lettere, diari, frammenti*, 1985, I, pp. 227–8.

page 49 For illustrated books of the period: G. Morazzoni, *Il Libro Illustrato Veneziano del Settecento*, 1943; and, much less useful, M. Lanckorońska, *Die Venezianische Buchgraphik des XVIII Jahrhunderts*, 1950.

page 49 Tessin's comments on various contemporary Venetian painters published by O. Sirén, *Dessins et Tableaux de la Renaissance Italienne dans les Collections de Suède*, 1902, pp. 103 ff.

page 50 For the date of Piazzetta's *St James* and the series of Apostles in S. Stae, see L. Moretti in *Arte Veneta*, 1973, pp. 318 ff.

page 53–7 G. B. Albrizzi's *Memorie intorno alla vita di G. B. Piazzetta*, prefaced to his *Studi di pittura designati da G.B.P.*, 1760. Cochin, *op. cit.*, p. 137, for Piazzetta's *Death of Darius* in Palazzo Pisani.

246

page 57 Balestra's protests against the 'rococo': see his letters in Bottari-Ticozzi, *op. cit.*, II, *passim*. On Balestra generally, see M. Polazzo, *Antonio Balestra, pittore veronese del Settecento*, 1990.

page 57 For a provincial person's efforts to copy Tiepolo, see A. Ricci, ... *Artisti di Ancona*, 1834, II, p. 369, on his relation Alessandro Ricci copying without realizing that Tiepolo 'è uno originale che difficilmente s'imita . . .'.

pages 58–60 Algarotti's letter of 13 February 1751 (from Potsdam) to Mariette: Bottari-Ticozzi, *op. cit.*, VII, pp. 387 ff. Madame Geoffrin's comments on the picture commissioned from Vien, in *Correspondance inédite du Roi Stanislas-Auguste Poniatowski et Madame Geoffrin* (ed. C. du Mouÿ), 1875, pp. 218/9.

page 60 Pittoni's altarpiece at Edinburgh is from the church of the Miracoli in Venice, as published first by F. Haskell, *Burlington Magazine*, CII, 1960, p. 366; on the church and the altarpiece, see D. Howard, *Burlington Magazine*, CXXXI, 1989, pp. 684–92.

pages 61–6 For G. A. Guardi's copy after Balestra (but not identified as such) see N. Coe in *Bulletin of Cleveland Museum*, November 1957, pp. 198 ff. For the 1731 mention of pictures by the Guardi brothers, see the catalogue of the *Mostra dei Guardi*, Venice, 1965, p. lxx. F. Guardi's Roncegno altarpiece discovered and published by M. Muraro in *Burlington Magazine*, C, 1958, pp. 3 ff. For a very thorough stylistic analysis of the Guardi brothers' figure paintings, see the pioneering article by D. Mahon in *Problemi Guardeschi*, 1967, pp. 66–155.

page 67 For Fontebasso's work in

Venetian palaces, see M. Magrini, *Arte Veneta*, 1974, pp. 219–234; she has now published a complete monograph: *Francesco Fontebasso (1707–1769)*, 1988.

page 69 Guarana has been rather neglected by modern criticism. The Ospedaletto frescoes seem never to have been properly published. A. Mengozzi Colonna signs and dates his share there (above the right-hand doorway): *Augustus Colonna Pin. Anno MDCCLXXVI.* There is a useful article by B. Scott in *Apollo*, May 1966, pp. 364 ff.

2 LANDSCAPE PAINTING

page 73 For the English attitude in general see E. Manwaring, *Italian Landscape in Eighteenth-Century England*, 1965 ed.

page 76 On the Bolognese caprice landscape frescoes, see G. Zucchini, *Paesaggi e Rovine nella Pittura Bolognese del Settecento*, 1947; Girolamo Zanetti's comment in his *Memorie . . . , op. cit.*, p. 104.

pages 77–8 For the 'Tombs', see T. Borenius, *Burlington Magazine*, LXIX, 1936, p. 245; E. Arslan, *Commentari*, July/September 1955, pp. 189 ff.; F. J. B. Watson, *Burlington Magazine*, XCV, 1953, pp. 362 ff. Four previously untraced Tombs from Goodwood were in Sir Humphrey de Trafford sale, London, 26 July 1957 (lots 53–55; Birmingham picture lot 54); another was in Ronald Avery sale, London, 14 May 1958 (lot 46). Walpole knew some of them: 'the stories being ill told . . . it is extremely difficult to decypher to what individual so many tombs, edifices and allegories belong in each respective piece,' *Anecdotes . . . , IV*, 1827, p. 116.

There are now major studies of the 'Tombs': B. Mazza in *Saggi e memorie di storia dell'arte*, 10, 1976, pp. 79–102, 141–51, and G. Knox in *Arte Veneta*, 1983, pp. 228–35 (letters of McSwiny to the Duke of Richmond). Pignotti's *La Tomba di Shakespeare*, 1779, mentioned by G. Natali, *Storia Letteraria d'Italia: Il Settecento*, 1929, I, p. 594. Juvarra's 'Tombs' for the Ricci in Blunt & Croft-Murray, *op. cit.*, pp. 41 ff.

page 78 Interesting comments on M. Ricci's gouache scenes, and indications of commissions to him, are given in a letter of 1761 from the elder Zanetti to Algarotti: 'li paesi a tempera di Marchetto Ricci che son difficiliss.^{mi} a trovarsi. . . .'; G. Lorenzetti in *Misc. di Storia Veneta*, 1917, p. 138. Valuable discussions of Marco and his art, by G. M. Pilo and R. Pallucchini, in the catalogue of the exhibition *Marco Ricci*, Bassano del Grappa, 1963.

page 81 Gasparo Gozzi's letter to Caterina Dolfin Tron on town and country life ('. . . invece d'udire canti d'uccelletti, ho da sentire otto giorni continui le campane di S. Zaccaria che fanno allegrezza per una reverendissima Badessa . . .' in *Raccolta di Prose e Lettere scritte nel secolo XVIII*, 1830, II, p. 113.

page 82 On Zuccarelli and Wilson at Venice (and on Wilson's portrait of Z.) M. Levey in *Burlington Magazine*, CI, 1959, pp. 139 ff. Smith apparently possessed some classical landscapes by Z. (like the *Apollo and Daphne*, engraved by Wagner) which did *not* pass into the Royal Collection; perhaps they are the pictures by Z. in the Smith sale of 1776. Z's sale of his work was in London to February 1762; for it and Z.'s English career further, see M. Levey in *Italian Studies*, 1959, pp. 1–20.

pages 84–7 Algarotti's patronage in recorded in Posse, *op. cit.* Baretti thinks of 'mio Z.' apropos the landscape outside Lisbon: *Lettere Familiari*, 1763, II, p. 8. Some mention of Z. bringing Algarotti's bequest to Chatham in F. Viglione, *L'Algarotti e l'Inghilterra*, 1919, p. 12. H. Angelo, *Reminiscences . . .*, 1904, *passim* for anecdotes and praise of Z. On this concept of Arcady, and Steele on pastoral poetry, see for example, M. M. Fitzgerald, *First Follow Nature*, 1947, p. 40. Carey's thought quoted by the Redgraves, *A Century of Painters . . .*, 1866, pp. 180 ff., with their own pejorative comments. Zais' *Country Scene* borrows considerably from the Watteau composition (Edinburgh), engraved by L. Cars as 'Fêtes Vénitiennes'.

page 88 For pictures, probably by Antonio Diziani, owned by the Adam brothers, see their sale, London, 25 February 1773 (lots 1–2), where the pictures are attributed to 'Gas. Dizziano'. All the same, the subjects (*i.e. A Vintage* and *its companion*) suggest Antonio's work much more. Probably the two collaborated on large scale pictures, just as the Ricci had done. Antonio is discussed and his work catalogued by A. P. Zugni Tauro in her monograph on his father, *Gaspare Diziani*, 1971, pp. 114–121.

page 88 Rosalba's scorn for Z. and Wilson recorded by an anecdote in *The Farington Diary*; I, 1978, ed. K. Garlick & A. Macintyre, p. 198. Goethe's amazement quoted by L. Hautecoeur, *Rome et la Renaissance de l'Antiquité*, 1912, p. 179.

3 THE VIEW PAINTERS

page 91 On the phenomenon of the Grand Tour, see for example W. E.

248

Mead, *The Grand Tour in the Eighteenth Century*, 1914. For some idea of it in artistic terms, see the exhibition catalogue *Eighteenth-Century Italy and the Grand Tour*, Norwich, May/July 1958. Recent studies include: J. Black, *The British and the Grand Tour*, 1985; also by the same author, *The British Abroad: The Grand Tour in the Eighteenth Century*, 1992; and C. Hibbert, *The Grand Tour*, 1987. For view painting generally, see G. Briganti, *The View Painters of Europe*, trans. P. Waley, 1970.

pages 92–3 Fuseli's remarks on 'that last branch of uninteresting subjects, that kind of landscape which is entirely occupied by tame delineation of a given spot', cited and discussed by K. Clark, *Landscape into Art*, 1949 ed., p. 35. Goldoni on Venice: *Tutte le Opere: Mémoires* (ed. G. Ortolani), 1935, p. 35. Goethe's comment on the Doge in the *bucintoro: Italienische Reise* (*Goethes Werke*, XI), 1950 ed., p. 80.

page 94 For Canaletto's use of the *camera ottica* see T. Pignatti, *Il Quaderno di Disegni del Canaletto alle Gallerie di Venezia*, 1958, where the whole question is authoritatively discussed, and also D. Giosefi, *Il quaderno delle gallerie veneziane e l'impiego della camera ottica*, 1959. Early depictions of the Campanile: G. Fogolari in *Rassegna d'Arte*, 1912, pp. 49 ff.

pages 96–7 Boschini calls Heintz "'l piu capricioso' in *La Carta del Navegar* ..., 1660, p. 536. Balestra on Richter's *genio* in Bottari-Ticozzi, *op. cit.*, II, p. 123. For Vanvitelli see G. Briganti, *Gaspar van Wittel*, 1966.

page 98 Marshal Schulenburg sale, London, 12 April 1775 for a full study of S. and his collection, see A. Binion, *La galleria scomparsa del maresciallo von der Schulenburg. Un mecenate nella Venezia del Settecento*, 1990. The Foot's Cray reference published by F. J. B. Watson, *Burlington Magazine*, XCV, 1953, p. 206. Strange's sale (anonymous), London, 10 December 1789. Carlevaris' etchings, *Le Fabriche e Vedute di Venetia ...*, 1703; the dedication says the object is 'di rendere più facile alla notizia de Paesi stranieri le Venete Magnificenze ...'.

pages 99–101 For one aspect of the decline of Venice and rise of Savoy, see for instance E. P. Noether, *Seeds of Italian Nationalism 1700–1815*, 1951, p. 43; Noether, *op. cit.*, p. 24, for Campanella's striking phrase about Venice as a new Noah's ark. For Mr Cole and the Earl of Manchester's embassy see W. Nisser, *Burlington Magazine*, LXX, 1937, pp. 30 ff. Rawdon Brown's transcript and notes in the Public Record Office, London; see also M. Symonds, *Days spent on a Doge's Farm*, 1893, p. 21, for Pisani family picture of Venetian ambassador at the Tower of London. The Victoria and Albert sketchbook published by J. Pope-Hennessy in *Burlington Magazine*, LXXIII, 1938, pp. 126 ff. G. A. Moschini, *Della Letteratura Veneziana del Secolo XVIII ...*, 1806, III, p. 87, for Carlevaris' supposed apoplectic death.

pages 105–114 'Scomunicò ... il teatro' is Zanetti's reporting of Canaletto's decision (*Della Pittura Veneziana*, 1771, p. 463). That C. has more 'work than he can doe' is reported by McSwiny in a letter of November 1727: see H. Finberg in *Walpole Society*, IX, 1921, p. 23. For the Conti pictures, see F. Haskell in *Burlington Magazine*, XCVIII, 1956, pp. 296 ff., correcting all previous statements. Views of the *Interior of S. Marco* (versions at Windsor and

Montreal) are shown to be out of date by R. Gallo, *Atti dell' Istituto Veneto*, 1956–7 (offprint) who wrongly supposes the pictures to be early; they must be *c*. 1750, if not later; see the discussion in W. G. Constable, *Canaletto Giovanni Antonio Canal* (revised J. G. Links), 1976, reissued ed. with supplement, 1989, II, pp. 222–3, nos. 78 and 79. Algarotti's commission to C. is discussed by him in a letter: Bottari-Ticozzi, *op. cit.*, VII, p. 429.

page 112 Absorbing demonstrations of C.'s inventive attitude to topography, with complex arguments, in A. Corboz, *Canaletto. Una Venezia immaginaria*, 1985, and see also the same author's article in *Arte Veneta*, 1974, pp. 205–18.

pages 115–22 For Canaletto's Whitehall topography, see J. Hayes in *Burlington Magazine*, C, 1958, pp. 341 ff. For C.'s London work considered generally, see B. Allen, 'Topography or Art: Canaletto and London in the Mid-eighteenth Century', in the exh, cat. *The Image of London: Views by Travellers and Emigrés, 1550–1920*, London, 1987, pp. 29–48. On C.'s Warwick views, see D. Buttery, 'Canaletto at Warwick', *Burlington Magazine*, CXXIX, 1987, pp. 437–45. Turner's attitude to C. cited by A. J. Finberg, *In Venice with Turner*, 1930, p. 80; Turner's picture (Tate Gallery), *op. cit.*, pl. XIV. For attitude to landscape painters at Rome: L. Hautecoeur, *op. cit.*, p. 154. The Crew incident quoted by Watson, *Canaletto*, 1954, p. 9. Mrs Thrale's comments in *Thraliana* (ed. K. C. Balderston), 1942, I, p. 536; as well as Canalettos she bought some pictures by Amigoni. For Angelica Kauffmann's will (relevant portion): Lady V. Manners and G. C. Williamson, *Angelica Kauffmann*, 1924, p. 244.

Canova also collected some pictures by C.: G. A. Moschini, *op. cit.*, p. 77, note 1. Rose's comment in his *Letters from the North of Italy*, 1819, I, p. 272.

page 122 For Moretti: G. Delogu, *Pittori Veneti Minori del '700*, 1930; views by M. are mentioned as despatched to England by G. M. Sasso at Venice in a letter of 1789 to Sir A. Hume (MSS. in National Gallery archives).

page 122 Bellotto and Canaletto as '*rinomatissimi*' in 1743 according to Girolamo Zanetti's *Memorie* (ed. Stefani), *Archivio Veneto*, 1885, p. 145. For B.'s post-Italian activity see especially the exhibition catalogues *Bernardo Bellotto...*, Whitechapel, 1957, *Bernardo Bellotto: Le Vedute di Dresda*, Venice, 1986, and *Bernardo Bellotto: Verona e le città europee*, Verona, 1990.

pages 125–6 For Costa's work discussed and illustrated fully: M. Pittaluga, *Acquafortisti Veneziani del Settecento*, 1953, pp. 75 ff. Ruskin's disapproval of the Brenta villas is stated in *The Stones of Venice*. 1851, I, pp. 344/5.

page 127 For dating of the Waddesdon Guardi *Basin of S. Marco* (and its pendant) see J. Byam Shaw in *Burlington Magazine*, XCVII, 1955, pp. 12 ff.

page 132 The Doge's speech in 1780 is given by S. Romanin, *Storia Documentata di Venezia*, 1859, VIII, p. 262. For growth of rationalism, see M. Berengo, *La Società Veneta alla fine del Settecento*, 1956, pp. 243/4. It was Angelo Querini, then safely in Switzerland, who presented the medal to Voltaire: W. Carew Hazlitt, *The Venetian Republic*, 1900 ed., II, p. 317.

page 134 Mr Slade's stay in Venice: W. Buchanan, *Memoirs . . .*, 1824, I, pp. 320 ff.; his catalogue included the picture mentioned (No. 49). The cheapness of G.'s pictures is instanced by a contemporary, see G. Fiocco, *Francesco Guardi*, 1923, p. 8. Strange's letter to Sasso quoted by Mauroner, *Arte Veneta*, 1947, p. 49. An important article on patronage of Francesco as a view painter by F. Haskell in *Journal of the Warburg and Courtauld Institutes*, 1960, pp. 256–76; see also the same author in the exh. cat., *Francesco Guardi: Vedute, Capricci, Feste*, Venice, 1993, pp. 15–26.

page 136 On Migliara (1785–1837) see M. Pittaluga, *Arte Veneta*, 1954, pp. 334 ff.

A stimulating conspectus of literary and visual concern with later, post-eighteenth-century Venice, including samples of brilliant photography, in H. Honour & J. Fleming, *The Venetian Hours of Henry James, Whistler and Sargent*, 1991.

4 GENRE

page 137 For Crespi and the theme generally, see the catalogue of the exhibition, *Giuseppe Maria Crespi and the emergence of genre painting in Italy*, Fort Worth, 1986.

page 142 Mariette's unfortunate remark about Longhi: 'il devint un autre Watteau' (*Abecedario*, 1856, III, *ad vocem*) can be accepted only by heavy emphasis upon 'autre'. For some comment on Pietro Verri, see E. P. Noether, *op. cit.*, Notes to chapter 3, 'The View Painters'. For his sense of being powerless amid the social conditions of the period in Italy, his own remarks are sufficient, i.e. 'Had I been born in England or in France, I should be a man like the others . . .' (see further Noether, *op. cit.*, p. 101).

page 143 For Longhi as valuer, see M. Brunetti in *Arte Veneta*, 1951, pp. 158 ff. Vertue mentions engravings by Flipart after L.: *Notebooks*, III (*Walpole Society*), p. 154. Orlandi, *op. cit.*, 1753 ed., under 'Lunghi' for the 'grossi prezzi' and also for the fact that Agostino Massetti possessed much of L.'s work (a reference yet to be pursued). Maffei's *Sopra il Rinoceronte che si è veduto in Venezia*, 1751, referred to by G. Silvestri, *Un Europeo del Settecento: Scipione Maffei*, 1954, p. 54. At Verona the rhinoceros was drawn by the Tiepolesque Lorenzi 'per Mr Francesco Seguier francese': D. Zannandreis, *Le Vite dei Pittori . . . Veronesi*, 1891, p. 428.

page 144 Gozzi on Longhi: *Gazzetta Veneta*, 1760 (ed. B. Romani), 1943, II, p. 41; *Osservatore Veneto*, 1761, quoted by V. Moschini, *Pietro Longhi*, 1956, pp. 62–63. A critical anthology of opinions on Longhi precedes the full catalogue of his work in T. Pignatti, *Pietro Longhi*, 1968, pp. 70 ff.

page 144 Grimm's comment quoted by E. Hirschberg, *Die Encyklopädisten und die Französiche Oper im 18 Jahrhundert*, 1903, p. 52.

page 148 For the fate of P. Felice Cignaroli (who painted the Franciscan *Four Seasons*) see Zannandreis, *op. cit.*, p. 436.

page 148 Goldoni's sonnet to Longhi was in the *Raccolta* of poems for the marriage in 1750 of Caterina Contarini and Giovanni Grimani (for latter of whom Longhi's Ca' Rezzonico *Rhino-*

ceros was painted in the subsequent year); perhaps this is merely a coincidence. Goldoni *Mémoires* (ed. Ortolani), *op. cit.*, p. 263, for what he thought of Chiari's play; for the censorship imposed see Ortolani, *op. cit.*, p. 1106.

page 149 For votive pictures connected with guilds and trades at Venice: G. Fogolari in *Dedalo*, 1929, pp. 723 ff. For the Guardi *Arte dei Coroneri*, see also F. Pedrocco and F. Montecuccoli degli Erri, *Antonio Guardi*, 1992, p. 150 (no. A31).

page 150 The life and career of Zompini more than fully discussed in O. Battistella, *Della Vita e della Opere di Gaetano Gherardo Zompini*, 1930. Amigoni's genre work has remained largely undiscussed (and unknown?). Wagner's engravings, with English titles, exist. Farinelli's ownership of A.'s genre scenes, in C. Burney, *Present State of Music in France and Italy*, 1773 ed., p. 222.

page 150 For Carlo Contarini's speech, see Romanin, *op. cit.*, pp. 244 ff. It was afterwards published, in 1780. The Doge's reply in April 1780 is perhaps most revealing of all statements in the century (already referred to in Chapter 3): 'Nel mezzo a tante difficoltà, all' odierna inerzia nostra, al languore, alla lentezza intellectuale e corporea della nazione...'; further see Romanin, *op. cit.*, p. 262. By July Contarini was arrested.

page 152 For Clemens August's collection, see his sale (after death), Bonn, 14 May *sqq*, 1764. Cochin on Piazzetta, Tiepolo, and nature, cited by A. Fontaine, *Les Doctrines d'Art en France*, 1909, p. 233, note 2.

page 156 On Castiglione drawings and paintings collected by Consul Smith, and their popularity in eighteenth-century Venice, see A. Blunt, *The Drawings of Castiglione and Stefano della Bella at Windsor Castle*, 1954, pp. 24 ff.

page 158 Facts about Count Giustino Valmarana as they relate to the Tiepolo published in an important article ('I Tiepolo a Vicenza e le statue dei 'Nani' di Villa Valmarana a S. Bastiano') by L. Puppi in *Atti dell'Istituto Veneto...*, 1967–8 (Vol. CXXVI), pp. 211–50. Goethe's comment on the frescoes was not published in the *Italienische Reise*, but see *Goethes Werke* (XI), 1950, p. 586, for what he recorded about his visit. For frescoes still in part remaining at Zianigo see J. Byam Shaw in *The Burlington Magazine*, CI, 1959, pp. 391–5.

page 163 By an unexpected twist of art history, the shift of subject matter for Spanish tapestries was actually caused by Mengs; on this point see for example F. J. Sánchez-Cantón's introduction to the exhibition, *De Tiepolo à Goya*, Bordeaux, 1956, p. xxx.

5 PORTRAIT PAINTING

page 165 Coleridge's comment in *Table Talk*, 1835, I, p. 181.

page 168 Goethe on the benevolent appearance of Venetian officials in public: *Italienische Reise*, *op. cit.*, p. 84.

page 170–6 Crozat's letters to Rosalba among those published by V. Malamani in *Le Gallerie Nazionali Italiane*, 1899, IV, pp. 27 ff. Rosalba's *Diario* published with elaborate annotations in a French ed. by A. Sensier, 1865; see

now B. Sani, *Rosalba Carriera; Lettere, diari, frammenti*, 1985. Mariette, *Abecedario*, I, p. 330, for Rosalba's incorrectness yet beauty of colour. For, for instance, copies by Mrs Delany after Rosalba, see letter in *Country Life*, 31 May 1946. A Scottish patron (Sir Adam Fergusson) and Zuccarelli referred to by E. K. Waterhouse, *Painting in Britain 1530–1790*, 1994 ed., p. 235. Crozat's friend M. de Laporte is referred to in a letter published by Malamani, *op. cit.*, p. 132. Crozat on the Polignac sculpture, *loc. cit.*

page 176 Nazari's portraits of Tiepolo, Pittoni, Visentini, etc., referred to by F. M. Tassi, *Vite de' Pittori ... Bergamaschi*, 1793, II, p. 92.

page 178 The comedy of Mariette and Temanza fully revealed in Mariette's letters in E. Müntz, *Les Archives des Arts*, 1890, pp. 101 ff.

page 179 For Amigoni's English portrait work see J. Woodward in *Burlington Magazine*, XCIX, 1957, pp. 21 ff. Burney on the Amigoni portrait: *The Present State of Music in France and Italy*, 1773 ed. p. 220.

page 180 On a group of 'official' portraits, see T. Pignatti in *Bollettino d' Arte*, 1950, pp. 216 ff. For Joseph Smith's will of 1761, see K. T. Parker, *Canaletto Drawings at Windsor Castle*, 1948, 1990 reprint, pp. 59 ff., where it is printed in full (spelling modernized in portion quoted in text).

pages 181–2 For the three portraits of Francesco Correr by B. Nazari, see Tassi, *op. cit.*, p. 85. Tassi, *loc. cit.*, refers to the equestrian portrait of Schulenburg which was included in the Schulenburg London sale already cited in notes to Chapter 3.

pages 183–4 Napoleon's reported comment and frequently cited on this portrait by David shows his quick eye for good propaganda: 'Vous m'avez deviné, David: la nuit je travaille au bonheur de mes sujets' etc. Further, see, for example, the exhibition catalogue, *David*, Tate Gallery, 1948, p. 26.

pages 184–5 Fox's request to Reynolds cited in Graves & Cronin, *A History of the Works of Sir Joshua Reynolds, P.R.A.*, 1899, I, p. 332. See E. K. Waterhouse, *Reynolds*, 1941, p. 10, for suggestions (not acceptable) that portraits like No. 3934 in the National Gallery, London (actually by Alessandro Longhi) influenced Reynolds.

pages 185–92 Nogari was usefully reconstructed by H. Honour in *The Connoisseur*, November 1957, pp. 154 ff. Tessin on Nogari: Sirén, *op. cit.*, p. 108. For the subject of Rembrandt's influence in Venice at the period, see F. W. Robinson's article in *Nederlands Kunsthistorisch Jaarboek*, (18), 1967, pp. 167–96. Diderot on La Tour's Rousseau in *Essai sur la Peinture: Œuvres Complètes*, (ed. J. Assézat), 1876, X, p. 483. Goldoni's 'rien ne m'interesse ...' in *Mémoires, op. cit.*, p. 81. It was virtually in front of Canova's *Helen* that Byron first met Teresa Guiccioli; see I. Origo, *The Last Attachment*, 1949, p. 37; his comments on the *Helen, op. cit.*, p. 494, note 33.

6 THE PRESIDING GENIUS: GIAMBATTISTA TIEPOLO

page 193 For Eugenia Tiepolo's will, see G. M. Urbani de Gheltof, *Tiepolo e la sua Famiglia*, 1879, pp. 16 ff., not entirely accurately transcribed. For pic-

253

tures by Canaletto, see Urbani, *op. cit.*, pp. 72–3 (Domenico Tiepolo's will).

pages 194–5 Winckelmann's comment on Tiepolo cited by P. Molmenti, G. B. *Tiepolo*, 1909, p. 332. For an English denunciation of Tiepolo's work see for example Bryan's *Dictionary*, 1816 ed., *ad vocem.*

page 195 'I pittori presti' comparison, not intended favourably, is in A. Franchi, *La Teorica della Pittura*, 1739, p. 161. See also Reynolds' 12th *Discourse.*

page 195 A *Crossing of the Red Sea* sketch exists (A. Pallucchini, *L'opera completa di Giambattista Tiepolo*, 1968, no. 1a) of the subject, an obviously very early work if by Tiepolo.

page 195 For Lazzarini's *Crossing of the Red Sea* (more than one version) see V. da Canal, *Vita...*, 1809, pp. xxxix and liii. Pictures by Lazzarini ex-Smith collection in Strange sale, London, 1789, already cited in Chapter 3 notes. Strange's comment, under No. 35 of his Catalogue.

page 196 That the patrician family of Tiepolo had some concern for the painter's family is shown by the fact that the Cavaliere Alvise Tiepolo was a witness at the marriage of Domenico Tiepolo in 1776, and it was to him that Domenico dedicated publication of his etchings.

page 199 The Old Testament Patriarchal theme in the *galleria* of the Patriarch's palace at Udine had a particular, topical application, for the Patriarchate of Aquileia was a bone of contention between Venice and the Holy Roman Emperor at Vienna. Suggestions about this relevance were first made by M. Muraro in *Atti dell'Accademia di Scienze*

Lettere e Arti di Udine, IX, 1970–72, pp. 5–67, and developed in detail by W. Barcham in *Interpretazioni Veneziane* (Studies in honour of Michelangelo Muraro), 1984, pp. 427–38; see also, more briefly, the same author, *The Religious Paintings of Giambattista Tiepolo*, 1989, pp. 58–64.

page 202 Dent's relationship of Scarlatti's characters to the Udine fresco, in his *Alessandro Scarlatti*, 1905, p. 50. Caylus' comment on the *Sacrifice of Iphigenia* (by C. van Loo), *Description d'un tableau...*, 1757, p. 22. See also D. Webb's comment on the subject in general, *An Inquiry into the Beauties of Painting...*, 1769 ed., p. 147.

page 203 It seems likely that more than one of the Ospedaletto canvases is by Tiepolo; for very full discussion of the whole subject, see B. Aikema, 'Early Tiepolo Studies: I. The Ospedaletto Problem' in *Mitteilungen des Kunsthistorischen Institutes in Florenz*, XXVI, 1982, pp. 341–82.

pages 204–5 Cochin's remarks discussed by J. Seznec in *Journal of the Warburg and Courtauld Institutes*, January/June 1957, p. 108.

page 206 The Glasgow project was that of Robert Foulis; *Memorandum among Foulis papers*, Edinburgh University Library. Reynolds on lack of seriousness in Venetian painters including Guardi, see F. W. Hilles, *The Literary Career of Sir Joshua Reynolds*, 1936, p. 221.

page 207 Tessin's note on arriving at Vienna, 'On m'a parlé et fortement recommendé un peintre nommé Tiepoli': Sirén, *op. cit.*, Notes to chapter 1, The History Painters, p. 106. Algarotti on the very young Domenico Tiepolo: Posse,

loc. cit., Notes to the Introduction, p. 64.

pages 208–9 Diderot on sketches, *Salon* of 1767 *Œuvres Complètes* (ed. J. Assézat), XI, 1876, pp. 245–6. S. Ricci on his own *modello* in a letter to Tassi, Bottari-Ticozzi, *op. cit.*, IV, pp. 93 ff.

pages 209–12 Further for the *St Clement*: M. Levey in *Burlington Magazine*, XCIX, 1957, pp. 256 ff., and A. Morassi in *Arte Veneta*, 1957, pp. 173 ff. The other S. Clement sketch is in the Princes Gate Collection, Courtauld Institute of Art; for it further, see H. Braham, *The Princes Gate Collection*, 1981, no. 109, p. 74; the matter of its relation to the Nymphenburg commission, or to some other project of the Archbishop-Elector's, cannot be pursued here.

page 212 A sketch of the subject of *Christ Falling under the Cross*, by Rubens, was owned by Joseph Smith; see F. Vivian, *Il Console Smith mercante e collezionista*, 1971, pp. 223–4.

pages 212–13 Ruskin on Tiepolo in *St Mark's Rest* (1st Suppl.), 1887, p. 30.

page 214 For the Carmelite scapular and its benefits, see for instance, M. A. R. Tuker and H. Malleson, *Handbook to Christian and Ecclesiastical Rome*, II, 1900, pp. 191–2.

page 216 For Zanetti's letter to Mariette, see the catalogue of the exhibition *Le Cabinet d'un Grand Amateur P. J. Mariette*, Musée du Louvre, 1967, pp. 180–1.

page 216 For an extremely interesting 'Vente Tiepolo' in Paris in 1845, certainly part of the estate of Domenico,

see J. Byam Shaw, *The Drawings of Domenico Tiepolo*, 1962, pp. 18–19.

pages 216–24 Reynolds' sketch after *The Meeting of Antony and Cleopatra* is in the British Museum; attention is drawn to it by F. J. B. Watson in *The Connoisseur*, November 1955, p. 214. Comment on the appearance of the Labia ballroom, 'ora abbandonata e squallida', in A. Berti, *Elogio di G. B. Tiepolo: Atti dell'... Accademia... in Venezia*, 1856, p. 20. Orlandi, 1753 ed., mentions Mengozzi's work in Palazzo Labia; but not Tiepolo's; perhaps this is significant? Algarotti on the two painters' collaboration in a letter to G. P. Zanotti: Bottari-Ticozzi, *op. cit.*, VII, pp. 397/8. Suggestions that Cleopatra is partly a symbol of Venice made by F. Haskell in *Burlington Magazine*, C, 1958, p. 213; that the subject is a compliment to the *doyenne* of the family, Maria Labia, seems more generally accepted, and originates with the same author, see *Patrons and Painters*, 1980 ed., p. 257. Of the considerable literature that has developed around the frescoes, note should be taken particularly of T. Pignatti, F. Pedrocco, E. Martinelli Pedrocco, *Palazzo Labia a Venezia*, 1982; valuable discussion, with emphasis on the sketches, in the catalogue by B. L. Brown of the exhibition *Giambattista Tiepolo, Master of the Oil Sketch*, Fort Worth, 1993, pp. 250–55; some evidence for dating the scheme around 1746/7, and not later, is provided by a drawing by F. M. Kuen, a German artist then visiting Venice, which copies the allegorical group above the *Banquet* fresco; see further M. Levey, *Tiepolo: Banquet of Cleopatra* (Charlton Lecture), Newcastle upon Tyne, 1965; irritatingly unpaginated; see now *Vorbild Tiepolo: Die Zeichnungen des Franz Martin Kuen aus dem Museum Weissenhorn*, 1992. Stothard's

Banquet for Burley House, still *in situ.* An early post-Renaissance attack on the dangerous beauty of strange women in C. Ripa, *Iconologia*, 1645 ed., p. 464, with special mention of 'gl'acuti dardi de gli occhi' of Cleopatra.

pages 224–30 For Würzburg in full documentary and photographic detail, M. H. won Freeden and C. Lamb, *Das Meisterwerk des G.B.T.*, 1956. Würzburg staircase as Tiepolo's Sistine Chapel: T. Pignatti, *Tiepolo*, 1951, p. 98. The sources and significance of the iconography have increasingly been discussed; a major article on the staircase fresco's iconography is M. Ashton's in *Art Bulletin*, March 1978, pp. 109–125; for the Kaisersaal frescoes, in relation particularly to sketches connected with them, analysed with great clarity, see B.L. Brown, *op. cit.*, pp. 268–71.

pages 232–6 On G. B. Tiepolo at Valmarana, see M. Levey in *Journal of Warburg and Courtauld Institutes*, June/December 1957, pp. 298 ff., but unfortuately not linking the frescoes with Bettinelli (himself asserting the powers of the imagination in an age of 'reason'). For quotations from Bettinelli, his *op. cit.*, pp. 249 ff. For treatment of the Iliad theme in the period and later, see D. Wiebenson in *Art Bulletin*, March 1964, pp. 23–37.

pages 236–7 Tiepolo's letter (to Algarotti) of 16 March 1761, with details of his commissions, published by G. Fogolari in *Nuova Antologia*, September 1942, p. 37.

page 237 For details of Tiepolo's choice in staying in Spain etc. see G. M.

Urbani de Gheltof, *Tiepolo in Ispagna*, 1881, pp. 8/9.

pages 237–8 Tiepolo's career in Spain is still not entirely elucidated but important contributions are made by C. Whistler, 'G. B. Tiepolo and Charles III: The Church of S. Pascual Baylon at Aranjuez'. *Apollo*, CXXI, March 1985, pp. 321–7, and 'G. B. Tiepolo at the Court of Charles III', *Burlington Magazine*, CXXVIII, 1986, pp. 199–203. Tiepolo's five surviving *modelli* for the Aranjuez altarpieces are in the Princes Gate Collection, Courtauld Institute of Art; see H. Braham, *op. cit.*, nos. 111–15 and pp. 75–80; only the *modello* of St Joseph with the Christ Child is of less than the highest quality in composition and execution. The *St Pascual Baylon* and *St Charles Borromeo* were included in the exhibition *Giambattista Tiepolo, Master of the Oil Sketch*, Fort Worth, 1993; see B. L. Brown in the catalogue, pp. 318–21.

pages 238–9 A painful drop in quality is apparent between the *modello* for the *Stigmata of St Francis* and the actual altarpiece. An early *St Francis* by Tiepolo (probably a scene of his stigmata) is mentioned in Zanetti's ed. of Boschini's *Ricche Minere...*, 1733, p. 230.

page 241 For the disdainful attitude of Voltaire and Diderot (among others) to Watteau, see R. Rey, *Quelques Satellites de Watteau*, 1931, pp. 15 ff. For a 'daub by Gainsborough' contrasted with 'a picture by Sir Joshua', see the letter of Countess Spencer quoted by E. K. Waterhouse, *Reynolds*, 1941, p. 17.

Select Bibliography

The bibliography below is select in two senses. It does not attempt to provide a comprehensive list of all book publications on the subject, but indicates the majority of important and more recent ones, inclusive of exhibition catalogues. It is also restricted to works dealing solely with the subject. Books relevant but of wider scope, as well as references to some periodical literature, are cited in the Notes.

EXHIBITIONS

Eighteenth-century Venice, London and Birmingham, 1951
Venice 1700–1800, Detroit, 1952
The Guardi Family, Houston, 1958
Disegni e dipinti di Giovanni Antonio Pellegrini, Venice, 1959
Disegni incisioni e bozzetti del Carlevarijs, Udine and Rome, 1963–4
Marco Ricci, Bassano del Grappa, 1963
Canaletto, Toronto and Ottawa, 1964–5
Mostra dei Guardi, Venice, 1965
Michele Marieschi (1710–43), Bergamo, 1966
I vedutisti veneziani del Settecento, Venice, 1967
Dal Ricci al Tiepolo, Venice, 1969
Tiepolo, Zeichnungen von Giambattista, Domenico und Lorenzo Tiepolo . . ., Stuttgart, 1970
Tiepolo. A Bicentenary Exhibition (Drawings . . .), Cambridge, Mass., 1970
Venise au dix-huitième siècle, Paris, 1971

Mostra del Tiepolo, Passariano, 1971
Rare etchings by Giovanni Battista and Domenico Tiepolo, Washington, D.C., 1972
I Maestri della Pittura Veneta del' 700, Gorizia, 1973–4
The Tiepolos: Painters to Princes and Prelates, Birmingham, Ala., and Springfield, Mass., 1978
Canaletto, Paintings and Drawings (Royal Collection), London, 1980–81
Canaletto: Disegni, dipinti, incisioni, Venice, 1982
Nicola Grassi, Tolmezzo, 1982
Da Carlevarijs ai Tiepolo; Incisori veneti e friuliani del Settecento, Gorizia and Venice, 1983
Giambattista Piazzetta: il suo tempo, la sua scuola, Venice, 1983
G. B. Piazzetta: disegni, incisioni, libri, manoscritti, Venice, 1983
Piazzetta: a tercentenary exhibition of drawings, prints and books, Washington, D.C., 1983
Vedute: Architektonisches Capriccio und Landschaft in der venezianischen

Graphik des 18 Jahrhunderts, Berlin, 1985

Giambattista Tiepolo, il segno e l'enigma, Gorizia, 1985; Venice, 1986

Canaletto e Visentini. Venezia e Londra, Venice, 1986

Venedig. Malerei des 18 Jahrhunderts, Munich, 1986

Bernardo Bellotto: Le Vedute di Dresda, Venice, 1986

Guardi. Metamorfosi dell' immagine, Gorizia, 1987

Michiel Marieschi, Venezia in scena, Bergamo, 1987

I Tiepolo: virtuosismo e ironia, Mirano, 1988

Capricci veneziani del Settecento, Gorizia, 1988

Canaletto, New York, 1989–90

Marieschi tra Canaletto e Guardi, Gorizia, 1989

Sebastiano Ricci, Passariano, 1989

I Tiepolo e il settecento vicentino, Montecchio Maggiore, Vicenza, Bassano del Grappa, 1990

Giambattista Tiepolo, Hanover, 1990

Bernardo Bellotto. Verona e le città europee, Verona, 1990

Painters of Venice. The Story of the Venetian Veduta, Amsterdam, 1990-91

Venedigs Ruhm im Norden. Die grossen venezianischen Maler des 18 Jahrhunderts, ihre Auftraggeber und ihre Sammler, Hanover and Düsseldorf, 1991–2

Francesco Guardi. Vedute, Capricci, Feste, Venice, 1993

Guardi. Quadri Turcheschi, Venice, 1993

Marco Ricci e il paesaggio veneto del Settecento, Belluno, 1993

Giambattista Tiepolo. Master of the Oil Sketch, Fort Worth, Tex., 1993

Canaletto and England, Birmingham, 1993–4

Pietro Longhi, Venice, 1993–4

The Glory of Venice: Art in the Eighteenth Century, London and Washington, D.C., 1994–5

BOOKS

W. L. Barcham, *The Religious Paintings of Giambattista Tiepolo*, New York and Oxford, 1989

W. L. Barcham, *Giambattista Tiepolo*, New York, 1992

O. Battistella, *Della vita e delle opere di Gaetano Gherardo Zompini*, Bologna, 1930

A. Binion, *I disegni di Giambattista Pittoni*, Florence, 1983

R. Bromberg, *Canaletto's Etchings*, London and New York, 1974; revised ed., San Francisco, 1993

G. Brunel, *Tiepolo*, Paris, 1991

J. Byam Shaw, *The Drawings of Francesco Guardi*, London, 1951

J. Byam Shaw, *The Drawings of Domenico Tiepolo*, London, 1962

E. Camesasca, *L'opera completa del Bellotto*, Milan, 1974

A. Corboz, *Canaletto. Una Venezia immaginaria*, Milan, 1985

W. G. Constable, *Canaletto, Giovanni Antonio Canal*, Oxford, 1962; 2nd ed., revised J. G. Links, 1976; reissued with supplement by J. G. Links, 1989

J. Daniels, *Sebastiano Ricci*, Hove, 1976

J. Daniels, *L'opera completa di Sebastiano Ricci*, Milan, 1976

G. Delogu, *Pittori veneti minori del '700*, Venice, 1930

J. von Derschau, *Sebastiano Ricci*, Heidelberg, 1922

C. Donzelli, *I Pittori Veneti del Settecento*, Florence, 1957

G. Fiocco, *Francesco Guardi*, Florence, 1923

G. Fiocco, *Venetian Painting of the*

Seicento and the Settecento, London, 1929

H. Fritzsche, *Bernardo Bellotto genannt Canaletto*, Burg b.Main, 1936

A. M. Gealt, *Domenico Tiepolo: The Punchinello Drawings*, New York and London, 1986

M. Gemin and F. Pedrocco, *Giambattista Tiepolo. I Dipinti. Opera Completa*, Venice, 1993

M. Goering, *Italienische Malerei des 17 und 18 Jahrhunderts*, Berlin, 1938

P. Gradenigo, *Notizie d'Arte* (ed. L. Livan), Venice, 1942

D. von Hadeln, *Handzeichnungen von G. B. Tiepolo*, Munich, 1927

I. Haumann, *Das Oberitalienische Landschaftsbild des Settecento*, Strasbourg, 1927

G. Knox, *Catalogue of the Tiepolo Drawings in the Victoria and Albert Museum*, revised edition, London, 1975

G. Knox, *Giambattista and Domenico Tiepolo. A Study and Catalogue Raisonné of the Chalk Drawings*, Oxford, 1980

G. Knox, *Giambattista Piazzetta 1682–1754*, Oxford, 1992

S. Kozakiewicz, *Bernardo Bellotto*, London, 1972

M. Levey, *Giambattista Tiepolo. His life and art*, New Haven and London, 1986

J. G. Links, *Canaletto and his Patrons*, London, 1977

J. G. Links, *Canaletto*. Oxford and Ithaca, NY, 1982

A. Longhi, *Compendio delle vite de' Pittori Veneziani Istorici*, Venice, 1762

M. Magrini, *Francesco Fontebasso (1707–1769)*, Vicenza, 1988

V. Malamani, *Rosalba Carriera*, Bergamo, 1910

A. Mariuz, *Giandomenico Tiepolo*, Venice, 1971

A. Mariuz, *L'opera completa del Piazzetta*, Milan, 1982

E. Martini, *La Pittura Veneziana del Settecento*, Venice, 1964

E. Martini, *Pittura veneta dal Ricci ai Guardi*, Venice, 1977

E. Martini, *La pittura del Settecento veneto*, Udine, 1982

F. Mauroner, *Luca Carlevarijs*, Padua, 1945 ed.

P. Molmenti, *G. B. Tiepolo*, Milan, 1909 (French ed., 1911)

A. Morassi, *Tiepolo*, London, 1955

A. Morassi, *A Complete Catalogue of the Paintings of G.B. Tiepolo*, London, 1962

A. Morassi, *Guardi; Antonio e Francesco Guardi, I Dipinti*, Venice, 1973 (see also 1984, 1993, below)

A. Morassi, *Guardi: Tutti i disegni di Antonio, Francesco e Giacomo Guardi*, Venice, 1975 (see also 1984, 1993 below)

A. Morassi, *Guardi, L'Opera Completa* (combined reprint of the above volumes), Milan, 1984; new ed., 1993

V. Moschini, *Francesco Guardi*, Milan, 1952

V. Moschini, *Canaletto*, Milan, 1954

V. Moschini, *Pietro Longhi*, Milan, 1956

A. Pallucchini, *L'opera completa di Giambattista Tiepolo*, Milan, 1968

R. Pallucchini, *I disegni di Giambattista Pittoni*, Padua, 1945

R. Pallucchini, *Piazzetta*, Milan, 1956

R. Pallucchini, *La Pittura Veneziana del Settecento*, Venice and Rome, 1960

K. T. Parker, *The Drawings of Antonio Canaletto at Windsor Castle*, London, 1948; reprinted with appendix by Charlotte Crawley, Bologna, 1990

F. Pedrocco, *Disegni di Giandomenico Tiepolo*, Milan, 1990

F. Pedrocco and F. Montecuccoli degli Erri, *Antonio Guardi*, Milano, 1992

T. Pignatti, *Tiepolo*, Milan, 1951

T. Pignatti, *Pietro Longhi*, Venice, 1968

T. Pignatti, *L'opera completa di Pietro Longhi*, Milan, 1974

T. Pignatti, F. Pedrocco, E. Martinelli Pedrocco, *Palazzo Labia a Venezia*, Turin, 1982

M. Pittaluga, *Acquafortisti Veneziani del Settecento*, Florence, 1953

M. Precerutti Garberi, *Affreschi Settecenteschi delle Ville Venete*, Milan, 1968

M. Precerutti Garberi, *Giambattista Tiepolo, Gli affreschi*, Turin, 1971

L. Puppi, *L'opera completa di Canaletto*, Milan, 1968; reprinted 1981

A. Rizzi, *Carlevarijs*, Venice, 1967

A. Rizzi, *Tiepolo a Udine*, Udine, 1971; 2nd ed., 1974

A. Rizzi, *The Etchings of the Tiepolos*, London, 1971

A. Rizzi, *La Varsavia di Bellotto*, Milan, 1990

G. Rosa, *Zuccarelli*, Milan, 1945

E. Sack, *G. B. und D. Tiepolo*, Hamburg, 1910

B. Sani, *Rosalba Carriera: Lettere, diari, frammenti*, Florence, 1985

B. Sani, *Rosalba Carriera*, Turin, 1988

A. Scarpa Sonino, *Marco Ricci*, Milan, 1991

G. Simonson, *Francesco Guardi*, London, 1904

D. Succi, *Francesco Guardi*, Florence, 1993

R. Toledano, *Michele Marieschi: L'opera completa*, Milan, 1988

F. J. B. Watson, *Canaletto*, London, 1954 ed.

T. R. Wessel, *Sebastiano Ricci und die Rokokomalerei*, Freiburg, 1984

P. Zampetti, *A Dictionary of Venetian Painters, IV: 18th Century*, Leigh-on-Sea, 1971

A. M. Zanetti, *Della Pittura Veneziana*, Venice, 1771; 2nd ed., 1792

F. Zava Boccazzi, *Il Settecento (Gli affreschi nelle ville venete dal Seicento all'Ottocento)*, Venice, 1978

F. Zava Boccazzi, *Pittoni*, Venice, 1979

A. P. Zugni Tauro, *Gaspare Diziani*, Venice, 1971

260

Index

Photograph Credits

In most cases the illustrations have been made from photographs and transparencies provided by the owners or custodians of the works. Those illustrations for which further credit is due are listed below.

Alinari, Florence: 12, 14, 18, 28, 31, 32, 33, 39, 44, 90, 111, 113, 120, 143, 144, 146, 157; Rossi, Venice: 17, 52, 105, 106, 129, 133, 134; Eileen Tweedy: 25; Osvaldo Böhm: 26, 97, 147; Fiorentini, Venice: 29, 30, 37, 45, 74, 92, 102, 130, 139, 140; Fondazione Giorgio Cini, Venice: 38, 41; Royal Academy of Arts, London: 40, 123; Archivo Museo Correr, Venice: 42; Metropolitan Museum of Art, New York: 68; Courtauld Institute of Art, University of London: 73, 116; National Galleries of Scotland, Edinburgh: 77; Lauros-Giraudon, Paris: 82; Fotocommissif Rijksmuseum, Amsterdam: 84; Gabinetto Fotografico Nazionale, Rome: 89; Direzione Civici Musei, Venice: 94, 95, 96, 110, 112, 124, 154, 155, 156; Scala, Florence: 107, 117, 127; A.F.I., Venice: 135; Graeme Cookson: 148, 149, 150, 151, 152.